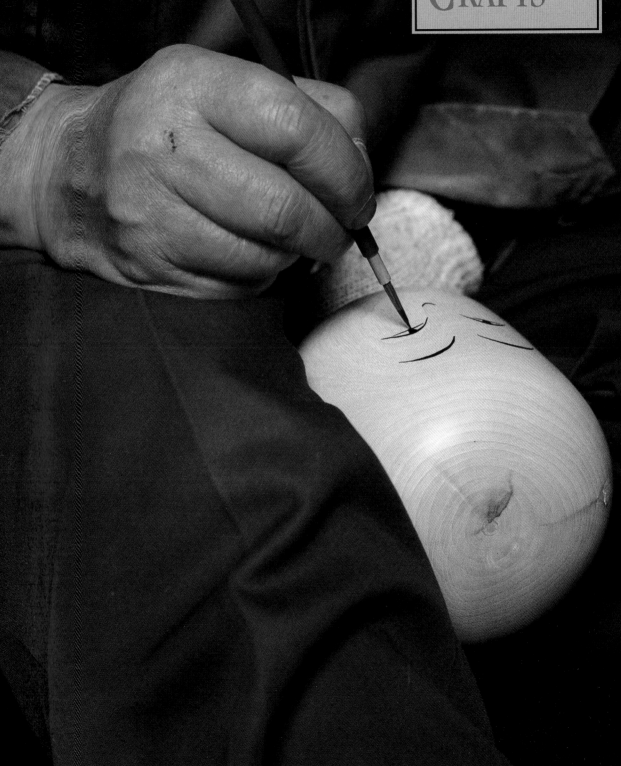

JAPANESE CRAFTS

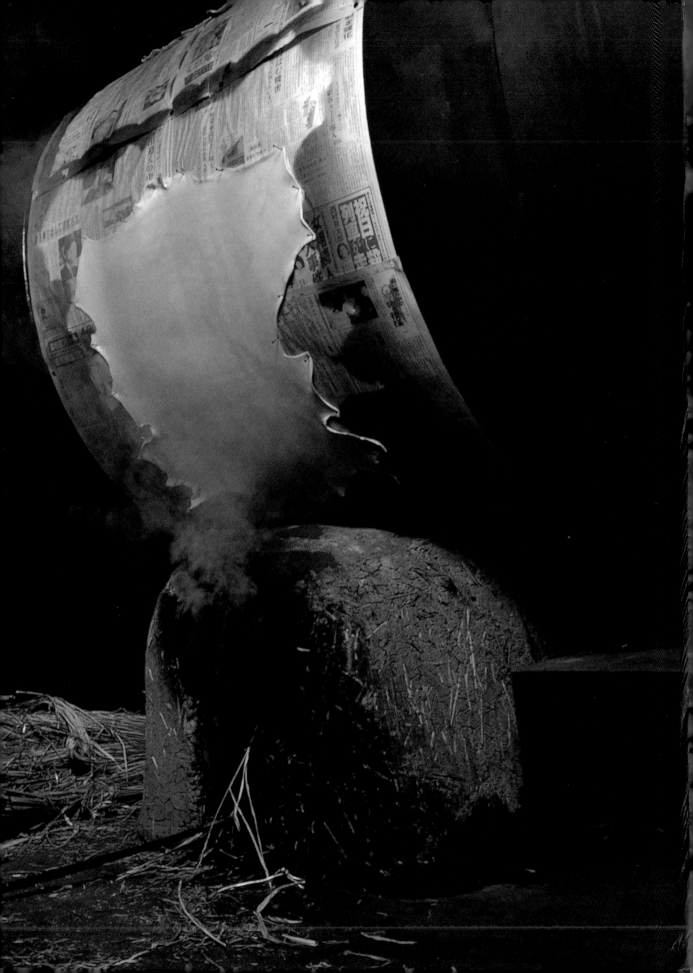

JAPANESE CRAFTS

CRAFTS

A Complete Guide to Today's Traditional Handmade Objects

Traditional Craft Centers

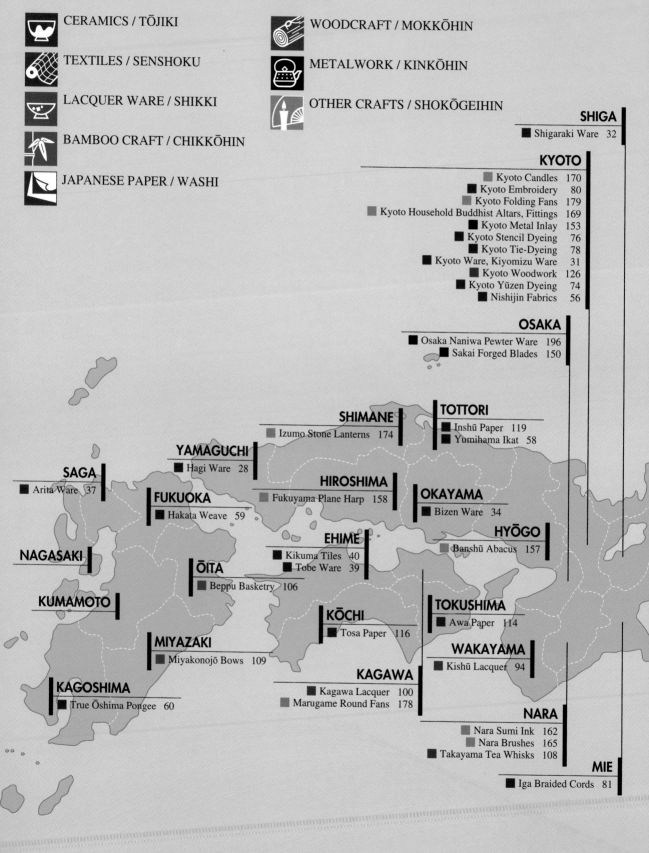

- CERAMICS / TŌJIKI
- TEXTILES / SENSHOKU
- LACQUER WARE / SHIKKI
- BAMBOO CRAFT / CHIKKŌHIN
- JAPANESE PAPER / WASHI
- WOODCRAFT / MOKKŌHIN
- METALWORK / KINKŌHIN
- OTHER CRAFTS / SHOKŌGEIHIN

SHIGA
- Shigaraki Ware 32

KYOTO
- Kyoto Candles 170
- Kyoto Embroidery 80
- Kyoto Folding Fans 179
- Kyoto Household Buddhist Altars, Fittings 169
- Kyoto Metal Inlay 153
- Kyoto Stencil Dyeing 76
- Kyoto Tie-Dyeing 78
- Kyoto Ware, Kiyomizu Ware 31
- Kyoto Woodwork 126
- Kyoto Yūzen Dyeing 74
- Nishijin Fabrics 56

OSAKA
- Osaka Naniwa Pewter Ware 196
- Sakai Forged Blades 150

SHIMANE
- Izumo Stone Lanterns 174

TOTTORI
- Inshū Paper 119
- Yumihama Ikat 58

YAMAGUCHI
- Hagi Ware 28

SAGA
- Arita Ware 37

FUKUOKA
- Hakata Weave 59

HIROSHIMA
- Fukuyama Plane Harp 158

OKAYAMA
- Bizen Ware 34

NAGASAKI

EHIME
- Kikuma Tiles 40
- Tobe Ware 39

HYŌGO
- Banshū Abacus 157

ŌITA
- Beppu Basketry 106

KUMAMOTO

KŌCHI
- Tosa Paper 116

TOKUSHIMA
- Awa Paper 114

MIYAZAKI
- Miyakonojō Bows 109

WAKAYAMA
- Kishū Lacquer 94

KAGOSHIMA
- True Ōshima Pongee 60

KAGAWA
- Kagawa Lacquer 100
- Marugame Round Fans 178

NARA
- Nara Sumi Ink 162
- Nara Brushes 165
- Takayama Tea Whisks 108

MIE
- Iga Braided Cords 81

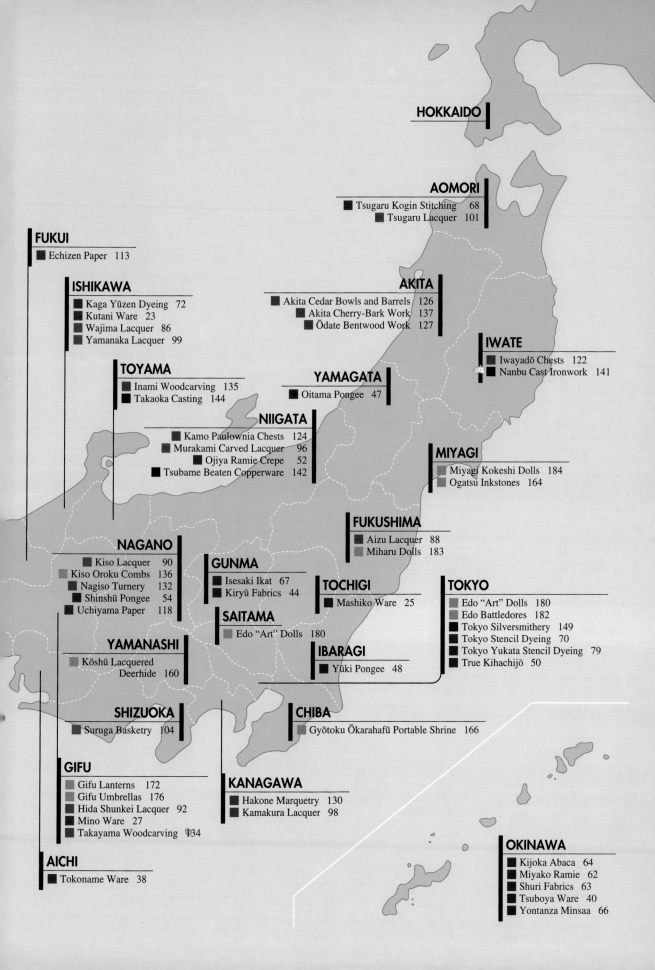

HOKKAIDO

AOMORI
- Tsugaru Kogin Stitching 68
- Tsugaru Lacquer 101

FUKUI
- Echizen Paper 113

ISHIKAWA
- Kaga Yūzen Dyeing 72
- Kutani Ware 23
- Wajima Lacquer 86
- Yamanaka Lacquer 99

AKITA
- Akita Cedar Bowls and Barrels 126
- Akita Cherry-Bark Work 137
- Ōdate Bentwood Work 127

IWATE
- Iwayadō Chests 122
- Nanbu Cast Ironwork 141

TOYAMA
- Inami Woodcarving 135
- Takaoka Casting 144

YAMAGATA
- Oitama Pongee 47

NIIGATA
- Kamo Paulownia Chests 124
- Murakami Carved Lacquer 96
- Ojiya Ramie Crepe 52
- Tsubame Beaten Copperware 142

MIYAGI
- Miyagi Kokeshi Dolls 184
- Ogatsu Inkstones 164

FUKUSHIMA
- Aizu Lacquer 88
- Miharu Dolls 183

NAGANO
- Kiso Lacquer 90
- Kiso Oroku Combs 136
- Nagiso Turnery 132
- Shinshū Pongee 54
- Uchiyama Paper 118

GUNMA
- Isesaki Ikat 67
- Kiryū Fabrics 44

TOCHIGI
- Mashiko Ware 25

TOKYO
- Edo "Art" Dolls 180
- Edo Battledores 182
- Tokyo Silversmithery 149
- Tokyo Stencil Dyeing 70
- Tokyo Yukata Stencil Dyeing 79
- True Kihachijō 50

SAITAMA
- Edo "Art" Dolls 180

YAMANASHI
- Kōshū Lacquered Deerhide 160

IBARAGI
- Yūki Pongee 48

SHIZUOKA
- Suruga Basketry 104

CHIBA
- Gyōtoku Ōkarahafū Portable Shrine 166

GIFU
- Gifu Lanterns 172
- Gifu Umbrellas 176
- Hida Shunkei Lacquer 92
- Mino Ware 27
- Takayama Woodcarving 134

KANAGAWA
- Hakone Marquetry 130
- Kamakura Lacquer 98

AICHI
- Tokoname Ware 38

OKINAWA
- Kijoka Abaca 64
- Miyako Ramie 62
- Shuri Fabrics 63
- Tsuboya Ware 40
- Yontanza Minsaa 66

Originally published as the Japan Crafts Sourcebook.

FRONTISPIECE: *Painting a Miyagi Kokeshi Doll (page 184).*
TITLE PAGE: *Curing a hide, Kōshū Lacquered Deerhide (page 160).*

Note: An asterisk following the name of a village or city in an entry heading indicates the craft is being produced exclusively at that location. For the majority of entries, the place name indicates the main or central area of production. • The names of Japanese historical figures follow the traditional manner, surname preceding given name. All other names take the Western order.

The publication of this book was assisted by a grant from the Japan Foundation.

Distributed in the United States by Kodansha America, Inc., 575 Lexington Avenue, New York, New York 10022, and in the United Kingdom and continental Europe by Kodansha Europe Ltd., 95 Aldwych, London WC2B 4JF.

Published by Kodansha International Ltd., 17–14 Otowa 1–chome, Bunkyo-ku, Tokyo 112–8652, and Kodansha America, Inc.

LCC 95-51751
ISBN 4-7700-2734-6

CONTENTS

LACQUER WARE • *Shikki* — 84

BAMBOO CRAFT • *Chikkōhin* — 102

JAPANESE PAPER • *Washi* — 110

WOODCRAFT • *Mokkōhin* — 120

PREFACE

Centuries before there was any need to make a distinction between craft and mass-produced items, the work of Japanese artisans found favor outside the country among the fashionable and wealthy, especially in Europe. As is well known, the sheer quantity and quality of the lacquer ware which was exported from Japan encouraged people to tag this ware with the name of its country of origin. More recently, however, it is the giants of the electrical and automotive industries in Japan whose names have become household words throughout the developed world while the export of what are now known as Japan's traditional crafts is all but a trickle.

It could be argued that part of the reason for this decline is that insufficient efforts have been made to introduce these crafts to a non-Japanese public, which is now unaware of the wealth of artistic skill and technical genius embodied in Japan's traditional crafts. Admittedly, there are many people throughout the world who admire these crystallizations of Japanese life, culture, and nature. Nevertheless, there are few people who really know and understand these crafts and there are even fewer introductory publications to inform those who are willing or eager to learn more. Inevitably, this is due in great part to the difficulty in translating material related to the very core of Japan and Japanese life. Most Japanese people today find themselves as alienated from Japanese traditional crafts as Westerners are, and many of the terms and words associated with these crafts are beyond their comprehension. This is, however, no reason for not trying to inform.

At present, the consensus in most parts of the world is that it is important to preserve traditions of value, not simply for their inherent value but also as the possible roots from which the accouterments of contemporary life may sprout. In this belief, work on this book began despite the difficulties that were bound to be encountered. First of all, the legacy of each craft—its history, terms, materials, techniques, and present-day standing—had to be examined and verified. This required long hours of research through historical archives, as well as travel to every corner of Japan to interview and photograph craftsmen and craftswomen. Next, the information on each of the ninety-one unique crafts had to be translated as naturally as possible into English, and explanations for many of the traditional craft methodologies rendered in understandable terms. Consequently, seven years have now passed since the project's inception.

What has evolved into the *Japanese Crafts* was one of the first major projects to be undertaken by the Japan Craft Forum. The Forum's present director, Yuko Yokoyama, who was also instrumental in its founding, has always believed in the value of Japan's traditional crafts and views them as a potential fountainhead of inspiration and technique for those involved in design, interior decorating, and contemporary craft both at home and abroad. It was undoubtedly her faith in the value of this project that brought it to fruition. The first stage of painstaking research was undertaken by Yujiro Sahara, a craft consultant to the Japan Traditional Craft Center. He compiled information on each traditional craft from throughout Japan. The arduous task of translating this material fell to Bill Tingey, who, as a craft researcher, designer, and photographer, has devoted much of his time in Japan to working for the Forum. More than simply translating, he significantly added to the original text and finally wrote what became the draft of this book. Thanks must also be extended to all those who contributed so much to this authoritative volume which, perhaps for the first time, provides basic information on so many of Japan's traditional crafts in an encyclopedic yet very readable form.

I hope, therefore, that this book will inspire its readers, giving them a better understanding of work that has been honed and refined over many generations by craftspeople who have sought to combine the alchemies of nature with the skills of hand and eye. The quality of the many crafts produced stands as a permanent testimony to Japanese creativity.

Shin Yagihashi
Professor
Kanazawa College of Art

ACKNOWLEDGMENTS

The sheer breadth of this project, which introduces crafts from all corners of Japan, required the willing participation of numerous people, some of whom are noted above by Professor Yagihashi. There are, however, a number of others who deserve special recognition, for without their diligence and dedication this book would not have come into existence. Considerable contributions were made in checking and clarifying the initial manuscript by Patricia Massy, Kim Schuefftan, and Philip Meredith, each of whom added his or her own specialist knowledge. Diane Durston provided an informative introduction. Takayuki Maruoka of the Japan Traditional Craft Center supplied updated information about local crafts and Kyoko Ishikawa of Jomon-sha assembled the lists of associations and craft centers. The fine photography of craftspeople at work was done by Soichiro Negishi, and Tetsuro Sato graciously allowed us to reproduce the color photographs from *Japanese Traditional Crafts*, published by Diamond Incorporated. Several supplementary photographs were provided by the craft center and the Haga Library/American Photo Library. Additional assistance was provided by Peter Dowling, Michiko Uchiyama, and Pat Fister, who also assembled the selected reading list. Finally, all of these loose ends were professionally and patiently edited and shaped into book form by Barry Lancet of Kodansha International. The handsome design of the sourcebook was conceived by Shigeo Katakura. Thank you all for unselfishly donating your time and energy toward the publication of this book.

Yuko Yokoyama
Director
Japan Craft Forum

JAPANESE HISTORICAL PERIODS

PREHISTORIC

Jōmon ca. 10,000 B.C.–ca. B.C. 300
Yayoi ca. 300 B.C.–ca. A.D. 300
Kofun ca. 300–710

ANCIENT

Nara 710–94
Heian 794–1185

MIDDLE AGES (MEDIEVAL)

Kamakura 1185–1333
Northern and Southern Courts 1333–92
Muromachi 1392–1573
Warring States 1482–1573

PREMODERN

Momoyama 1573–1600
Edo 1600–1868

EARLY MODERN / MODERN

Meiji 1868–1912
Taishō 1912–26
Shōwa 1926–1989
Heisei 1989 to present

INTRODUCTION

by Diane Durston

Down from the mountain forests that surround his tiny village runs an icy stream that flows through the life of the old paper maker. His hands are rough and gnarled. They have worked the cold waters of sixty winters, not yet numb to the pain. Swoosh—the fibers rush across the framed bamboo sieve, settling evenly into the hand-held frame, a technique that appears simple and is not. The craftsman has been making paper since he was fifteen years old and he doesn't make much money. He is not famous—not even known. He has no apprentice, but his work will live on beneath the masterful brushstrokes of a Zen priest and momentary insights of a haiku poet. Of this he is proud.

Drawn far from home by a yearning for something real, the young woman patiently struggles to make the tenacious bamboo strips obey her novice hands. She doesn't lose patience; she has chosen this path and she is no quitter. The master craftsman glances over at her with affectionate disgust. "Hopeless," he mutters. Praise doesn't come easily from a tenth-generation craftsman—lucky if it comes at all. With serious reservations (she was not from a bamboo maker's family), he relented and allowed her to work for a while in a corner of his workshop. He suspects she'll run home when winter sets in and the workshop is cold. Surprising, though, how long she has lasted and how well she's done, considering. When she first came to him, she said she "wanted to learn how to make beautiful things with her own hands." Well enough, he thought, perhaps she will *survive.*

The variety and bounty of fine decorative arts still produced by hand in modern Japan is astonishing. In the fields of ceramics, textiles, lacquer ware, bamboo craft, paper making, woodcraft, and metalwork, the Japanese practice what are among the greatest surviving traditions of fine craftsmanship in the world. Producing everything from wooden barrels to the luxurious brocades of wedding kimono, thousands of craftspeople across the country continue to follow the ways of their ancestors.

They are trained not in schools, but in workshops where, like their predecessors, they are apprenticed from a very young age. It is still a given among Japanese craftsmen that no skill of any worth can be learned in less than ten years. Apprenticeships are long and tedious; the results are impeccable.

Cutting corners is not a part of the Japanese craftsman's vocabulary. The real evidence of their ingenuity and meticulous workmanship is hidden beneath the silent layers of an immaculately finished surface. Wise customers know better than to press for arbitrary deadlines at the

risk of a less-than-perfect product or an irritated master craftsman in whose hands the fate of their desire lies.

The quest for fame is not foremost in the minds of most traditional Japanese craftspeople. They ask only for a chance to demonstrate hard-won skills and for ways to survive in a society growing more and more dependent on mass-produced goods. Most of them work anonymously, as their grandfathers did, masters of one special step in a complicated process, expecting little more than a living and the respect of the patrons for whom they labor.

Supporting Traditional Crafts

The fact that so many craft forms have survived is due in large part to the survival of Japanese traditional arts such as the tea ceremony and ikebana. These practices require fine handwork as an integral part of their performance—the ceramic vases and tea bowls, the hanging scrolls and tatami mats, the fine kimono and white *tabi* socks. Masks for Noh actors, oiled paper parasols for geisha dancers, ink sticks for the serious calligrapher—all are supplied through the dedication of traditional craftsman.

Another factor in the survival of traditional Japanese crafts and craftsmanship is the continued encouragement of the Japanese government. Traditional crafts and the people who make them are recognized and promoted in many different ways, including the Living National Treasure program which has been honoring craftspeople and performing artists since 1950.

"Living National Treasure" is the popular term to describe those designated as *Jūyō Mukei Bunkazai Hojisha*, or Bearers of Intangible Cultural Assets. Craftsmen are selected by a government-appointed committee to receive this national honor. The purpose of the award is both to recognize and encourage exceptional craftspeople and to provide them with incentives to carry on their craft and hand it down to others. With an annual stipend and national acclaim comes the responsibility of teaching, lecturing, and appearing throughout the country at special exhibitions aimed at promoting an interest in Japan's artistic heritage.

The economic development and industrialization that took place in Japan following World War II left much traditional culture behind in the rush to embrace a new, more modern way. Traditional crafts were in danger of being lost altogether. But even as the new lifestyle took root, it was noted that "a certain feeling of dissatisfaction with the cold inhumanity of a technologically dominated and stereotyped lifestyle" had begun to pervade modern life in Japan.

In 1974, the Japanese government passed the Law for the Promotion of Traditional Craft Industries to protect and promote traditional crafts. They also undertook a nationwide study of the state of traditional craftsmanship and set up guidelines for ensuring its survival. The measures taken included the provision of subsidies for apprentices, the conservation of natural materials, and guidelines for healthier working environments.

The law also established criteria for the identification of craft objects

to be protected. Craftspeople applying for official designation had to show that their products were used in everyday life, were made primarily by hand from natural materials, and followed techniques dating at least from the Edo period. They also had to be part of a craft tradition embracing at least thirty craftsmen in the same region. The designation was to be administered by local governments on behalf of the Minister of Trade and Industry in conjunction with a committee of craft experts, historians, and critics.

In the 1990s, a survey of regional crafts produced throughout Japan was conducted on the city and prefectural levels. Over 1060 distinctive crafts were identified, employing over 240,000 craftspeople, although not every craft met the full criteria for official designation. Today, over 184 objects bear the Mark of Tradition symbol identifying crafts that have qualified for government recognition. The mark is in the form of the stylized Chinese character for the word "*dentō*," or tradition, placed above a rising sun to form an official seal, a guarantee of quality and authenticity.

In 1975, a public foundation was created for the promotion of crafts bearing this seal. The Japan Traditional Craft Center in the Aoyama district of Tokyo opened an exhibition hall in 1979, providing craftsmen with an outlet for their products both in its permanent display and in rotating annual exhibitions that feature the crafts of a particular region.

In 1987, the Japan Craft Forum was established as a non-profit organization associated with the Japan Traditional Craft Center. The aim of the Forum is to develop a better understanding and awareness of Japan's traditional crafts, both at home and abroad, and to foster the development of new directions for craftsmen engaged in the making of traditional craft products.

One of the Japan Craft Forum's first projects was to compile information on one hundred traditional crafts from throughout Japan. The study was then translated into English with the aim of introducing a wide range of traditional Japanese crafts to an international audience. While a thorough treatment of the hundreds of crafts produced in Japan was beyond the scope of this project, the present volume introduces ninety-one traditional crafts and is intended as a reference for English-speaking readers with an interest in learning more about the subject.

The crafts presented in this book fall under the general category of *dentō kōgei*, or fine traditional craft, noted for refinement of technique and perfection of finish. This category does not generally include the roughly hewn objects referred to as *mingei*, or folk crafts for everyday use. The list does, however, include objects such as *kasuri* (ikat) fabrics and natural-ash glazed ceramics that have roots in a rustic tradition but are now created with a level of refinement that distinguishes them as fine rather than folk crafts.

History, Geography, and Craftsmanship

Although the beauty and integrity of the objects in this book speak for themselves, an understanding of the history behind individual crafts adds much to an appreciation of their importance as cultural survivors.

Each object has a story to tell—of the history and character of the Japanese people.

Perceived abroad as a homogenous island country, Japan has extreme regional differences that are often overlooked. The delicate, aristocratic porcelains of Kiyomizu in Kyoto belong to a different world from the earthy, blue-and-white merchant-class stoneware of Tobe, on the island of Shikoku. The handsomely ornate metalwork on the wooden chests of Iwayadō in Iwate Prefecture is far removed from the unvarnished simplicity and sophistication of the paulownia-wood Kamo cabinets of Niigata.

Historically, too, each object has its tale to tell. The small, leather *inden* purses decorated with intricately stenciled lacquer patterns come to life when you understand that this is the same craft that decorated the armor worn by samurai in the Middle Ages. The natural, wheat-colored texture of abaca (*bashōfu*) textiles earns even more attention when it is noted that the "threads" from which it is woven are split by hand from fiber of the banana tree by a dwindling group of dedicated women on a remote island in Okinawa.

Razor-sharp *hamono* cutlery from Sakai seems even more formidable when you learn that these blades descended from the matchless swords of the samurai. The gorgeously dyed *yūzen* kimono fabrics gain social relevance if you understand that the technique for dyeing these elaborate patterns was the result of attempts by the low-ranked merchant class to rival the grandeur of the samurai's silk brocades, a cloth their class was forbidden to wear during the Edo period.

The Changing World of Traditional Crafts

Historically, the line between art and craft has always been ambiguous in Japan. No particular need for distinction was felt until the close of the nineteenth century, when the term *bijutsu* (art) was formulated to differentiate work done in a Western mode, such as oil painting. Until that time, the great names in Japanese art worked in many different media without differentiating greatly between painting, designing lacquer boxes, or decorating ceramic bowls.

In Japan, as in other industrialized nations, craftspeople have begun to create works that seek to expand traditional definitions of art and craft. Individual expression has become an important consideration. Some of the crafts presented in this book were made by young craftspeople who are searching for new means of personal expression, at times challenging traditional definitions of craft.

The concept of "tradition" itself is also being redefined today by these young craftsmen, eager to adapt the lessons and skills of the past successfully to the demands of the modern age. Crafts were formerly handed down from father to son, but in the contemporary setting some young Japanese are choosing a life of craftsmanship over the alternative of office work. In so doing, they bring a new eye and new ideas to the workshops of craftsmen carrying on centuries-old traditions.

Yet new ideas and dreams alone cannot halt the seemingly inevitable decline in the production of many of the traditional crafts described in

this book. While the number of different objects recognized for official protection increases each year, the number of craftspeople who make them decreases. The median age of craftspeople in every category rises and the number of young people willing to carry on their family trade falls. The majority of people whose crafts bear the Mark of Tradition earn far less than the average wage, and prospects for increasing their incomes are meager.

Nonetheless, the role these people play within their society, both artistically and in terms of importance to community life, is vital. Their success is inextricably linked to neighboring craftsmen and merchants, who provide them with the finest materials and tools required to carry on their work at the present level of refinement. A master carpenter is lost without the best handmade chisel in his hand and the highest-quality natural sharpening stone on his workbench. Unless ample natural resources are preserved and fine craftsmanship among traditional tool-makers is carried on, the master craftsman must number his days and worry about his successor's future.

The Japan Craft Forum will continue to seek new ways of encouraging traditional craftspeople to carry on their honored crafts, of promoting an international exchange of ideas among craft cultures around the world, and of recognizing and rewarding lesser-known yet intrinsically valuable crafts.

There is much for a hardworking traditional craftsman to be proud of in the industrialized Japan of 1995. The survival of twenty centuries of unbroken artistic tradition is important in a culture that has otherwise lost patience with things that take time and care to create. For with that loss of patience—here as elsewhere in the modern world—has come a loss of appreciation for the finer expressions of the human spirit: the beauty of delicate painting on the edge of a porcelain cup, the natural softness of indigo fabric woven by hand, the sheen of a perfect lacquer finish on a serving tray offered respectfully to honored guests.

Beyond beauty and refinement, the Japanese craftsman's way of life has much to teach a modern world in which these simple, constructive human achievements are at risk of vanishing.

JAPANESE CRAFTS

Ceramics

Introduction

Japan is a mecca for ceramic enthusiasts. Many of the country's pottery traditions have been handed down from generation to generation and continue to prosper to this day, a rare circumstance in a highly industrialized nation. Several reasons exist for this paradox. Flourishing schools of tea ceremony (*chanoyu*) and flower arrangement (ikebana) instill an appreciation of and create a continuous demand for ceramic ware. Restaurants of all ranks, from the lowest noodle shop on up to the exclusive by-introduction-only Japanese haute cuisine establishments, rely on the availability of suitable ceramic vessels for the meals they prepare, their needs often changing with the seasons. But chief among the reasons for the ongoing popularity of handmade pottery is that a wide variety of dishes are still used in the average home. Because visual presentation remains as important as the requirements of the palate, an endless market exists for dishes, bowls, platters, cups, and plates.

Broadly speaking, ceramics in Japan can be divided into three categories: porcelains, glazed stonewares, and unglazed (or natural-ash glazed) stonewares. Porcelains from Kutani and Arita have long been popular both in and outside of Japan. Thousands of pieces were exported from as early as the mid-seventeenth century, often with designs particularly suited to the tastes of the targeted countries. Those familiar only with export porcelain will find the indigenous pieces quite different. Gone are the court gentlemen and ladies-in-waiting, the flamboyant polychrome dragons, and the clipper ships. In their place are what the Japanese themselves prefer: flowers, birds, perhaps a fallow field with Mount. Fuji in the background, and simple hand-painted patterns.

Stoneware is heavier than porcelain, with thicker walls and coarser clay, yet the better pieces are as striking as the most delicate porcelain. Among the glazed stoneware are Shino and Seto ware from Mino; Mashiko ware from the village of the same name, where the famed potter Shōji Hamada worked; and Hagi ware, with its creamy whites, pinks, and grays, and a web of crackle, or crazing.

Last, there comes the unglazed stoneware. Pieces in this category are not dipped in a vat of glazing liquid before being set in the kiln, but receive their final decoration during the firing of a wood-stoked kiln. Flames color the clay and in many cases the ash of the burning wood is allowed to settle on the pots, fusing at high temperatures with elements in the clay to form pools or drips or spatters of green, gray, brown, or

gold, depending on the elements in the clay and the method of firing. The random ash deposits are often referred to as a "natural-ash glaze." Unglazed pots are quieter pieces—at their best serene, dignified, and unpretentious. Decorated by event rather than brush, they stand or fall by the kiln's whim and the potter's ability to play on the kiln's potential.

Instrumental in the rise of such unglazed stonewares as Shigaraki and Bizen was the development of the *noborigama*, or climbing kiln, a multichambered kiln built on a slope. The kiln is fed at the front with wood, usually pine, and then at side ports to reach the required temperatures and obtain the sought-after effects. There is a certain element of unpredictability with each firing since the fuel, stoking rhythm, weather, and interior conditions of the kiln will vary with each firing. This variation yields different effects and the skilled potter sets his pots in the kiln and then feeds the flame bearing in mind the potential of each firing.

In modern times, many of the glazed stoneware and porcelain makers have taken to using gas and electric kilns. Much of this interaction between fuel, flame, and potter has therefore been lost since the atmosphere of modern kilns is uniform, allowing a higher yield of salable pots but decreasing the variation of effects. Even potters of unglazed stoneware may rely on the less-expensive fuels in the early stages of firing their *noborigama* to conserve costs, a practice that often draws cries of protest from purists. Others argue that it is just such modern conveniences that allow cherished traditions to continue to thrive in an increasingly competitive environment. The tools may change, but in the end, as with any hand-crafted object, the skill and sensibility of the craftsperson determine the success of the outcome. Tools are the means, but the heart leads the way.

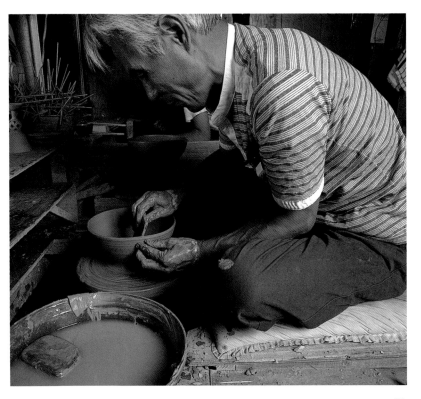

A Kiyomizu potter at the wheel.

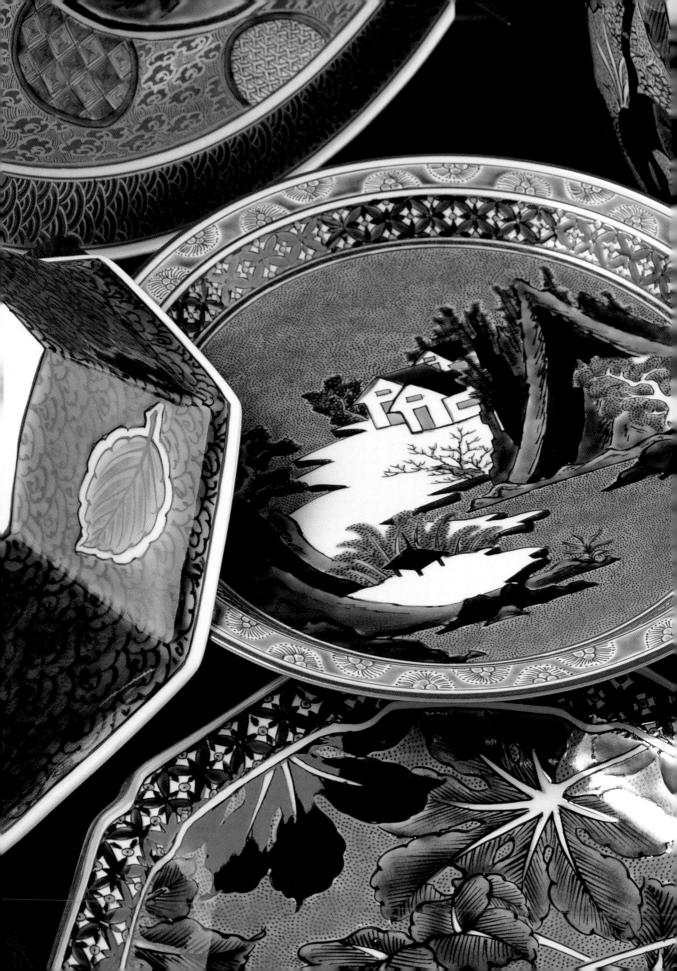

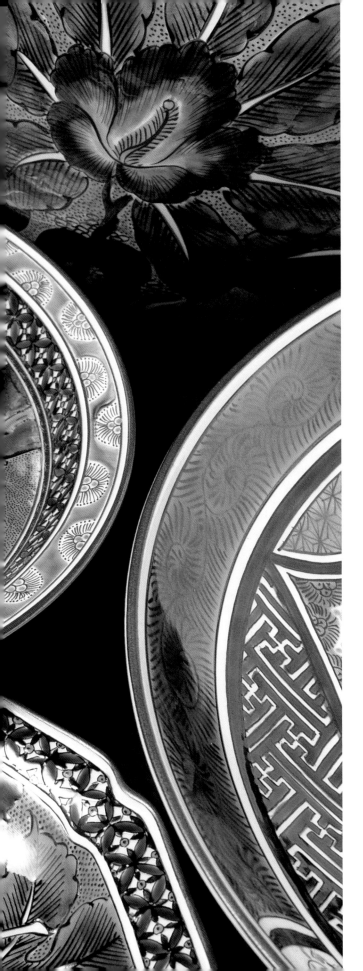

KUTANI WARE • *Kutani Yaki*

Terai-machi, Ishikawa Prefecture

Porcelain has been produced in Japan for hundreds of years, but pottery making in Kutani only began in the mid-1600s when Maeda Toshiharu, the head of the Daishōji clan, discovered clay suitable for making porcelain in Kutani, which was within his domain. Maeda directed two retainers, Gotō Saijirō Sadatsugu and Tamura Gonzaemon, to set up kilns in the villages of Kutani and Suisaka to make tea-ceremony utensils. Soon after, Gotō's son Tadakiyo was sent to learn the techniques of porcelain making in Arita in Kyūshū. There he was fortunate to meet a potter exiled from Ming China. He returned with this exile, and the high-quality work produced by their joint effort is now termed *Ko Kutani*, or Old Kutani ware.

For reasons that are not completely clear, around 1694 the kilns in Kutani fell into disuse for more than a century. It was again with the help of an invited outsider, this time from Kyoto, that activities resumed. Aoki Mokubei (see Kyoto ware) came to Kutani in 1804 and fired a kiln in Kasugayama. His work eventually inspired the construction of other kilns in the surrounding areas. The pottery produced by this second wave of activity resulted in the reestablishment of Kutani ware, and was called *Saikō Kutani*, or what is loosely referred to as new Kutani ware. The general term "Kutani ware" came into use around 1803, but it was only the original, Old Kutani ware that was actually made in Kutani.

Red, green, yellow, purple, and Prussian blue make up the five-color palette of Kutani ware. This color scheme, emphasizing bold yellows and greens, remains the best known of the Kutani repertoire, which includes blue-and-white as well as red-and-gold schemes. The designs tend to be bold, in keeping with the purity of the overglaze enamel colors. The motifs are first outlined with cobalt blue, manganese black, and iron red. The enamels are then applied on top. After being fired, the colors exhibit a glasslike transparency, allowing the underdrawing to show through as part of the design.

While Kutani ware owes much to Chinese models, it has the distinction of being one of the first Japanese porcelain wares to find a place in the hearts of many people in Europe. A great deal of Kutani ware was exported there at the end of the nineteenth century, and now, inevitably, Japanese collectors and museums are busy buying it back. Meanwhile, potters are still actively producing utilitarian objects such as saké cups and bottles displaying traditional designs as well as modern innovations.

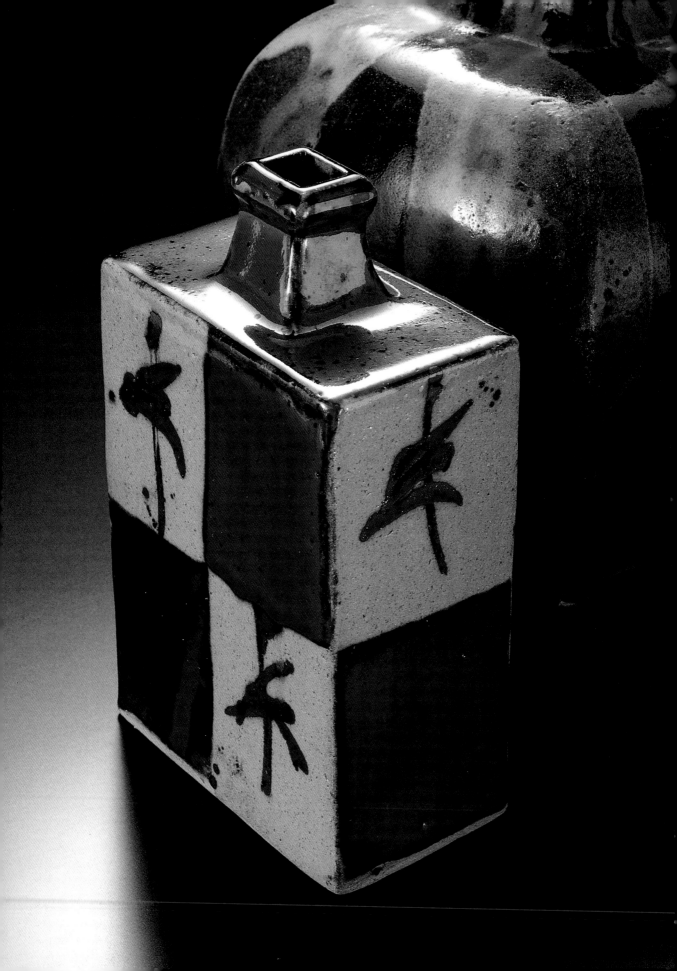

MASHIKO WARE • *Mashiko Yaki*

Mashiko-machi, Tochigi Prefecture

For many people the ceramic town of Mashiko is inexorably linked with the potters Shōji Hamada (1894–1978) and Bernard Leach (1887–1979). Leach, a British potter who was eventually to settle in England's St. Ives in Cornwall, and Hamada, later designated a Living National Treasure, worked closely with Sōetsu Yanagi (1889–1961) and others to promulgate the virtues of *mingei*, or folkcraft, of which Mashiko ware became a prime example.

While shards of *sueki* and *hajiki* have been unearthed from several ancient settlements and tumuli in the Mashiko area dating to the Nara period, the type of pottery being made there today has more recent origins. Mashiko ware is thought to have been initiated by Ōtsuka Keisaburō from the nearby village of Fukute (now Motegi-chō). After visiting the neighboring province to learn the techniques of Kasama ware, he established a kiln in Mashiko in 1853 and began producing household articles such as water jars, pouring bowls, and teapots. Ōtsuka was joined by others, and encouraged by the support of the local clan, the number of kilns gradually increased.

Although the production of Mashiko ware declined at the beginning of the twentieth century, it revived after the Great Kantō Earthquake in 1923, which devastated much of nearby Tokyo. Thereafter a large percentage of the tableware used in homes and restaurants in the capital came from Mashiko. Shōji Hamada settled in Mashiko the following year and began to make pottery drawing upon Mashiko traditions. It was in part through his efforts that others became interested in preserving the old folkcraft traditions and consequently the standard of Mashiko wares was raised.

The distinctive folkcraft appearance and the modest simplicity of Mashiko ware make it an appealing tableware. At present the kilns are producing primarily large platters, bowls, saké cups, and bottles as well as some cooking vessels. In addition to the conventional wheel-thrown articles, the slip trailing method of is used to create linear glaze designs that have become a trademark of Mashiko pottery. The old climbing kilns fired by wood were have given way to gas or electric kilns, particularly in the production of simple.

Mashiko ware was officially designated as a Traditional Craft Industry in 1979, and at present there are approximately eight hundred potters active in this pottery town. It remains, even today, as the best known of the folkcraft pottery traditions, and visitors still flock to Mashiko to purchase wares for their tables.

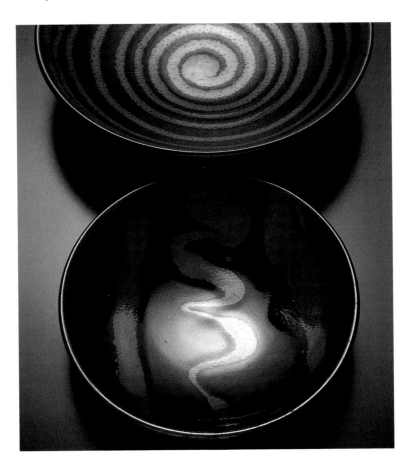

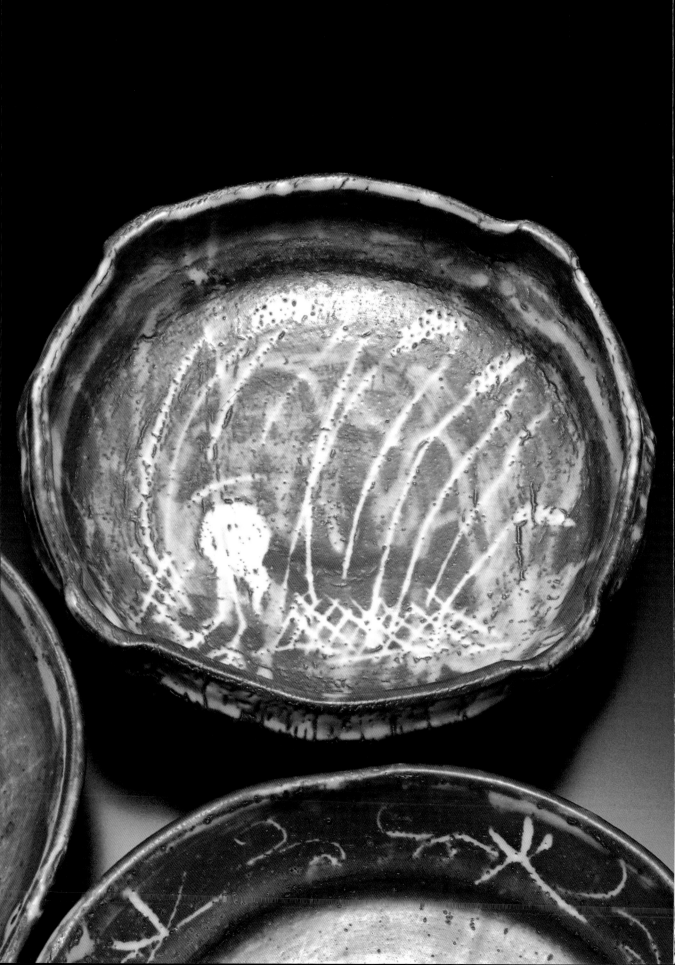

MINO WARE • *Mino Yaki*

Tajimi and Toki, Gifu Prefecture

Although primitive *sueki* dating from the seventh century have been discovered in the vicinity, the history of Mino ware itself dates back to the year 905, when it gained mention as one of the places that produced fine ceramics. At the time, ash-glazed stoneware was the main type of pottery. The potter's wheel came into use during the Kamakura and Momoyama periods, and the range of glazes and decoration expanded, leading to the creation of some relatively sophisticated pottery. During the Momoyama period, growing interest in the tea ceremony stimulated the production of tea wares. Many potters migrated to Mino, which had abundant supplies of clay and fuel, leading to the development of the distinctive stonewares discussed below. Porcelain was not produced in Mino until the end of the nineteenth century.

While Mino wares are colorful, they still retain a sense of serenity. One of the best known of Mino wares is Shino, made from the local clay called *mogusa tsuchi* and a feldspar glaze (*chōsekiyū*), which when fired turns a milky white through which the red body of the pot can be seen in places. There are many varieties of Shino ware, which can be left plain or decorated with simple motifs (*e-shino*). Shino wares that are predominantly gray in color are termed *nezumi shino*, and those that are a deep earthy red with creamy colored motifs are called *aka shino*.

Another traditional Mino ware is *ki seto*. Although the name suggests that it is yellow (*ki*), it is actually a bone-colored ware derived from a wood-ash glaze and fired at a high temperature. This causes the minerals in the clay and in the glaze to oxidize, and produces the particular color and texture of this ware. In *ki seto*, motifs are etched in the clay, then highlighted with judicious use of green glaze over the yellow.

Perhaps the most bold and colorful of Mino wares is Oribe ware, combining freely brushed designs of abstract shapes or semi-abstract scenes from nature. These are painted on while clay in iron pigment, and open areas are covered in an irregular manner with dark bottle green (the result of an ash glaze to which some copper has been added). While there are variations within this ware such as the salmon pink-colored *aka oribe*, it is the greens of *sō oribe* and *ao oribe* which are most admired. In addition to ash glazes, some Mino potters use a glaze containing iron to produce a black Oribe ware. Another Mino ware known as Ofuke ware is made from a special clay called *sensō tsuchi* containing iron. This ware is covered with a glaze containing some wood ash that turns a beautiful transparent pale creamy yellow when fired. *Seiji*, or celadon, ware is also produced in Mino.

In addition to coil-built and wheel-thrown pieces, Mino potters employ the technique of slab building (*tatara seikei*) to construct angular dishes and other asymmetrical forms. Among the common forms of decoration, aside from those mentioned above, are combing (*kushime*), impressing motifs into the damp clay with a stamp (*inka*), faceting the surfaces with a tool (*mentori*), and applying slip with a stiff brush (*hakeme*). One of the most distinctive decorative techniques is called *mishimade*, whereby impressions are made in the clay and then filled with a slip of a different clay before firing. Underglazes and overglazes are applied by dipping, ladling, or brushing.

After suffering a decline, interest in traditional Mino stonewares was revived in the mid-twentieth century by potters such as Arakawa Toyozō and Katō Hajime. At present there are approximately 150 potters working in the Mino district, producing primarily tea utensils, vases, household utensils, and religious paraphernalia and ornaments.

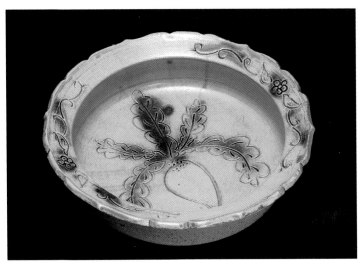

Shino ware. *Ki seto* ware.

HAGI WARE • *Hagi Yaki*

Hagi, Yamaguchi Prefecture

The origins of Hagi ware can be traced back to Korea. When the shogun Toyotomi Hideyoshi dispatched troops to Korea in the last decade of the sixteenth century, among them was the leader of the Hagi clan, Mōri Terumoto. While in Korea, Mōri met two brothers who were potters, Lee Chak Kwang and Lee Kyung, whom he brought back to Japan. In 1604, a kiln was first fired in Matsumoto under their direction. In addition to this *goyōgama*, or "clan kiln," Lee Chak Kwang's son established another kiln in Fukagawa in 1657 that also received the full support and protection of the clan. In fact, the two types of pottery that were produced in these kilns are still being made today by the Saka and Miwa families, both of which have produced potters who became Living National Treasures.

Important to the development of Hagi ware was the discovery in 1717 of a type of clay called *daidō tsuchi*, which underwent a lot of subtle changes in color and texture during firing. If it was mixed with another more, fire-resistant clay called *mitake tsuchi*, the number of changes increased.

The muted qualities of Hagi ware are still among its special features. In addition, tea stays hotter longer in Hagi teacups because the clay actually absorbs some of the liquid and changes color the more they are used. This is called *chanare* (becoming accustomed to the tea) or *Hagi no nana bake* (the seven changes of Hagi). Flower vases and saké vessels are also common forms of Hagi ware.

Hagi ware is still made on a type of Korean kickwheel known as a *kerokuro*. After the forming of the foot, a wedge-shaped cut is made. This "split foot" (*wari kōdai*) is the formalized gesture of a gimmick devised to allow potters to sell their pottery to commoners during a time when Hagi ware was reserved exclusively for the use of the upper class. As "damaged goods," these "disfigured" pieces could be bought by commoners.

Hagi pots are almost never decorated with painted motifs. Instead they rely on wood-ash glazes (*dobaiyū*), an ash glaze called *isabaiyū* made from the wood of the *isu* tree (*Distylium racemosum*), or a straw-ash glaze (*shirohagi gusuri*). These glazes coupled with the changes that occur during the lengthy firing at a low temperature in a climbing kiln give them decorative interest and tone gradations that become more prominent with use. Kilns are usually fueled with pine and will probably continue to be as long as the qualities of Hagi ware are valued.

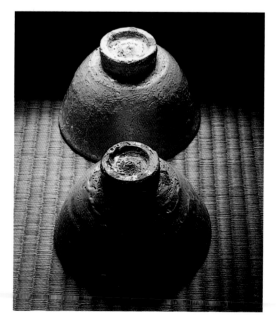

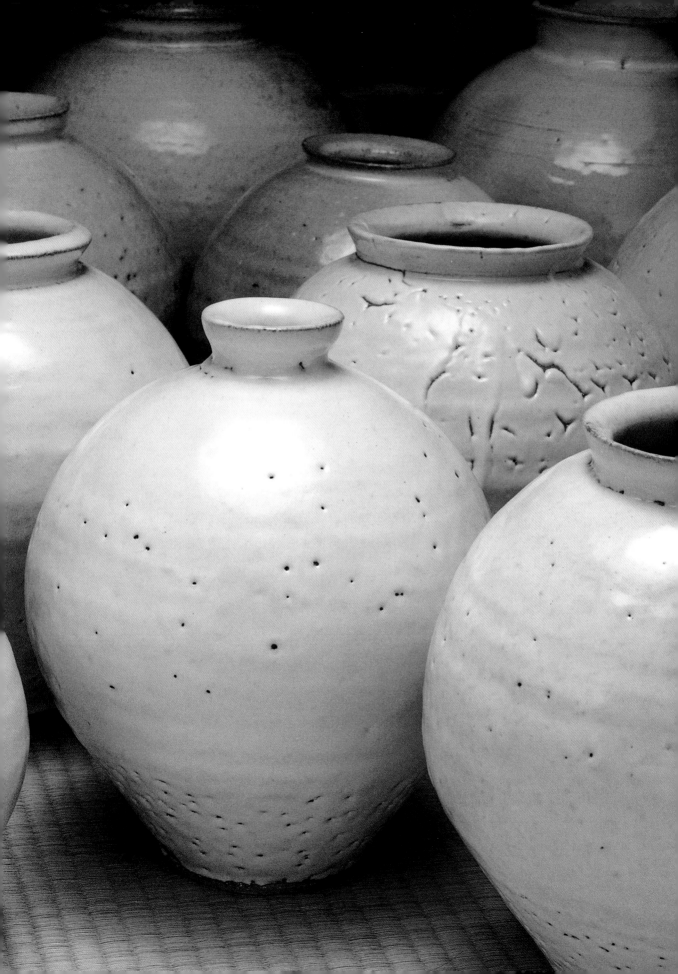

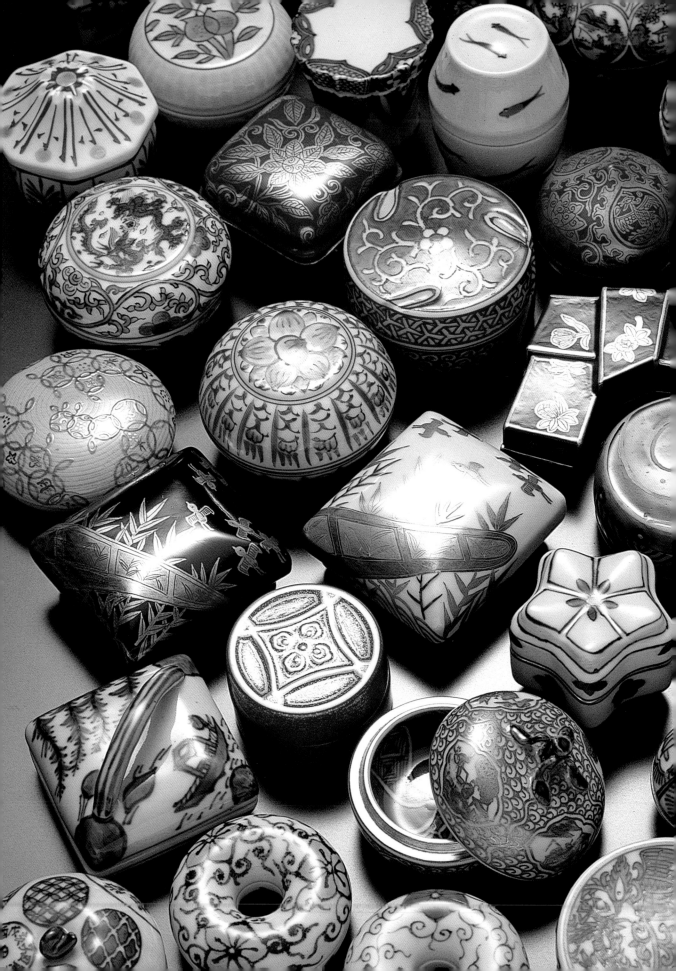

KYOTO WARE • *Kyō Yaki*
KIYOMIZU WARE • *Kiyomizu Yaki*
Kyoto

Kyoto is a treasure-trove of traditional crafts that have been perpetuated by generation after generation of craftsmen and craftswomen. Many of these crafts still thrive in the traditional atmosphere of the old capital, including a diversity of ceramics that are collectively referred to as Kyō *yaki*, or Kyoto ware. Of these, Kiyomizu ware is perhaps the most well known.

There is evidence that *sueki* ware was being made in the Kyoto area during the reign of Emperor Shōmu (724–49) and that tiles (*ryokuyū gawara*) were produced in the Enryaku era (782–806). Raku ware, favored for the tea ceremony, began to be made during the Eishō era (1504–21), but what is now called Old Kiyomizu (*Ko Kiyomizu*) is actually the pottery from kilns in Yasaka, Otowa, Kiyomizu, Seikanji, and Mizorogaike—all within the bounds of Kyoto—that emerged during the Kan'ei era (1624–44). It was not until the potter Nonomura Ninsei became active after 1647 that the overglaze enamel techniques and decoration associated with Kiyomizu ware were firmly established.

After Ninsei, several individuals played important roles in the development of Kyō *yaki*. Ogata Kenzan perfected several techniques for a lustrous pale yellow ware decorated with indigo designs modeled after pottery and porcelain imported from Holland. Between 1789 and 1801, Okuda Eisen succeeded in producing actual porcelain modeled upon Ming prototypes. Two of the techniques he was able to perfect were *sometsuke*, or the use of transparent glazes for decoration, and *akae*, a multicolored overglaze technique in which red predominated. Okuda also instructed a number of other potters, including Aoki Mokubei. Through the efforts of Okuda and those who followed in his footsteps, the range of porcelain produced in Kyoto increased significantly and included works modeled after Korean and Chinese examples. Apart from *seiji*, or celadon, ware, there was also *kōchi*, inspired by a three-color ware made during the Sung and Ming dynasties featuring green, yellow, and purple. This ware first reached Japan via Indochina and consisted mostly of small incense containers (*kōgō*) made from molds. Another ware emulating continental models was *gohon*, resembling the ceramics produced at a kiln at Pusan in Korea between 1661 and 1688. The clay was mostly white with a dull, reddish-yellow glaze, and it was decorated with white, indigo blue, or iron glazes.

The fact that much of what is produced under the heading of Kyō *yaki* is derived from foreign models is in itself one of the special features of this ware. With so much borrowing, it is not surprising that a wide range of techniques is used. Wheel-thrown pieces predominate, but some are hand-formed and a variety of mold methods are used. Designs are added by impressing with stamps (*inka*), combing (*kushime*), inlay (*zōgan*), and slip trailing (*itchin*). Glazes are applied in all of the common ways (dipping, dripping, trailing, painting) as well as by spraying (*fukigake*) and by allowing the glaze to dribble and collect. The glazes themselves are mainly mineral, iron, copper, or the Raku glazes associated with Raku ware. The methods of applying motifs with glazes are more limited; Dutch pigments are used on underglazes, and overglaze decoration is either transparent enamels or in alternating colors in the manner of three-color ware.

A large number of the articles produced in the kilns of Kyoto today are of a traditional nature. They include utensils for the tea ceremony, ikebana, and the less well-known *kōdō*—the pastime of enjoying the scent of incense. In addition there are the usual tablewares that can be found in homes, hotels, traditional inns, and restaurants throughout the nation.

SHIGARAKI WARE • *Shigaraki Yaki*

Shigaraki-chō, Shiga Prefecture

The origins of this rustic, rough-textured stoneware date back to very ancient times. During the reign of Emperor Suinin (29–71 B.C.), potters who had been making *sueki* in what was once called Kagami no Hazama (present-day Kagamiyama) apparently found a need for a different clay than the one they had been using. They thought they might find a clay to their liking in Shigaraki, where in fact, a good-quality clay was also being used to produce *sueki*. However, the true beginnings of Shigaraki ware date considerably later. While pottery tiles were made for Shigaraki no Miya, the capital established by Emperor Shōmu in 742, it was not until the end of the twelfth century that pottery production really commenced.

At first potters made primarily utilitarian wares such as small bowls for seeds (*tanetsubo*), mortars (*suribachi*), and large jars for storing liquids. Objects that were made before 1573 are referred to as Old Shigaraki, or *Ko Shigaraki*. The natural, unpretentious beauty of Shigaraki ceramics became recognized during the subsequent Momoyama period, especially by tea masters such as Sen no Rikyū and Kobori Enshū. The practice of drinking of tea actually helped to bring Shigaraki ware to the attention of the people at large. This was especially true during the years that Tokugawa Iemitsu was shogun (1622–51), when a Shigaraki tea jar (*chatsubo*) containing tea was transported from Uji, near Kyoto, to Edo (present-day Tokyo), the seat of the shogunate, in a formal procession known as the *chatsubo dōchū*.

Various kinds of household goods came to be made in large quantities in Shigaraki after climbing kilns were introduced during the Edo period. The reputation of Shigaraki ware was further heightened when an indigo blue glaze called *namakogusuri* was developed at the end of the nineteenth century. This glaze was used on hibachi (charcoal braziers), which were still a major form of domestic heating. Shigaraki hibachi were so popular that at one time eighty to ninety percent of the nation's braziers were being produced in Shigaraki kilns. Hibachi are still being made today, along with other household utensils, ornaments, and gardenware.

The Shigaraki "look" of the unglazed stoneware has a lot to do with the rugged natural elements of the finished pieces. Small pebbles of feldspar permeate the clay. When the ware is fired, the white feldspar "rises" to the surface. While no glaze is applied to the pieces, a natural-ash glaze forms on some pieces when ash from the wood fuel of the firing settles on the pieces and fuses with the clay, turning green or brown. The chunks of feldspar, the random ash-glaze effect, the warm reddish coloring, and the rough texture all combine to give the ware a natural quality that appeals to Japanese sensibilities for subdued but dignified work. It was the accidental qualities of Shigaraki ware that caught the eye of the tea masters, and more recently, have also gained the attention of people far from this corner of western Japan.

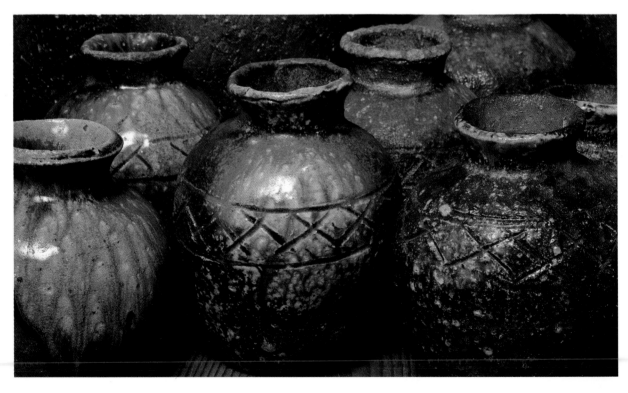

BIZEN WARE • *Bizen Yaki*

Inbe, Okayama Prefecture

The oldest of Japan's Six Old Kilns, Bizen ware is essentially a continuation of the stoneware tradition that started with *sueki*. During the ninth and tenth centuries, *sueki* was being produced in the village of Sue (now Nagafune-chō). However, at the end of the Heian period the potters of Sue moved to Inbe in search of good-quality clays and fuel for their kilns. During the Kamakura period more and more kilns were built, until potters were active all around Inbe. It was at this time that they began to produce pottery with the distinctive red to chocolate brown coloring for which Bizen ware is known today.

The ceramic industry became more centralized during the Muromachi period, and with the fashion for drinking tea during the subsequent Momoyama period, Bizen ware reached new heights. Inbe potters received the protection and encouragement of the local clan during the Edo period, when large quantities of practical pottery such as bottles for saké and other liquids, small water jars, mortar bowls, and seed jars were being made alongside the more artistically inclined articles offered to the court and shogunate. By the end of the nineteenth century, a new type of climbing kiln came into general use, and the potters of Bizen switched to making tea wares, saké cups and bottles, and flower vases. Since the end of World War II, the number of artists and potters in the area has risen to more than two thousand, some of whom have acquired the accolade of Living National Treasure. Selected works have been designated as Important Cultural Treasures by the prefecture, thus ensuring the position of Bizen ware in the contemporary world.

Bizen ware can be divided into six distinct types according to firing techniques and the accidental effects that occur during firing. Winding straw around a piece leaves red streaks on the pot when it is fired—a technique called *hidasuki*. Another effect known as *goma* (sesame), so named because it appears as if sesame seeds were sprinkled on the surface of the pot, is caused by ashes from the wood fuel spotting the surface and turning into a glaze in the intense heat. Those pieces having a dark gray color are referred to as *sangiri*. The gray occurs when a piece near a stoke hole is buried in ash during the firing so that the flames do not touch the surface directly. The fourth type is called *botamochi* and takes its name from a red rice cake. A small cup or pot is placed on another one so that the surface is partly covered. Those areas which are exposed will be completely fired, but because the covered parts are not directly exposed to the heat they turn red. Pieces which are fired with their openings facing down are called *fuseyaki*. This is a way of preventing the interior surface

from becoming speckled with ash, which is less desirable for some dishes, platters, and other pieces. The last of these types is *ao bizen*, wares having a very dark blue color resulting from firing them in a kiln rich in carbon flames.

The natural beauty of Bizen ware stems largely from the unforeseen changes that occur during the firing, affecting the shape, color, and texture. Moreover, because glazes are not applied, the elemental feeling of the iron-rich clay is retained. Consequently, Bizen ware is often cited as the quintessence of Japanese ceramics.

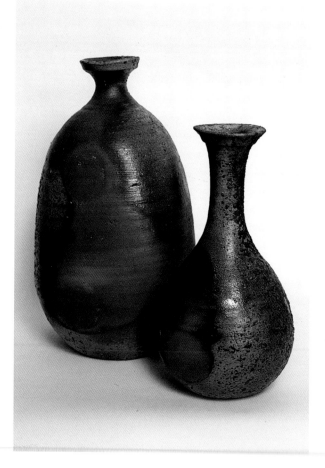

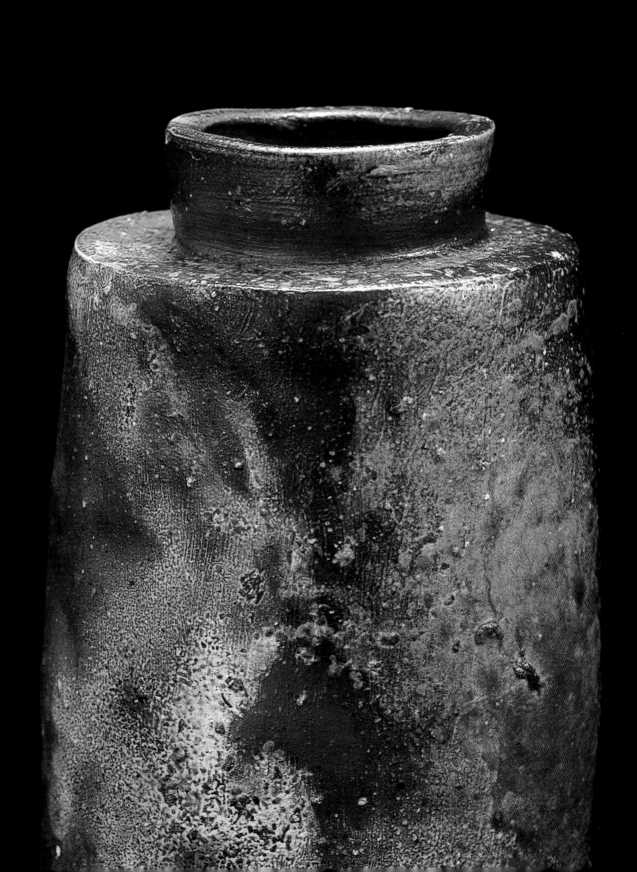

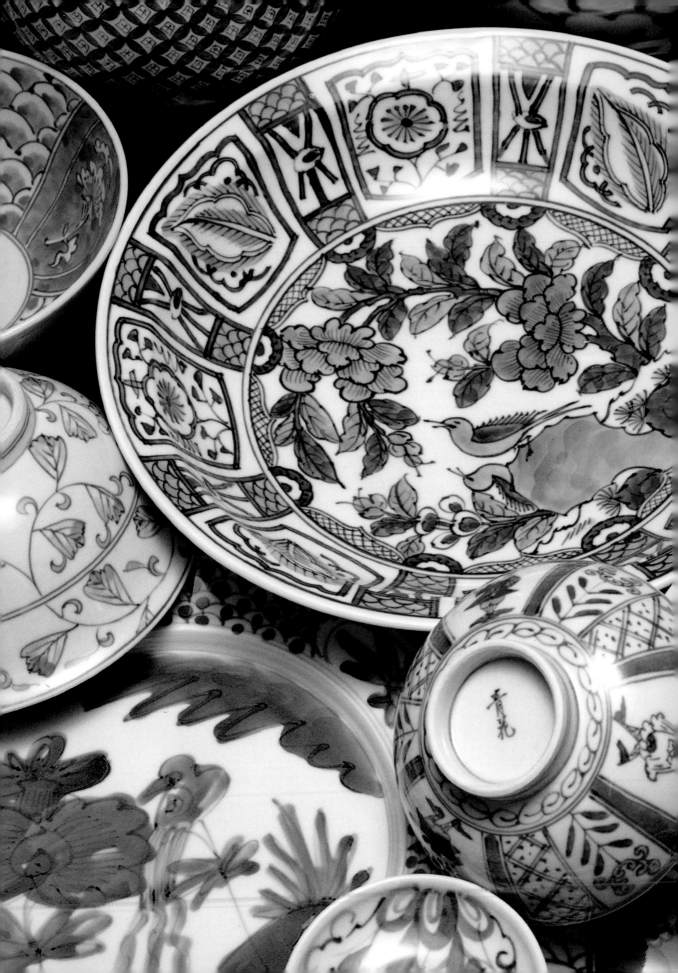

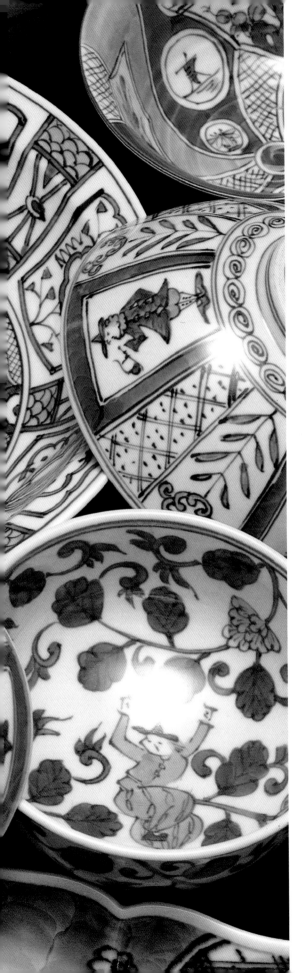

ARITA WARE • *Arita Yaki*

Imari and Arita-machi, Saga Prefecture

Arita ware, popularly known as Imari ware, was first made at the end of the Momoyama period, around 1590. The earliest ware was actually a type of old Karatsu pottery made mainly in and around what was known then as Aritagō, located near the present-day Arita-machi. However, changes occurred as a result of shogun Toyotomi Hideyoshi's campaign in Korea (1592–98), when the Korean potter Lee Cham Pyung was brought back to Japan by the head of the local Nabeshima clan. Lee discovered the kaolin clay necessary for porcelain in 1616 on Mt. Izumi near Arita, and successfully produced some pieces of porcelain. This event marked the true beginnings of contemporary Arita ware.

At first the ceramics produced in Arita followed Korean pottery styles, but in 1643, Shodai Sakaida Kakiemon perfected the polychrome overglaze enamel technique called *akae* that he had learned from studying Chinese wares. The designs on what became known as Kakiemon ware were first outlined in blue on a white porcelain ground, then overglaze enamels, with red predominating, were applied on top. Around this time the Nabeshima clan built its own kiln, and with the clan's backing Shodai Imaemon created a ware known as Iro-Nabeshima. He was also successful in perfecting two much more individual styles of porcelain. One called *nishikide* displays red, blue, yellow, green, purple, gold, and other colors applied as overglaze pigments, resulting in some spectacular pieces. The second, *somenishiki*, combines the use of *nishikide* or polychromatic overglazes on a *sometsuke* or blue-and-white ground.

The porcelain from Arita kilns was shipped to various parts of Japan through the port of Imari, from which the popular name Imari derived. The ware was also exported to Europe, where it became known as Old Imari. Arita ceramics began to influence some of the major European porcelain wares such as Maissen in Germany, Delft in Holland, Chantilly in France, and Worcester and Bow in England. The influence of Arita porcelain was also felt at home, especially in the pottery-producing areas of Kyoto, Kutani, and Tobe.

A vast range of ceramics which are both practical and decorative continues to be produced in Arita today. What is still termed Old Imari is characterized by blue-and-white *sometsuke* ceramics and the more colorful *somenishiki*. In addition there is the detailed and refined Iro-Nabeshima ware and the brilliantly colored *akae* ware.

Among the glazes used are limestone, a wood-ash glaze made from the wood of the *isu* tree (*Distylium racemosum*), a celadon iron glaze (*seijiyū*), other iron glazes, and a cobalt oxide glaze (*rurigusuri*). Gold and silver colors are also added if both underglazes and overglazes are to be applied.

While mass-produced items are now made in molds and the glazes are applied by machine or sprayed on, the more exclusive pieces of Imari ware are still highly prized at home and abroad, and continue to carry the banner of Japan's first porcelain.

TOKONAME WARE • *Tokoname Yaki*

Tokoname, Aichi Prefecture

Tokoname is known primarily for the rugged, reddish brown stoneware produced there from the twelfth century onward. However, the history of ceramics in and around the city of Tokoname dates back even further. The remains of a large number of old kilns were discovered at the southwestern foot of Mt. Sanage in Mikawa, Aichi Prefecture, about 45 kilometers from Tokoname. This area appears to have had the largest concentration of kilns in Japan between the Kofun period and the Heian period. From the Heian through the Muromachi period, various kinds of stoneware, including teacups, plates, cooking pots, bowls, and large jars, were being fired in kilns scattered over the whole of the Chita Peninsula. The products of these kilns became known collectively as Tokoname ware, the origin of which is said to be around 1100 A.D. Large jars for household and ceremonial purposes in particular were made in great quantities. Characteristic of these dark stoneware vessels, formed by coiling ropes of clay and pinching, are the natural-ash glaze deposits and encrustation on the shoulders, which often were the result of droppings from the kiln roof.

The Tokoname ceramic industry suffered during the wars of the sixteenth century, but by the mid-eighteenth century, the demand for tea-ceremony ware had attracted a number of famous potters to the area. In the late nineteenth century, Tokoname potters also began producing unglazed tea ware made from a fine-grained clay containing a high percentage of iron. Pieces were fired to produce a range of shades from red to dark brown. The firing technique for this ware is similar to that used for the large jars. Both wares are fired in an oxidizing atmosphere with slow heating and cooling to avoid cracking caused by sudden changes in temperature.

In addition to being a popular domestic ware, by the 1920s, Tokoname ware was being exported to the United States and Italy. Today the pottery industry continues to flourish. A variety of items—both glazed and unglazed—are produced in Tokoname, including the traditional teacups, jars, flower vases, saké bottles, hibachi, and drainpipes for industrial use.

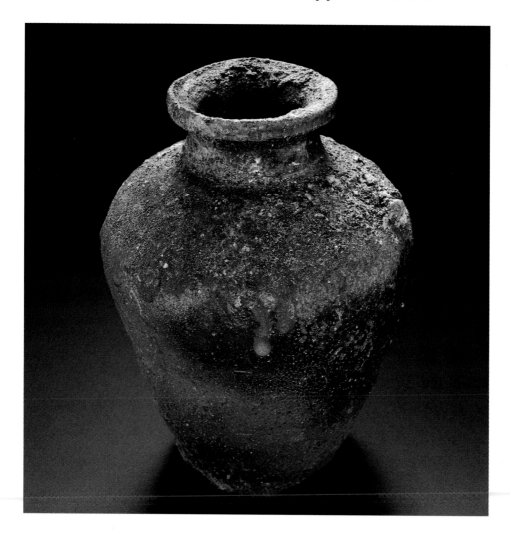

TOBE WARE • *Tobe Yaki*

Tobe-chō, Ehime Prefecture

Tobe ware had very plebeian beginnings. During the eighteenth century, boats called *kurowanka-bune* sold food and saké to people on the vessels that plied the waters of the Yodogawa River in the Hirakata area of Osaka. The simple bowls used by these venders were called *kurowanka chawan*, and they became very popular with the people at large. Present-day Tobe ware rice bowls with their thick bottoms are representative of this simple, unassuming ware, although the types of ceramics that take the name Tobe are diverse.

Stonewares were made in this area earlier, but the production of Tobe porcelain officially began when the Ōzu clan built a kiln in the village of Gohonmatsu (Tobe-chō). Porcelain was first fired there in 1777 with the help of some potters from the Ōmura clan in Hizen. Initially sponsored by the domain, Tobe kilns developed into private operations. Colorful porcelain began to be produced after 1825 using the *nishie* multicolored technique learned from Hizen potters, and by the end of the nineteenth century, Tobe ware was technically and economically on firm footing.

The ivory-colored Tobe porcelain found favor in the United States, and tableware decorated with stenciled underglaze blue designs (the so-called Iyo bowls) was also exported in large quantities to Southeast Asia. Although production declined during the period between the two world wars, attempts were made to revive the industry after World War II. Advice was sought from top designers, kilns were rebuilt, and an effort was made to modernize production by introducing machines. The outcome of this quiet revolution has been the production of a great variety of work. Now, traditional pieces are made alongside wares with a folkcraft flavor and others that are more contemporary in spirit.

Unlike some other porcelain, Tobe ware is thick with a slightly cloudy surface. While often decorated with simple designs painted in charcoal-black glaze, it can also be very colorful. The primary glazes used are a clear glaze, *seijiyū* (celadon), and a black iron glaze called *tenmokuyū*. Both the underglazes and overglazes are applied by hand and help to give Tobe ware the distinctive, slightly rustic flavor that still has the ability to delight the eye at the dining table.

TSUBOYA WARE • *Tsuboya Yaki*
Naha,* Okinawa Prefecture

Okinawa played a significant role as a trading center during the fourteenth and fifteenth centuries, when it was a nominal kingdom known as Ryūkyū. Ceramics, particularly celadon wares (*seiji*), were imported from China and then re-exported to Southeast Asia and Japan. Around this time potters in Wakita (part of Naha) were making a type of unglazed ware known as *arayaki* for the local brew.

In an effort to better organize the ceramic industry, the court authorities in Shuri appointed Kobashikawa Kōin to the post of official tile maker (*kawara bugyō*) during the period between 1573 and 1619. This position was later modified to cover pottery in general, but initially he was in charge of making roof tiles and porcelain. The ceramic industry was further influenced by the arrival of potters from China and Korea. Among them were a Chinese tile maker. These craftsmen set about instructing the local potters. One of the Korean potters in particular—Chang Hun Kong (who later adopted the name of Nakachi Reishin)—significantly influenced the ceramic art in Okinawa. Another potter called Hirata Tentsū, who was originally from China, was given a house in Wakitahara by the king of Ryūkyū. Hirata went back to China to study techniques, and upon his return to Okinawa, he started making glazed pottery. One of his apprentices, Nakasone Kigen, began making ordinary wares for the common people instead of the expensive Chinese-style porcelain tableware being made for the upper classes up until that time.

In 1682 the court authorities at Shuri consolidated the widely scattered kilns by establishing a center at Tsuboya. Pottery production continued there until World War II, by which time the potters were dividing their time between making pottery and farming. Mechanized mass production, coupled with the complete change of lifestyle after the war, resulted in a decline in the production of unglazed ware in favor of the glazed ceramics that now constitute the mainstream of Okinawan pottery.

Apart from conventional bowls, plates, tea ware, and the original kind of unglazed *nanban tsubo*, some of the products of the Tsuboya kilns are rather unusual due to the special nature of Okinawan customs. Examples are the *dachibin*, or curved hip flask; the mythical lion-dog (*shiisaa*) standing on the slope of the roofs that is thought to ward off evil spirits; and *zushigame*, highly decorated caskets for the bones of the deceased in the form of an urn or a boxlike shape resembling a miniature traditional building.

In keeping with the subtropical climate, Okinawan ceramics are decorated with bright, mostly primary colors. The designs are simple but powerful and are derived from the life and customs of Okinawan people. Both unglazed and glazed wares are formed on a wheel, in molds, or by hand. Glazes, which themselves are unique to Tsuboya, are applied by dipping (*hitashigake*), sprinkling (*furikake*), or using a cloth that has been dipped in the glaze (*nunokake*). Any application of motifs is done by hand. The unglazed ware is fired in a *nanbangama*, the type of kiln found in Southeast Asia. Thus, even today Tsuboya ware is still representative of the distinctive nature of Okinawa's culture and historical background.

KIKUMA TILES • *Kikuma Gawara*
Kikuma-chō,* Ehime Prefecture

Silver-gray roofs are one of the most distinctive features of traditional Japanese buildings. The tiles for such roofs, which are still being made on the island of Shikoku, have noble beginnings extending back to the Kōan era (1278–88), when Kikuma tile makers went to Iyo to work for the powerful Kōno family. Ming tile-making techniques were introduced around 1573, and with the support and protection of the local clan during the Edo period, the foundations of an industry were laid. While roofing tiles made in Kyoto have always been recognized for their high quality, those produced in Kikuma are equally fine and were used in the construction of the new Imperial Palace in the late nineteenth century.

Apart from roofs, tiles have traditionally been used in Japan for paving floors (*shikigawara*) and also for walls (*kabegawara*). However, the word *kawara* is more or less synonymous with roof tiles. There are several kinds of roof tiles, which differ in size and shape according to their function. *Hiragawara* are the simplest, being completely flat or gently curved. They are used in conjunction with *marugawara*, or channel tiles, to create one of the oldest styles of roofs, called *honkawarabuki*. Used

mostly at the corners of a roof and sometimes along the edges for decoration, *sumigawara* are appropriately called corner tiles. Also falling under the category of corner tiles are the two kinds of ridge caps; one is decorated with a demon mask (*onigawara*) and the other is in the form of a fish with its tail arched up over its head (*shibi*). Two *shibi* are usually placed at either end of a ridge inside the capping *onigawara*.

Two types of clay are combined for the making of Kikuma roof tiles. One is called *sanuki tsuchi* and comes from the neighboring Kagawa Prefecture. The other is a locally obtained clay called *gomi tsuchi* (clay with "five flavors"). Once mixed, the clay is pressed into molds. After removing the clay from the molds, the tiles are dried and then fired for a full twenty-four hours. Mica is applied to the surfaces and burnished before firing in order to achieve a silvery luster.

Just as tiles have more or less replaced thatch as roofing material, so, too, have other materials taken the place of roof tiles. But do the new roofs ever look as wonderful as a tile roof after a light snow or a rain shower?

Textiles

Introduction

As the traditional textiles of Japan were made primarily for personal attire, what we know today as the kimono determined not only the construction of the weaves and the patterning of the fabric but also the width of the cloth itself. A single bolt, or *tan*, of cloth measures approximately 9 meters in length and 30 centimeters in width, and this usually suffices to make one kimono, whether for men or for women regardless of height and weight. Thus kimono fabrics as a rule are sold by the bolt and rarely by the meter. Essentially, the kimono consists of four strips of fabric, two forming the panels covering the body and two the sleeves, with additions for a narrow front panel and the collar.

Customarily, woven patterns and dyed repeat patterns are considered informal. Formal kimono have free-style designs dyed over the whole surface, or in the case of a married or older woman, along the hem and the front panel and perhaps also at the shoulder. Men wear woven fabrics, usually of blue or a subdued gray or brown, the only exceptions being for costumes worn at festivals or by entertainers. They will, however, take a hand-painted fabric for underclothes or a jacket lining.

Only fabrics of reeled silk are used for formal wear. These include silk crepes such as *chirimen* and satin weaves such as *rinzu*. The lightweight *habutae* is best suited for linings but also may be made into *obi* with a heavy backing. Pulled floss silk is called *tsumugi*. As it is made from waste cocoons, it is considered inferior in rank to reeled silk, although it is highly esteemed for its texture. A hand-pulled, hand-woven *tsumugi* may fetch a price many times above that of a reeled silk. *Kasuri*, the Japanese version of ikat, may also be very expensive, but it is not considered appropriate for formal occasions, nor are any of the bast fibers, such as ramie. The gauze weaves are worn at the height of summer, and if in silk, may be formal.

A woman's *obi* is usually 4 meters long. The 60-centimeter width is folded in half and the obi is wrapped twice around the waist, then tied in back, so ideally the fabric has some body and holds its shape well. *Obi* for casual wear may be as narrow as 10 centimeters. Formal *obi* are usually of a brocade or tapestry weave. The more pattern, the more formal is the basic rule. There are grandiose examples covered over their entirety with woven or embroidered designs. Such *obi* are now worn only by a bride. Casual *obi* can be made of *chirimen*, *tsumugi*, *habutae*, twill, satin, gauze weaves, cotton, or wool. Men's *obi* are either stiff (*kaku obi*),

in which case they are about 5 centimeters wide, or soft (*heko obi*), in which case they are made of a thin, tie-dyed silk.

Today, despite its beauty and many advantages, the kimono has been superseded by Western clothes for everyday wear. This has greatly affected the producers of casual-type fabrics. At the same time, crafts like weaving, which once were lucrative skills, cannot match the attraction of more fashionable ways of earning an income. As the number of professional people engaged in weaving, spinning, tie-dyeing, and so forth dwindles, local craft industries are working hard to produce a younger generation of skilled labor, and the kimono industry is striving to capture the hearts of young men and women.

Kyoto *yūzen* dyeing.

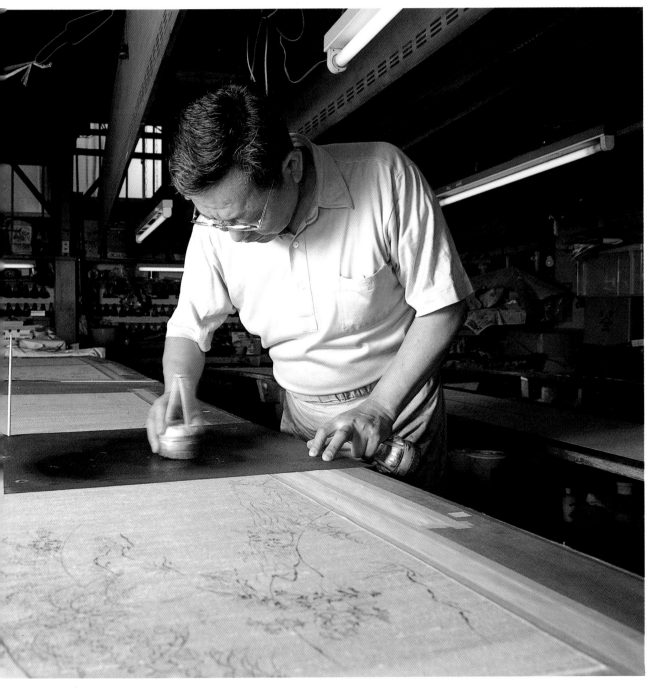

KIRYŪ FABRICS • *Kiryū Ori*

Kiryū, Gunma Prefecture

Kiryū is situated due north of Tokyo on the edge of the Kantō Plain, in one of Japan's major areas for sericulture; other well-known cities in this connection are Isezaki and Ashikaga. In the Edo period, boats carried the cloth woven in Kiryū to Nihonbashi, the commercial center of Edo (present-day Tokyo), where the top-quality silks vied with those of Nishijin in Kyoto. The origins of weaving in the area are said to date back to the reign of Emperor Junnin (ruled 758–64), when Princess Shirataki went to Kiryū to teach people to raise silkworms and to instruct them in the art and techniques of weaving. At first the fabric was called Nitayama silk, Nitayama being the former name of Kiryū. Following the establishment of a silk market, business grew; trading between Edo and Kyoto began, and it is thought that the contacts thus made resulted in improvements in dyeing techniques. At some point a draw loom known as a *sorabikibata* was introduced from Kyoto, making the weaving of complex cloths such as gauze and twill more feasible. A woman or child was usually stationed high atop the loom to pull on the warp yarns in sequence in much the same way as a Jacquard loom works today. Later, *hatchō-nenshiki* yarn-twisting machines driven by water wheels stimulated the production of crepe yarns, and after that yarn-dyed, figured-textile weaving techniques were also introduced. Jacquard looms have been employed in Kiryū since the end of the nineteenth century. These machines led to the specialization of production processes that began during the latter part of the 1920s.

Apart from raw silk, *tamamayu*, and *tsumugi*, such yarns as spun silk, cotton, linen, and gold or silver threads are also employed. Between four to eight thousand fine threads are used for the warp, and a thread that has been twisted more than two thousand times is employed for the weft. The actual method of weaving differs according to the type of cloth: weft brocade, warp brocade, double-weave, floating weave, warp *kasuri*, and twist weave. The representative *omeshi* crepe can be either a plain-weave yarn-dyed or pre-softened silk cloth, or a figured satin weave, or a *shusu* satin weave, or even a variation or combination of these. Rice paste is applied to the crepe yarn, which is used for the background weft after it has been lightly twisted by hand, then twisted further by machine.

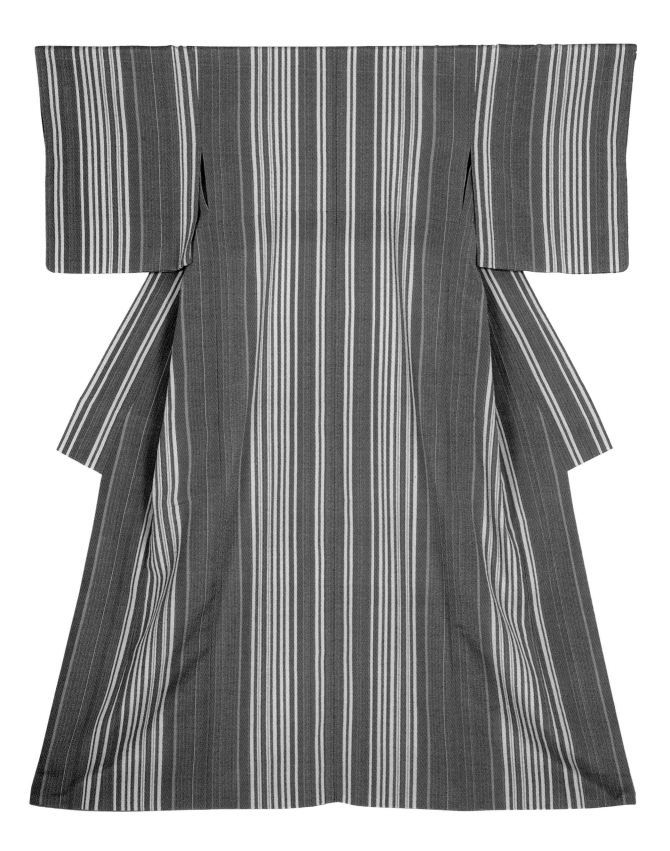

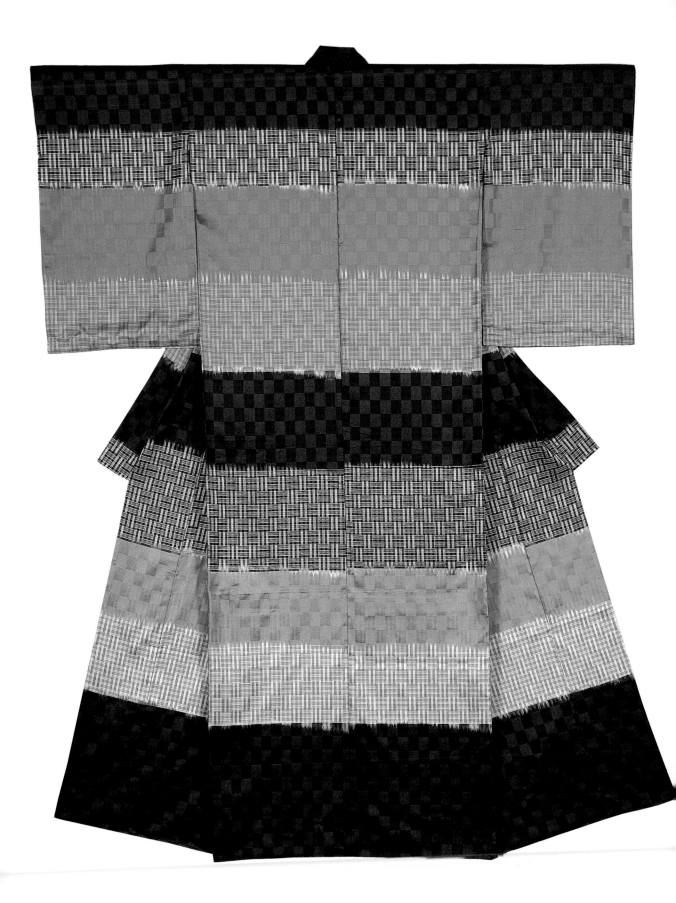

OITAMA PONGEE • *Oitama Tsumugi*

Okitama Region, Yamagata Prefecture

Oitama *tsumugi* is the collective name for the various types of silk *tsumugi* such as Nagai *tsumugi*, Shirataka crepe, and *Yoneryū* that are produced with natural dyes and motifs drawn from nature in the Okitama area of Yamagata Prefecture. This area has long been connected with sericulture and silk weaving: the Shiroko Shrine in the city of Nagai, which enshrines the deity of silk culture, seems to have been established in 712.

Basically, Oitama *tsumugi* is a yarn-dyed, plain-woven *kasuri* cloth that is occasionally striped. Slightly different combinations of yarn and *kasuri* techniques are used for the various types. For *Yoneryū* (to give it its full name, *Yoneryū itajime kogasuri*), the *kasuri* yarn is first dyed by the *itajime* technique. The warp is raw silk, and the weft is either raw silk, *tamamayu* silk, or a hand-spun *tsumugi* yarn. The yarn is dyed by the same technique used for Shirataka *itajime kogasuri* cloth, but both the warp and the weft are twisted raw silk. A yarn twisted three or four thousand times per meter is introduced in the areas having no pattern. After the cloth has been woven, a technique called *shibo dashi* is applied. This involves rubbing the cloth in hot water so as to crimp it. Raw silk, *tamamayu* silk, or *tsumugi* yarn is used for cloth in which the *kasuri* design is expressed either with just the weft, as in *yokosō gasuri*, or with both the warp and the weft as in *heiyō gasuri*. All the yarn for these is twisted, except the *tsumugi*, which is used for the warp of the *yokosō gasuri* cloth.

The natural dyes are obtained from logwood, a grass known variously as *kariyasu* or *kobunagusa*, and safflower. The latter is called *benibana* in Japanese, and the soft pink cloth it yields is known as *benibana zome*. Cloth dyed yellow with the grass is known as *kariyasu zome*. All the cloths woven with these techniques have an unpretentious, folk-cloth quality and are extremely durable. They are used for *obi* and kimono, and are usually worn by women over forty years of age.

YŪKI PONGEE • *Yūki Tsumugi*

Yūki, Ibaragi Prefecture

Just as wine improves with age, so does this cloth. Its appearance and feel are reputed to become more interesting the older it gets, but the processes involved in its production make it very expensive.

First, the *tsumugi* is hand-spun from silk floss for both warp and weft, then the *kasuri* yarns are bound by hand or clamped in various places to resist the dye. The cost of the cloth is further augmented by the use of a back-strap loom known as *izaribata*, but there is no doubt that this also contributes to the final look of the cloth. Besides the plain weave cloth, Yūki *tsumugi* also includes a crepe known as *chijimi ori*. For this, a twisted yarn is taken for the warp, and the woven cloth is put in warm water and rubbed by hand to produce a crinkled crepe texture.

The finished cloth is expensive, but this is balanced out by its durability and tendency to improve in appearance as it is worn, and the overall restrained effect is enhanced by its peculiar dull luster.

TRUE KIHACHIJŌ • *Honba Kihachijō*

Hachijōjima Island, Tokyo

Situated some 334 kilometers south of Tokyo, Hachijōjima Island was under the direct control of the Tokugawa shogunate during the Edo period, and supplied salt and silk cloth to the state as annual taxes. Due to its rather poor soil, sericulture was encouraged in lieu of the usual form of taxation, rice. Although there are no detailed records, it seems that a type of silk *tsumugi* known as *ki* (yellow) *tsumugi* was presented to the authorities in 1498, and a 1665 document mentions a striped *tsumugi*. The type of cloth woven today first appeared sometime during the eighteenth century. It found favor at the seat of the shogun and was worn by maids and servants who worked at Edo Castle, as well as the feudal lords and lower-ranking officers. The island, in fact, takes it name from the cloth, which was woven in lengths of *hachi-jō* (eight *jō*, one *jō* being equal to about 3 meters). After the end of the feudal era, the cloth became popular throughout the country. Production has actually increased in recent years through the efforts of local intellectuals and the combining of new equipment with traditional techniques.

Vegetable dyes, often mordanted with mud, are used to color the raw silk, *tamamayu*, or *tsumugi* yarn. The yarn is then either plain woven or woven up into a striped or plaid twill. Brilliant and distinctive colors are obtained from the various plants used. A bright yellow (*ki*), for example, is obtained from *kariyasu*, a grass similar to pampas grass. The main cloth produced on the island is known as *kihachijō*, and is primarily of this yellow. A deeper, reddish yellow is derived from the *tabunoki* (*Machilus thunbergii*), and cloth in which this color predominates is known as *tobihachijō*. Another of the island's outstanding cloths—*kurohachijō* (black Hachijo)—obtains its intense yet dull black from a type of chinquapin (*Castanopsis cuspidata*).

Though primarily made up into kimono and *obi*, Hachijō cloth is also used for ties and other small articles such as purses. As a silk cloth it has a sober, refined appearance that improves with age. It must be one of the few craft products that have had a place named after them.

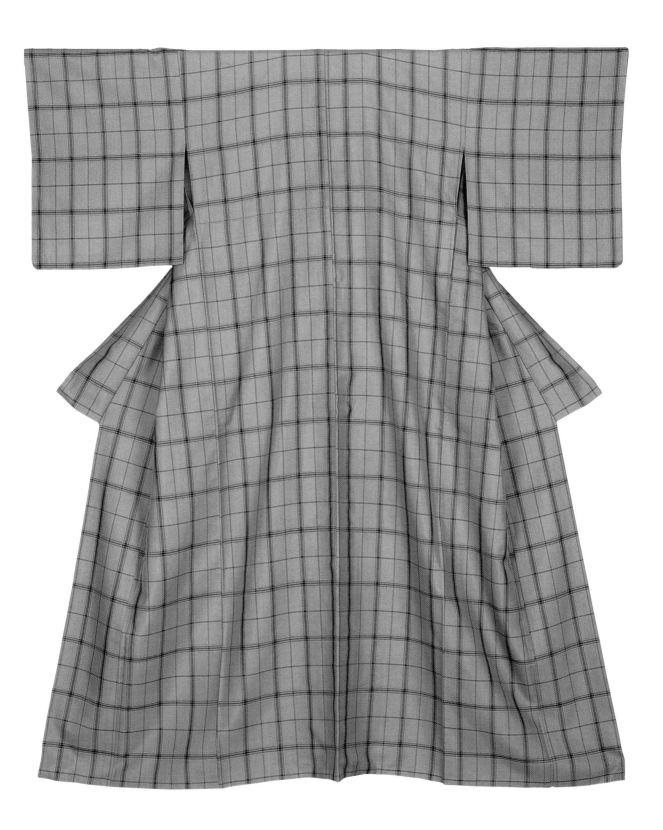

OJIYA RAMIE CREPE • *Ojiya Chijimi*

Ojiya, Niigata Prefecture

Environmental conditions in the region where this cloth is produced are the primary reason it is still being made. The Chinese silk plant or ramie (*Boehmeria nivea*), from which the yarn is produced, grows exceptionally well in Niigata Prefecture, and the high humidity in this area facing the Japan Sea makes the job of handling the yarn a good deal easier.

During its history, Ojiya ramie crepe has gone under several different names. It has frequently been lumped together with a cloth known as Echigo *jōfu*, both cloths in the past being variously called *Echigofu*, *Eppu*, *Hakuetsu*, or *Hakufu*, and then Echigo *chijimi*. During the Kanbun era (1661–72), Hori Jiro Masatoshi, a retainer of the Akashi clan, moved to the Ojiya area and passed on the method of making crepe cloth using a tightly twisted crepe yarn that is known as *chijimi*—a technique also used for another cloth called Akashi *honchijimi*. The production of *chijimi* and the number of locations where it was woven gradually increased, with the areas around Uonuma and Kubiki being most noteworthy. Ojiya, along with places such as Tōkamachi and Horinouchi, developed into distribution centers for the cloth. By the Meiji period, machine-spun yarn was being used along with hand-spun ramie. Apart from the very basic kind of back-strap *izaribata* looms, more conventional types of hand looms were also being used, with power looms coming into operation during the early part of the twentieth century. The work of weaving this cloth has, in other words, changed from a home industry to one organized along the lines of a mill, albeit one that still relies on some handwork.

Essentially, Ojiya *chijimi* is a yarn-dyed, plain-weave crepe *kasuri* cloth of ramie. The *kasuri* pattern is either in both warp and weft, or in the weft alone. The warp yarn is usually bound up by hand, and dye rubbed into it, again by hand, for a multicolored design. The weft is tightly twisted in order to produce the crepe effect when the woven cloth is washed in hot water. In the case of the plain *hakumuji* and slightly figured *jihaku* versions of this cloth, the lengths of woven cloth are stretched out on the snow in the early spring to be bleached by the rays of the sun, the melting snow, the oxygen in the air, and ozone. It is a splendid sight characteristic of this region of Japan.

The finished cloth is extremely fine and light. Kimono made of it are particularly comfortable in the summer, and it is also used for such items as cushion covers. Production of this cloth and of its sister cloth, Ojiya *tsumugi*, keeps some 435 people employed. While their primary interest is clearly to earn a living, their work nonetheless enables the long tradition of Ojiya *chijimi* to survive.

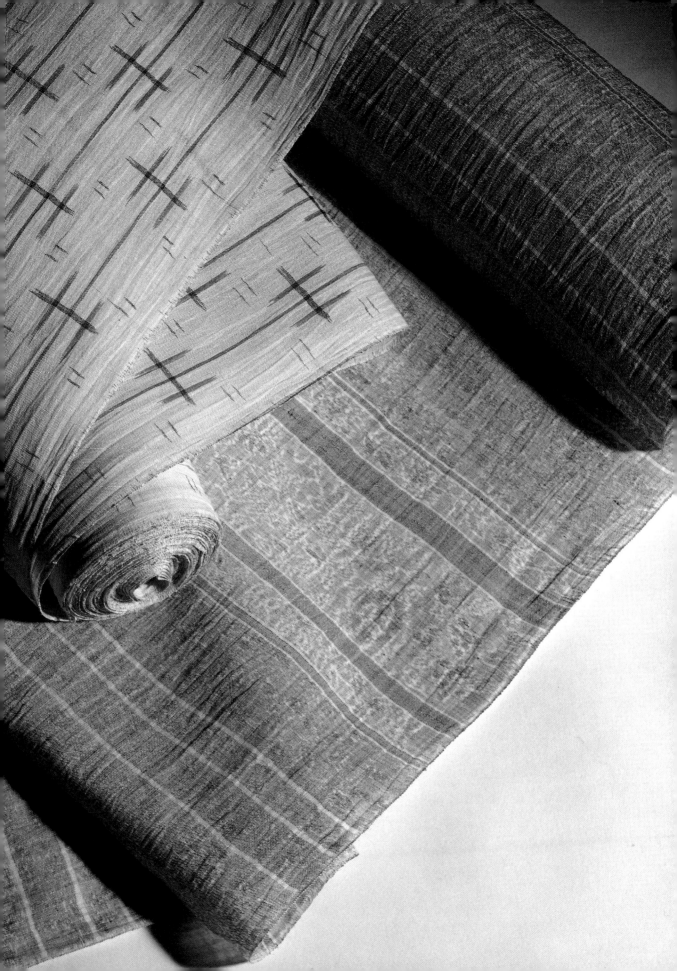

SHINSHŪ PONGEE • *Shinshū Tsumugi*

Nagano Prefecture

The attics in the great farmhouses of cold areas such as Nagano Prefecture provided ample, predator-free space for rearing silkworms as well as the requisite warmth in winter from the open fires below. Although technology has advanced, in Nagano Prefecture today the silk still comes mainly from the cocoons of silkworms reared indoors under controlled conditions. Some "wild" tussah silk is also included in the finished yarns. The tussah silkworms are farmed outside and allowed to free-range over their oak trees—which, by contrast with their indoor cousins, means a less than 25 percent harvest of cocoons.

Production of Shinshū *tsumugi* is centered in the city of Matsumoto, but includes a number of *tsumugi* cloths from Ueda, Iida, and Ina as well as Matsumoto. Historical references from as early as 1665 speak of a striped *tsumugi* being produced in Ueda. By the middle of the eighteenth century, *tsumugi* cloths from the area were well known throughout Japan, largely because the local clans vied with each other in their pursuit of sericulture as a source of income in places where rice did not grow well.

The yarns used are raw silk—including, as we have seen, some wild silk—and hand-spun *tamamayu*. The cloth itself is usually a yarn-dyed, plain-weave *tsumugi*, either *kasuri* or striped. Raw silk on its own is not used for the weft. Instead the thread used is produced on the *hatchō-nenshiki* yarn-twister by combining two or more raw silk and *tamamayu* yarns. Once a yarn of the required thickness is obtained, it is lightly twisted. *Kasuri* threads are bound up by hand, then dyed.

When wild silk is included, it lends its refined sheen to give this cloth a distinctive character. Shinshū *tsumugi* is also imbued with a sober, restrained quality resulting from the use of vegetable dyes, and it makes up well into kimono and *obi*.

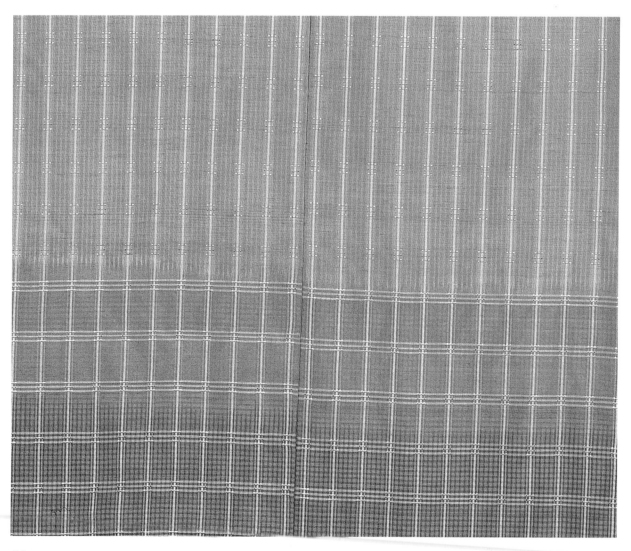

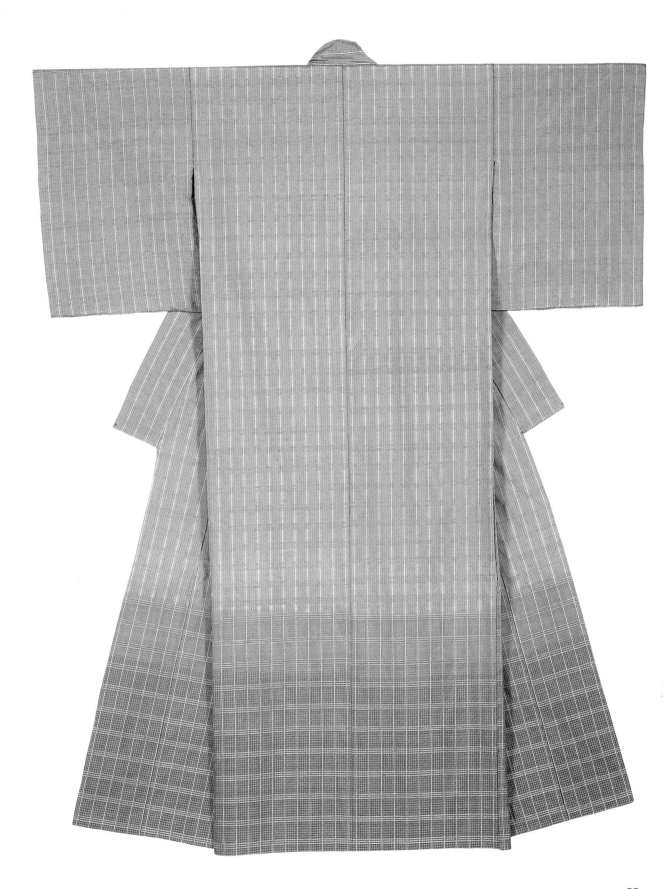

NISHIJIN FABRICS • *Nishijin Ori*

Kyoto

Having been spared from bombing during World War II, Kyoto is in many respects Japan's most traditional city, as well as being the seat of many traditional crafts. Among these, Nishijin *ori* is widely considered to be one of the nation's foremost achievements in any craft.

The history of Nishijin *ori*—actually, a collective title for silk cloth produced in the Nishijin district of Kyoto—goes back to the sixth century, when sericulture and silk weaving were started in the western part of Kyoto by the powerful Hata family, who may have originated from Korea or China. The Heian period witnessed the formation of an official weaver's guild, but civil strife during the eleven years of the Ōnin Wars (1467–77) laid Kyoto waste. Some weavers took refuge in the port town of Sakai, where they studied Ming weaving techniques. When calm was restored to the city they went back to the remains of the eastern camp of Kyoto, Tōjin, and began weaving *habutae*, a lightweight plain-weave cloth of untwisted raw silk, and *nerinuki*, a cloth using raw silk for the warp and glossed-silk thread for the weft. Meanwhile, the weavers who had settled in the western camp, or Nishijin, were busy bringing twilled cloths back to life, and it was they who established the foundation of today's Nishijin *ori*. At the end of the nineteenth century, the weavers sent a delegation to Europe to learn European methods and introduced the Jacquard loom to Japan. Development was further encouraged by the perfection of home-produced power looms.

Perhaps the most representative of Nishijin fabrics is the tightly woven tapestry cloth known as *tsuzure*. It is a yarn-dyed plain-weave cloth, and because the design is woven in the weft the density of these threads is

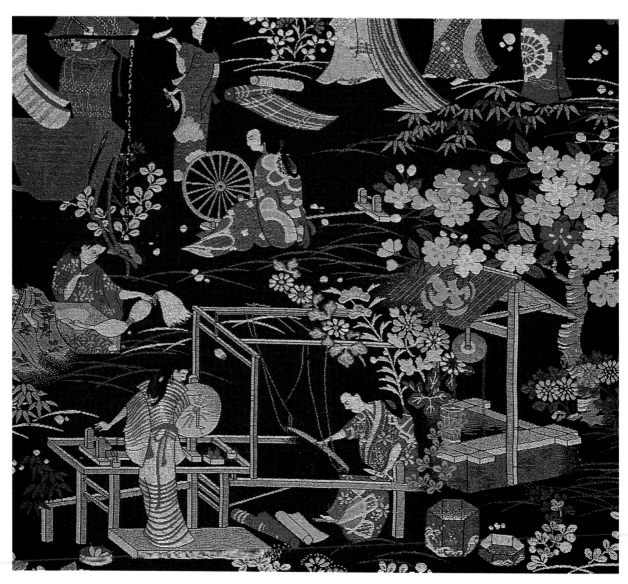

between three to five times that of the warp around which they are woven, so that the warp cannot be seen in the finished cloth. The small weft shuttles, moreover, do not go the full width of the cloth except where it is part of the ground of the design, but travel back and forth solely within their areas of color. Therefore a slight gap between the different colors sometimes appears. The fingernails of the weaver are used in place of a beater.

The cloths known as *nishiki* are a Japanese version of brocade woven on Jacquard machines using numerous colored yarns. One of these is *tatenishiki*, a yarn-dyed plain weave or twill with the design woven in the warp. *Nukinishiki* has a weft design. It is either a plain weave or a twill of pre-glossed silk, or sometimes a plain-woven cloth with variations in the warp and weft (*henka ori*). Figured satin weaves are represented by *donsu* and *shuchin*. Yet another variant, *shōha*, is a heavy twill of highly twisted yarn with a minute V patterned surface. And finally there is a figured double cloth called *fūtsū*.

The cloths produced in Nishijin have earned international renown, reflecting an endless wealth of designs and techniques. *Obi* and kimono fabrics are still being made as they were in the past, but the Nishijin looms these days also turn out fashion fabrics and cloth for interior decoration, bags, and ties. The variety is as great as the artistry and technique are brilliant. Today, the sounds of the looms in this quarter of Kyoto have been joined by a new one—the digital clicking and whirring of the computers now being used to control some of the looms, carrying the Nishijin tradition on irresistibly into the twenty-first century.

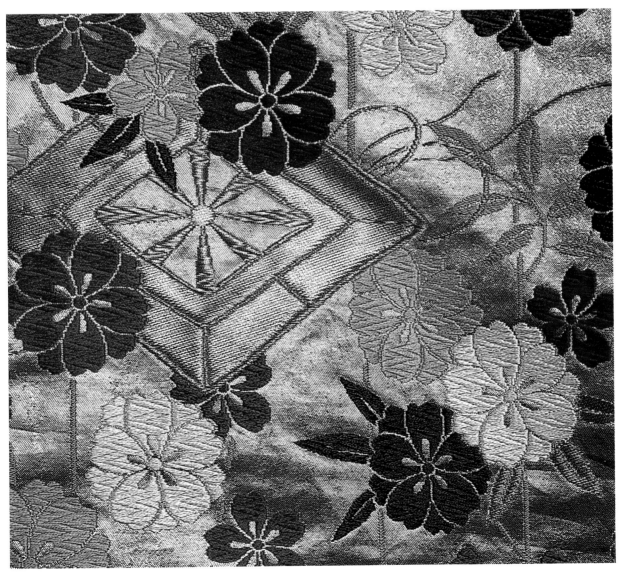

YUMIHAMA IKAT
Yumihama Gasuri

Sakaiminato, Tottori Prefecture

If local documents are to be believed, the cultivation of cotton in this area facing the Japan Sea started during the Enpō era (1673–81). By the time the production of indigo began around 1750, it seems that *kasuri* cloth was already being produced. In those days, *kasuri* weaving was a cottage industry, with the finished cloth being distributed through wholesalers. The amount of cloth increased year by year, supported by a stable supply of good cotton fertilized with sardine and seaweed from the Japan Sea and by equally good supplies of indigo. By the end of the Edo period it was a major source of income for the local clan, and the industry came under the direct control and protection of the fief. An official document on the production of *kasuri* cloth in 1874 ranked the area third after Ehime (Iyo *gasuri*) and Hiroshima (Bingo *gasuri*), but production has since declined. Yet today, the traditions of the cloth are supported by local patrons.

Yumihama *gasuri* is a yarn-dyed, plain-weave cotton weft *kasuri*. The yarn is bound by hand with a coarse type of ramie thread called *araso*, which is obtained by steaming the stems of the plant and drying the parings. Vegetable or synthetic dyes are used as well as indigo. The cloth is hand woven; adjustments are made to the pattern as the cloth is woven.

The designs are pictorial, using birds, flowers, scenery, and farm life as motifs. The cloth is made into kimono, *obi*, cushion covers, and the like. Though not so common in modern times, Yumihama *gasuri* once held such an important place in the local culture that, at the age of fourteen or fifteen, local girls were already accomplished weavers and would have started weaving cloth for their trousseau. Today, it is prized in a different way, by all those who admire traditional Japanese folk weaving.

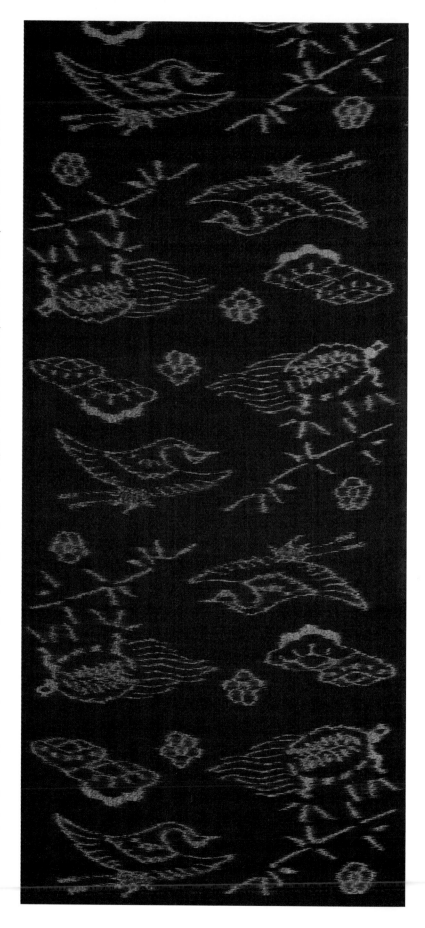

HAKATA WEAVE • *Hakata Ori*
Fukuoka, Fukuoka Prefecture

As a bouquet is to a bride, so the *obi* is to a kimono. The *obi* should complement and set off the color and pattern of the main garment; without an *obi*—it was traditionally said—the kimono is nothing. In this sense, Hakata *ori*, which is mainly an *obi* fabric, adds the finishing touch to kimono weaves.

The generally accepted theory of the fabric's origin is that one Mitsuda Yazaemon went to Sung China in 1235 to learn the techniques of weaving, and on his return initiated what has since become the craft's long tradition in his family. Later, descendants and other weavers to whom they passed on the trade improved and developed the techniques. In 1599, the head of the local clan began presenting some of this sturdy cloth to the shogunate every year; consequently it became known as *Kenjō* (Tribute) Hakata, and its fame spread. The technology of the Hakata weave greatly influenced other fabrics made in Nishijin, Kiryū, Ashikaga, Kōshū, Yonezawa, and Edo (present-day Tokyo).

Kenjō is a *tateune*, or ribbed weave. The density of the warp is extremely high; around 4,800 threads are used at the lower end of the scale, but most have a thread count of between seven to eight thousand, and in some cases more than ten thousand threads are contained in the approximately 30-centimeter width of the cloth. There are more than eight threads per *hane* or reed dent, and in less than 4 centimeters there are 72 *hane*. The yarn—a yarn-dyed glossed silk—is sometimes combined with raw silk, spun silk, or gold and silver thread, as well as a lacquered thread called *urushi ito*. The latter is made of cotton yarn wrapped with narrow strips of a Japanese paper called *torinome* and then coated with colored lacquer. The raised (floated) warp threads are the principal medium for expressing the designs. Stripes figure strongly, along with a motif called *dokko*, a metal object used in Buddhist rituals. *Hanazara*, another design derived from a Buddhist object, is expressed as a striped motif.

This stiff, lustrous cloth is nowadays made up into ties and small bags in addition to *obi*. The *obi* made of it do not slip once tied, but it is somehow indicative of the times that, although the techniques of the Hakata weave have managed to survive, the number of women who can actually tie such an *obi* on their own decreases year by year.

TRUE ŌSHIMA PONGEE
Honba Ōshima Tsumugi
Naze and Kagoshima, Kagoshima Prefecture

The Amami Islands, located between Kyūshū and Okinawa, enjoy a subtropical climate particularly suited to the cultivation of mulberry bushes. This, together with the warm, moist conditions, means that three or four batches of silkworms can be raised in one year. Production of what is known as *Honba*—"true"—*ōshima tsumugi* did not really get started until the beginning of the seventeenth century, however, and then only with the help and protection of the Shimazu clan, which collected the cloth as tax payment. Although originally produced solely on Amami-ōshima, the largest island of the group, by the Meiji period it had become more widely distributed. At the beginning of the twentieth century, the invention of the *shimebata*, a loom used for weaving the *kasuri* pattern into the warp and weft yarns before dyeing, made the production of the cloth feasible in other locations, principally in Kagoshima itself. Around the same time, raw *tamamayu* silk began to replace the original hand-spun silk yarn. In 1922, combined production in these two locations was over 6.6 million meters, and in 1977 it reached 8.7 million meters. With the trend away from the kimono as an everyday garment, however, it has since declined.

True Ōshima *tsumugi* is a plain-weave yarn-dyed silk *kasuri* cloth, with the *kasuri* design either in both warp and weft, or in the weft alone. Once the *kasuri* yarn has been woven on an *orijime* loom, the material is dyed twenty times. The resulting red-brown is achieved by using a dyestuff obtained from *sharinbai* (*Rhaphiolepis umbellata*), a member of the rose family, then mordanting it with mud, a procedure that deepens the color and softens the cloth. The *kasuri* yarn is unraveled and woven up again, this time into the most delicate of patterns, individual threads being adjusted at regular intervals during the weaving to make the pattern match properly. The precision of the patterns, the natural coloring, and the snappy feel of this light but warm cloth make it greatly admired for everyday kimono.

MIYAKO RAMIE • *Miyako Jōfu*

Hirara and Miyako Island, Okinawa Prefecture

Tradition attributes the origin of Miyako ramie (*jōfu*), to sometime during the second half of the sixteenth century, when Miyako Island was part of the nominally independent kingdom of Okinawa, or the Ryūkyūs. A high-quality cloth, it was at one time used as a means of paying taxes.

Jōfu in fact means "superior cloth," and the term basically indicates lightweight, finely woven cloth hand woven from a fine, hand-twisted ramie yarn. Compared to hemp, ramie produces a thinner filament and can be woven much more finely, and it was accordingly favored by the upper classes for summer kimono.

In its traditional form, Miyako *jōfu* is a plain-woven *kasuri* cloth of yarn-dyed ramie. The warp is twisted eight times on a spinning wheel and the weft seven times. The *kasuri* yarn is prepared either by binding it up by hand to create the resist, or by weaving it tightly (*orijime*) and repeatedly dyeing it with indigo before unraveling it. Either Ryūkyū indigo (a type of *indigofera*)

or the indigo found on the Japanese mainland is used. The actual setting up of the warp yarns is unconventional. The eyes of a heddle called *musō sōkō* are arranged at different heights, a pair of heddles making a set. One warp thread is passed through above the eye of a low heddle, then the next warp is passed through below the eye of a high heddle. This setup provides extra play to the warp yarn and produces a compact weave. The warp is then passed through the reed, and weaving can begin. The weft is hand beaten while the shuttle is passed back and forth in the traditional manner by hand. The woven cloth is washed in warm water to remove the starch applied to the yarns and then, after being dried, is finished by being laid out on a wooden block and beaten with a mallet.

Used almost exclusively for kimono, the resulting cloth is distinguished by its fine *kasuri* patterns and has the quiet luster befitting a top-quality, expensive cloth.

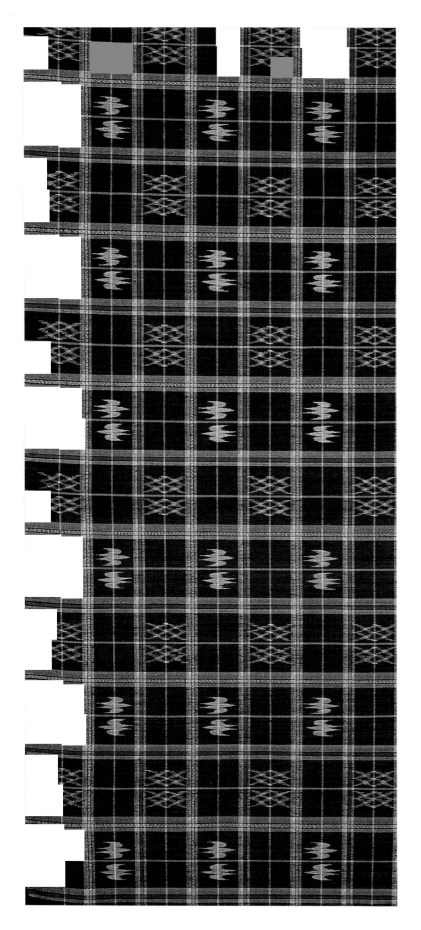

SHURI FABRICS • *Shuri Ori*

Naha, Okinawa Prefecture

Ikat techniques that originated in India around the eighth century are thought to have reached the kingdom of Ryūkyū sometime in the fourteenth century through trading links with Southeast Asia. Taken up and developed further on the islands, this complex way of producing patterned cloth gave rise over time to what might be called an individual *kasuri* culture. *Kasuri* cloth was particularly favored by the Ryūkyūan court, and the system of delivering cloth as a form of taxation that was established in the seventeenth century marked the real beginning of *kasuri* in Japan.

Apart from *kasuri*, other figured cloths with distinctive techniques that were first introduced from China and Southeast Asia include *Hana ori*; *Dōton ori*, which is basically a Chinese cloth woven in a locally developed manner; *Hanakura ori*; and *Minsaa*. The yarns used include raw silk, *tamamayu*, hand-spun *tsumugi*, cotton, ramie, and a yarn obtained from the Japanese banana plant (*Musa basjoo*). The dyestuffs are Ryūkyū indigo, *fukugi* (*Garcinia subelliptica*), smilax (*Smilax china*), and *sharinbai* (rose family; *Rhaphiolepis umbellata*). The generic name Shuri *ori* signifies the plain-woven yarn-dyed *kasuri* cloths, the *kasuri* yarn being either woven up on an *orijime* loom, bound by hand, or worked from memory. *Hana ori* and *Dōton ori* are yarn-dyed plain-woven figured cloths. The design of the former is inserted with an embroidery shuttle, whereas the design of the latter is expressed by the use of more than four heddles. *Hanakura ori* is a yarn-dyed, figured plain weave, so light and fine that its use was at one time restricted to the court. *Minsaa* is a yarn-dyed ribbed and figured cloth, produced for use in *obi*.

The designs look abstract at first sight, but are in fact derived from natural objects and even household articles. Textures and colorings are equally distinctive, yellow having been particularly favored at the Ryūkyūan court.

KIJOKA ABACA • *Kijoka no Bashōfu*

Village of Ōgimi,* Kunigami-gun, Okinawa Prefecture

An abaca cloth, *bashōfu* has been worn by the people of this chain of subtropical islands for many hundreds of years. It was certainly in existence before cotton was introduced to the islands, and its origins appear to date back to at least the thirteenth century when there were banana plantations under the direct management of the Ryūkyū court. Despite such royal patronage it knew no social barriers, and was indispensable for clothing in the long, hot summer months. In the past, people not only wove *bashōfu* for their own clothing but also planted the banana trees and prepared the yarn, thereby fulfilling the roles of both producer and consumer.

Fiber from the plant is first pared away in a process called *obiki*. It is then hand-twisted into a usable yarn. The cloth itself is yarn-dyed and either plain woven or figured, the *kasuri* threads being bound by hand. Normally only two colors are used: a brown obtained from *sharinbai* (rose family; *Rhaphiolepis umbellata*), and an indigo blue produced with Ryūkyū indigo. The weft is soaked in water before it is woven, and the woven cloth is mordanted with wood ash, exposed to the sun, and softened by being immersed in *yunaji*, a fermented mixture of soft rice, rice flour, and water. The final finish is given by rubbing the cloth with a teacup or rice bowl and pulling it both diagonally and across its width.

The *kasuri* designs take the form of wavy lines, vaguely described squares spaced regularly across the cloth, or steady grids in dark brown on a cream-tinted ground. The cloth has a cool look to it and feels light and comfortable against the skin. In use, it takes on a refined, dull luster, regardless of whether it is made into kimono, cushion covers, the short doorway curtains called *noren*, or tablecloths.

Kijoka is the birthplace of *bashōfu*, and although the fabric completely disappeared for a time before World War II, it has made a recovery and today holds a position among the best of the traditionally crafted cloths of Okinawa.

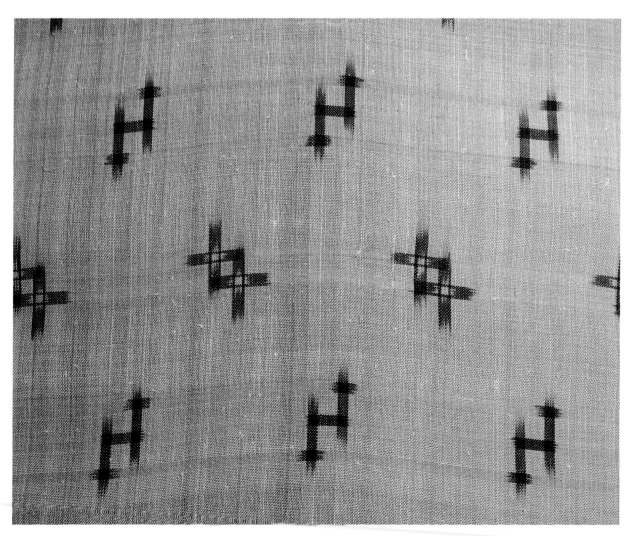

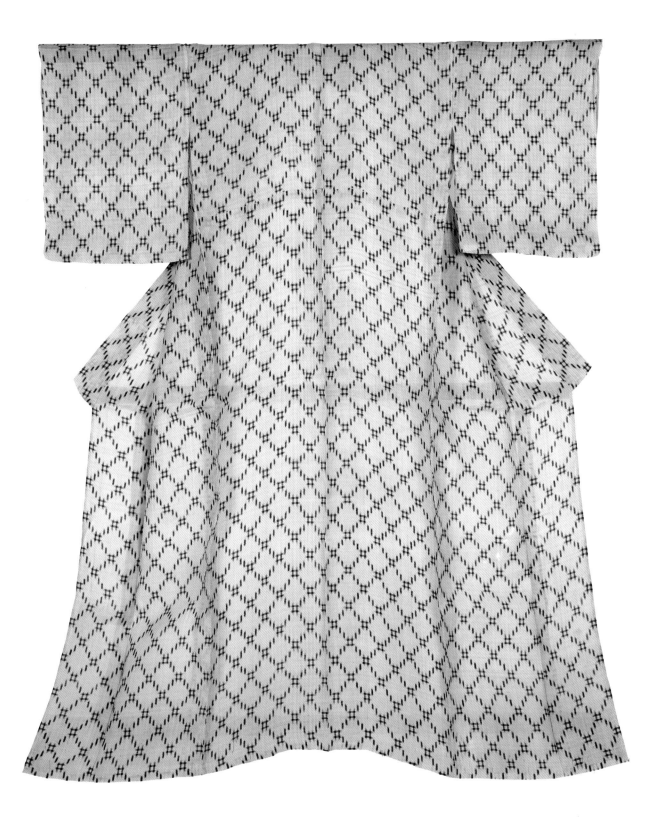

YONTANZA MINSAA • *Yomitanzan Minsaa*

Village of Yontan,* Nakagami-gun, Okinawa Prefecture

It was once the custom for a girl to give one of the narrow *obi* known as a *minsaa* to the man of her choice as a sign of her love, especially before he set off on a journey. Used exclusively by men, these *obi* were first woven around the same time that a figured *Hana ori* cloth, based on a type of weaving introduced from Southeast Asia, was being woven in the village of Yontan. Production of the cloth ceased for a time, but was started up again with the assistance of the village authorities in 1964.

Yontanza *minsaa* is a figured cloth with geometric flower designs in color on dark grounds, and is yarn-dyed and ribbed; *kasuri* designs are also used on occasion. The dyestuffs are obtained from local flora such as Ryūkyū

indigo, *sharinbai* (rose family; *Rhaphiolepis umbellata*), *fukugi* (*Garcinia subelliptica*), and myrica (*Myrica rubra*). In some cases *kasuri* threads run through the warp, while in others the cloth is a simple striped one. Other designs are of abstracted flowers created with heddles or, more simply, by lifting the warp yarns by hand in order to pass the weft under them.

The *minsaa*'s continued existence today is partly due to the fact that its techniques have been successfully handed down from an older generation, that may still have believed in its value as a talisman, to a younger generation able to recognize its value and beauty as a craft worth preserving and sustaining.

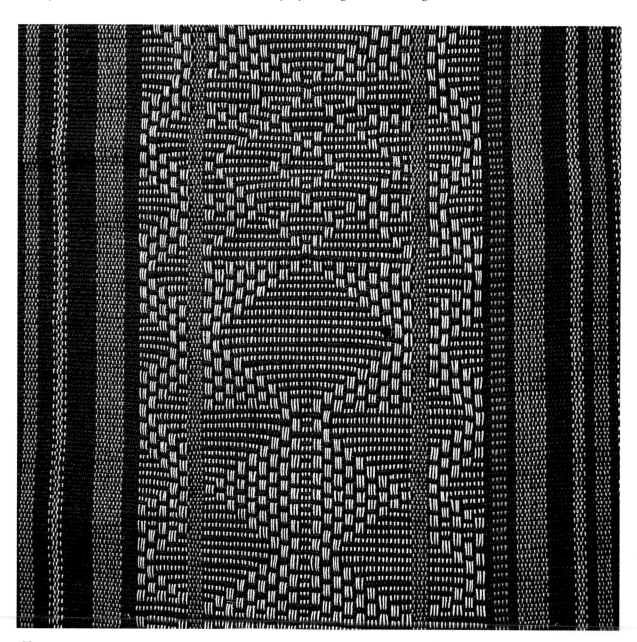

ISESAKI IKAT
Isesaki Gasuri
Isesaki, Gunma Prefecture

The silk cloth woven in the environs of Isesaki first gained notice between 1521 and 1527, when a market opened in the city for the sale of raw silk and cloth. In the late seventeenth and early eighteenth centuries, the cloth was further promoted when the city itself became an important distribution center for silk and silk goods. At that time there were two main types of cloth: a striped fabric called Isesaki *shima*, and Isesaki *futo-ori*, a sturdy fabric for working clothes originally woven by farmers during the winter using leftover silk floss and *tama-mayu* yarn. By the Meiji period, however, a plain-weave silk *kasuri* called Isesaki *meisen* had appeared and rivaled in quality similar cloths from Kiryū, Ashikaga, and Hachiōji. Nowadays, *meisen* refers to the cloths from Isesaki, almost all of which are large-patterned *chin gasuri*, or *heiyō gasuri* (a warp and weft *kasuri*).

The *kasuri* is made by one of three methods: hand-binding, *itajime*, or stenciling. In the latter method, a resist may be applied through the paper stencil or the dye may be brushed through the stencil, a technique known as *katagami nassen*. For *heiyō gasuri* (warp and weft *kasuri*) and *yokosō gasuri* (weft *kasuri*), the warp is either raw silk or *tamamayu*, and the weft is raw silk, *tamamayu*, or *tsumugi* yarn.

Utilizing a number of different motifs in its patterns, Isesaki *gasuri* has a real country feeling and is ideal for casual wear.

TSUGARU KOGIN STITCHING
Tsugaru Kogin
Hirosaki,* Aomori Prefecture

Situated at the northwestern tip of Honshū, Aomori Prefecture experiences some of the coldest winters in Japan. Despite the need for warm clothing, work clothes during the feudal period continued to be made of hemp and other native bast fibers that provide little comfort. Cotton cloth was not employed even after it had become widespread in other areas because local law virtually banned its use. The problem was partially overcome by stitching a thick white cotton thread along the weft of the hemp or similar fabric, thus making the cloth thicker and softer to the touch. Gradually, counted-stitch embroidery weft patterns developed. Because the embroidery yarn follows the weft yarn precisely over and under the warp yarns, it resembles a woven pattern.

Precisely when this technique began is unclear, but there are records of patterns that date from the Tenmei era (1781–89). As the number of patterns increased, the cloth also became a required costume for festive wear as well as part of a bride's trousseau among the farming villages north of Hirosaki. In the early part of the twentieth century *kogin* declined, but the crafts movement brought about a revival in the 1950s. Although colored yarns at one time had a run of popularity, the original white yarn on an indigo ground is now more common, and instead of hemp, a coarse wool or linen cloth is generally used. *Kogin* is now applied to wall hangings, table runners, handbags, business-card holders, and other items of daily use, as well as to *obi*, jackets, ties, and shawls. There are six or so basic patterns from which numerous variations can be made.

TOKYO STENCIL DYEING
Tokyo Somekomon
Tokyo

This type of stencil dyeing, which is also known as Edo *komon* ("Edo" was an early name for Tokyo), developed for use by samurai men during the Edo period. Originally, the small repetitive patterns (*komon*) were employed primarily on *kamishimo*, a samurai's ceremonial outfit consisting of culotte-type trousers worn over kimono and a separate vestlike top with exaggerated shoulders. Around the beginning of the seventeenth century the patterns were often of medium size, but by midway through the following century clans were competing to produce ever finer and more delicate patterns, and the dyers and stencil cutters were also drawn into this spirit of competition. From this were born patterns of extraordinary minuteness, often produced by multitudes of minuscule dots, that looked from a distance like a texture rather than a pattern.

With the ascendancy of the merchant class during the second half of the Edo period, this exquisite monochromatic cloth, previously worn exclusively by the warrior class, became fashionable among the townspeople, men and women alike. Since the end of the nineteenth century, *komon* has been regarded as more suitable for women. Because it refrains from ostentatious display, it is the favored fabric for the tea ceremony and other semiformal occasions that require a dignified but quiet presence.

Today the patterns are dyed on silk and applied with paper stencils that sometimes are so delicate that they must be reinforced with silk threads or a gauze backing. In *shigoki zome* the dye is mixed with a rice paste resist that is spread through the stencil; in *hiki zome* the dye is brushed directly onto the fabric through the stencil. Steaming sets the dye, and afterward the cloth is washed to remove the resist.

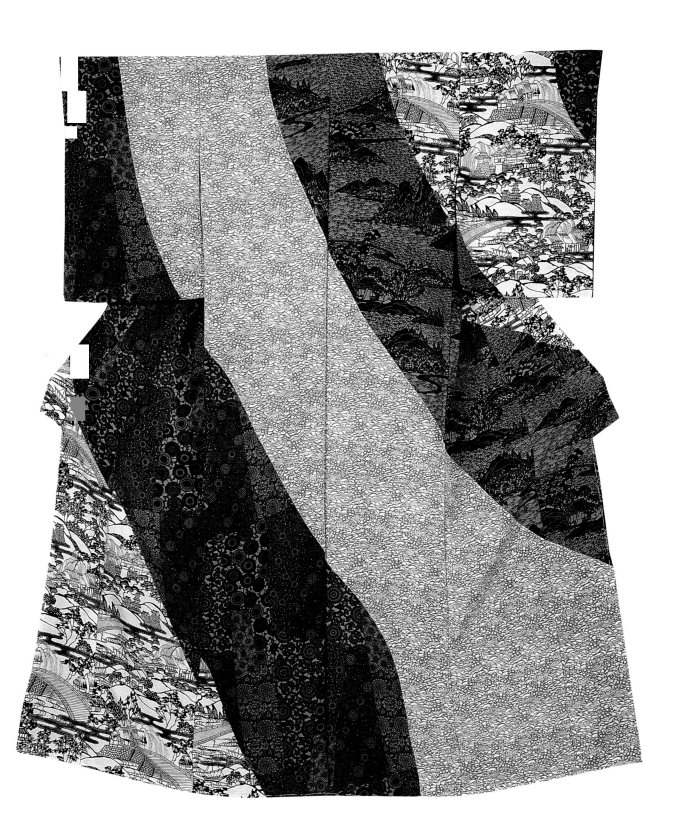

KAGA YŪZEN DYEING • *Kaga Yūzen*

Kanazawa, Ishikawa Prefecture

Situated close to the Japan Sea and backed by high mountains, Kanazawa, which was the seat of the Kaga clan, has long had a rich local culture. With the encouragement of its administrators, the province of Kaga toward the end of the seventeenth century became a center of art, industry, and learning rivaling Kyoto, where the *yūzen* process of dyeing seems to have originated.

The origins of today's Kaga *yūzen* date back to the Edo period. The dyeing techniques of Kaga, which had been perfected before the beginning of the eighteenth century, seem to indicate that *yūzen* dyeing was introduced by Miyazaki Yūzensai, who had moved to Kanazawa from Kyoto, with valuable assistance being given by Tarodaya, the official dyer to the local clan. Later on, stenciled *yūzen* was employed to dye the fine overall repeat patterns for *kamishimo* and *haori*, although the freehand *yūzen* is perhaps what characterizes Kaga *yūzen* most.

Nowadays, Kaga *yūzen* dyed cloth is used for various types of patterned goods including *furoshiki* (wrapping cloths), *noren* (a short, split curtain for hanging over a doorway), and *futon* (quilt) covers, as well as for *obi* and the more formal or dressy types of kimono, for which the cloth is usually silk. The designs are mostly of flowers and plants depicted realistically (to the extent, even, of showing the occasional insect-nibbled leaf). There is some shading of the color from the edges to the center of shapes, but in general, the designs are very colorful, with indigo, carmine, yellow ocher, grass green, and a warm grayish-purple figuring prominently on a cloth that is a remarkable tribute to the dyer's art.

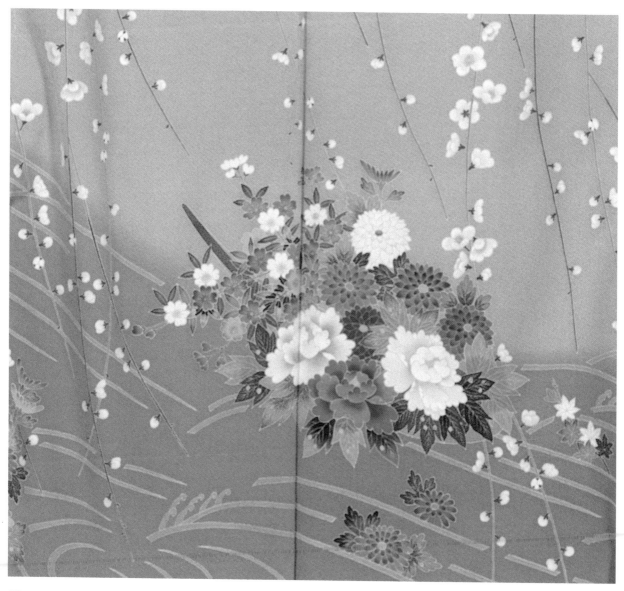

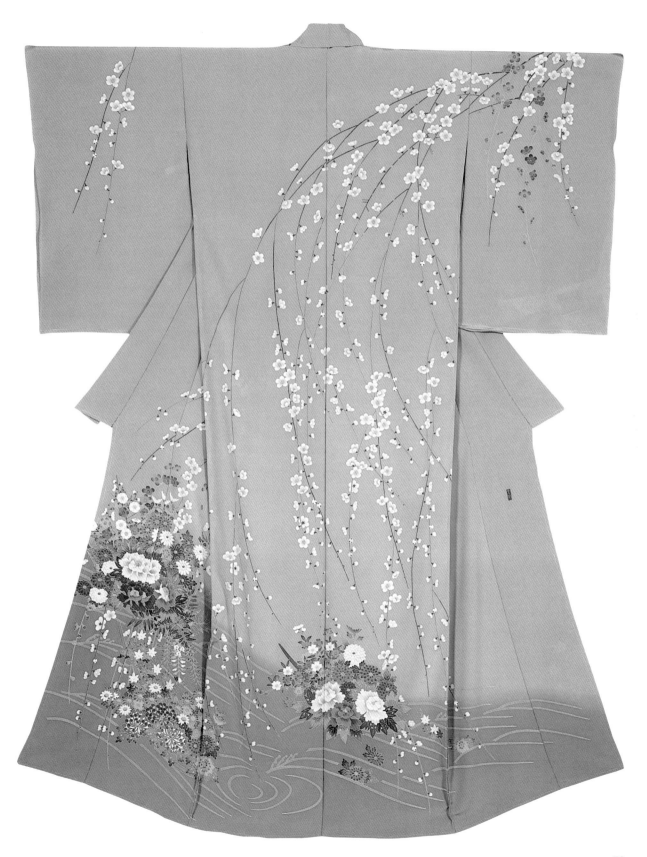

KYŌTO YŪZEN DYEING
Kyō Yūzen
Kyoto

Perhaps more than anyone else it was Miyazaki Yūzensai who contributed to the spectacular advances in the art of dyeing in Japan. In 1687 this fan painter turned his attention to developing contemporary dyeing techniques into a method for producing freehand designs. Not only was his style distinctive, he also made revolutionary improvements in dyes and methods of dyeing, as well as in the coloring and complexity of designs.

In freehand (*tegaki*) *yūzen*, the design is first traced with *aobana*, a fugitive blue made from the dayflower. Afterward a fine line of rice-paste resist is applied on the traced design in order to prevent dyes from running. Next, dye is rubbed into the fabric within the confines of the resist lines with stubby brushes, then the dyed areas are covered with resist (a step known as *fusenori oki*), and the background color is brushed over the entire fabric. When the resist is washed away, a thin white outline remains around the designs. This process, which is called *sashifuse yūzen*, has two variations. One is *sekidashi yūzen*. In this case, rubber resist is used, and around it another resist paste is applied in such a way that no white line remains after the resist has been removed. In the other variation, only the parts of the kimono that will carry a family crest are treated with resist, and the design itself is painted directly onto the cloth. This is called *musen yūzen*.

Kata yūzen (stenciled), which was first made in 1881, calls for the dye to be brushed through paper stencils. Numerous stencils are employed, each for a specific color. In 1892 it was found that the cloth could also be dyed by combining the dyestuff with rice-paste resist. This new technique was called *hikiotoshi yūzen*. Before the dye is set by steaming, the cloth is stretched and pulled diagonally in order to crack off the resist.

Kyoto *yūzen* designs generally feature birds, flowers, landscapes, and court scenes that are portrayed in a stylized manner. The colors tend to be brighter than those used for Kaga *yūzen*, and the fabric is often embellished with gold and silver leaf and embroidery, making it the aristocrat of dyeing and design.

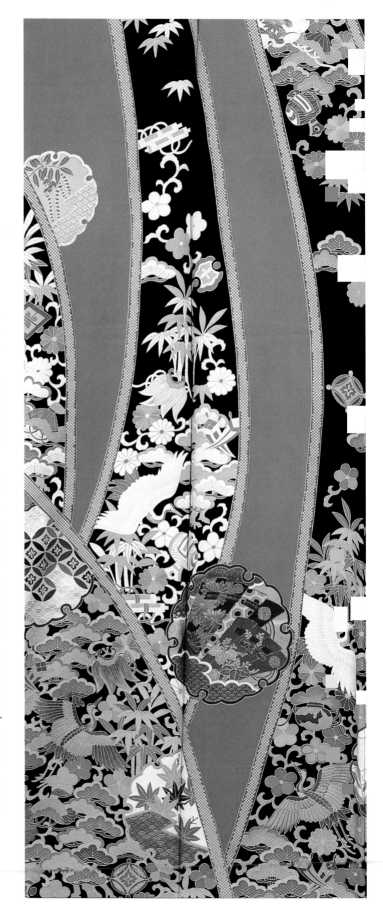

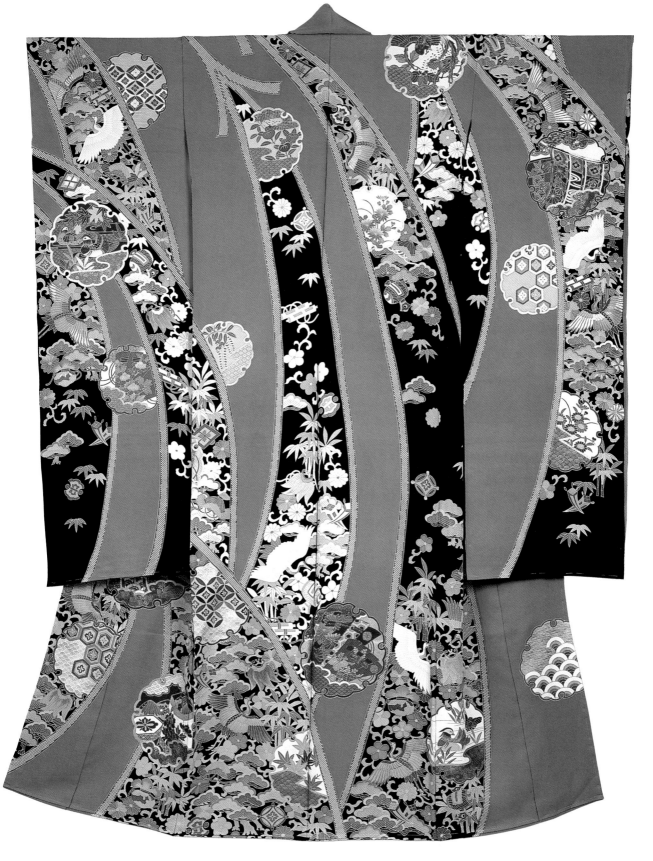

KYOTO STENCIL DYEING • *Kyō Komon*

Kyoto

This type of patterned cloth, like the Tokyo *komon* stencil dyeing, takes natural and geometric motifs and reduces them to the point where they assume a textual appearance. The word *komon* literally means "small crest," and the rich yet restrained character of this type of pattern was always favored by the warrior classes.

Although its origins are unclear, such examples of Kyoto *komon* stencil dyeing as the armor of Tokugawa Ieyasu, the first Tokugawa shogun, and the thin ramie kimono coat of Uesugi Kenshin, a warlord of the late sixteenth century, prove that the technique was already fairly well established at the end of that century.

In the early seventeenth century, *komon* was used for *kamishimo*, the ceremonial garment that was a symbol of the warrior class, each important family having its own exclusive design. The Tokugawa family, for instance, used *matsuba komon*, an elegant design based on pine needles, and another, *jūji komon*, made up of small "plus signs." The great family of Shimazu used a design known as *daishō arare komon* that utilized the family crest in two sizes to make a random overall dotted design. The *gokushō*

same (sharkskin) *komon* used by the Kishū family is perhaps the finest and most characteristic of all *komon* designs.

This overall textural type of design soon found followers among other sections of society in the Edo period. At the end of the nineteenth century, the time-saving technique of *utsushinori zome* was developed to dye these fine patterned cloths, which by then were being used, as today, for kimono. Instead of dyeing the cloth after it had been stenciled with rice-paste resist, the dye was mixed directly into the paste. Nowadays both techniques are emphycal. The fabric is white silk. After the dye has been fixed by steaming and the cloth thoroughly washed, the positive white part of the design is then dyed faintly in the same color as the background so as to give the cloth a more subdued appearance. If, however, color is to be used in the resist-covered areas of the design, the cloth is first piece-dyed

Differing technically very little from the *komon* stencil dyeing found in Tokyo, Kyoto *komon* stenciling is characterized by its brilliant coloring.

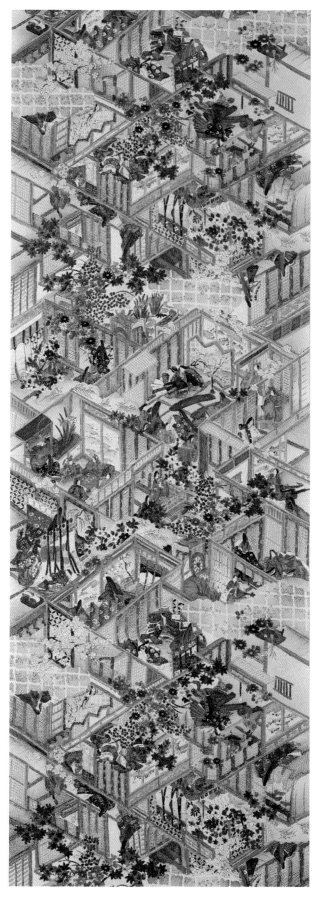

KYOTO TIE-DYEING • *Kyō Kanoko Shibori*

Kyoto

The well-known manual dexterity of the Japanese, coupled with an almost saintly patience and an ability in the abstraction of images, is surely what makes the elaborate tie-dyeing techniques of this island nation so special.

The origins of tie-dyeing in Japan, as in the rest of the world, are ancient. It would seem that shaped resist dyeing was already widespread by the six and seventh centuries. Tie-dyeing found its way into the Heian period in various forms, one of which, *mokkō kōkechi*, was the one most like the *kanoko* (fawn spot) tie-dyeing in use today.

The *kanoko* tie-dyeing associated with Kyoto earned numerous mentions in literature during the early part of the seventeenth century, and its praises were even extolled in a song around the same time. From the late 1680s on into the early part of the next century (Genroku and Kyōhō eras), when it was very fashionable to wear a tie-dyed kimono, the work of making this type of cloth had become highly organized, each process being carried out by different artisans, and the whole business of production and wholesaling was strictly controlled.

Numerous variations have been developed over the years, and they are still being added to. *Hitta shibori* most closely resembles the basic form of fawn spot tie-dyeing. A small portion of cloth is pinched and bound tightly with a silk thread—a relatively simple process, yet even someone highly skilled at the technique will still need six months to complete enough cloth to make one kimono. The minute dots of the technique known as *hitome shibori* have a diagonal slant, whereas other methods, tying up larger amounts of fabric, produce ringed effects.

Besides *kanoko* tie-dyeing, there are also techniques requiring folding and sewing. The result is a ribbed effect, or one resembling netting, depending on the way the cloth is tied. Sometimes techniques are combined: banded areas to be left undyed are sandwiched between boards while other areas are minutely tied. In the technique known as *oke shibori*, even larger areas can be kept out of the dye by putting them into a bucket and strapping a lid on it before the whole is immersed in the dye vat. But common to all to a greater or lesser degree is the blurred effect characteristic of tie-dyeing.

TOKYO YUKATA STENCIL DYEING • *Tokyo Honzome Yukata*

Tokyo

While many people know what a kimono is, very few people outside Japan have actually worn one. The *yukata*, on the other hand, has gained a large following during the last twenty years, especially in America and Europe. A simple cotton kimono that requires minimal care and can be worn as a bathrobe or dressing gown, its origins can be traced to a robe known as *yukatabira* that was worn in the bath. During the Heian period, when nakedness was frowned upon even in the bathroom, well-mannered people customarily wore an unlined linen garment known as *hitoe*. Later, the *yukata* became a garment to put on after taking a bath; in the Edo period, it became fashionable to wear cotton *yukata* dyed with bold designs after taking a bath at the *sentō*, or public bath, which had become a social center for the townsfolk. By the end of the nineteenth century *yukata* were being worn as a summer garment, becoming an essential part of the summer scene at festivals, firework displays, and other events during the hot, humid months.

The craft of Tokyo *yukata* stencil dyeing became established around the middle of the eighteenth century, using Edo *komon* stencil techniques on cotton. By the early part of the twentieth century such yukata were universally popular, and in the 1920s mass production started, using the *chūsen* technique of dyeing first developed at the end of the nineteenth century and still in use today. With this technique, the dye is poured through the cloth; first, plain white cotton is stretched out and lightly pasted on a long board and the design in resist is applied, then the back is treated the same way so that the design matches precisely on front and back. If the design is complex, separate stencils are used for the front and the back. The dye is then poured on by hand and soaked up from behind. Folding the cloth at each repeat and vacuuming the dye through the cloth is a modern labor-saving method.

Small hand towels called *tenugui* are also produced by this dyeing process, but the fresh-looking designs and the feel of the cotton are particularly suited to the *yukata*, which by now has—somewhat to the amusement of the Japanese themselves—become a kind of ambassador of Japan abroad.

KYOTO EMBROIDERY • *Kyō Nui*

Uji and Kyoto, Kyoto Prefecture

When Buddhism was introduced into Japan, the crafts and architecture associated with it came too. Carpenters, metal workers, and even artisans skilled in the techniques of embroidery were brought in to train the local people in skills developed on the continent.

Embroidery (*shishū*) in Japan really started at that time, a fact that is recorded in the chronicle of early times, the *Nihon Shoki*. It was soon being used for the ceremonial robes of the nobility, and in 603, some one hundred years after the arrival of Buddhism, Prince Shōtoku wore embroidered robes at a court ceremony. The oldest existing piece of ancient embroidery, executed in 622, is the *Tenjukoku Mandara*, or "Heavenly Paradise Mandala," at the temple of Chuguji in Nara.

In 794, when the capital was moved to Kyoto, an official embroidery department called the *nuibe no tsukasa* was established at the court of the emperor. By the Kamakura period embroidery was being employed for sword-hilt covers, sashes, and other decorative elements of the warrior's wardrobe. New stitches were added, and the more elaborate techniques become popular among the people at large. During the Muromachi period, *nuihaku*, embroidery combined with gold and silver leaf, produced Noh costumes of outstanding brilliance. Embroidery was also combined with tie-dying in the *tsujigahana* robes of the sixteenth century. During the early part of the Edo period, embroidery was applied to tie-dyed *kanoko* cloths to make richly embellished kimono. Since the end of the nineteenth century, embroidery has continued to be used on kimono and *obi* as well as on religious articles, and has also been applied, in a more pictorial manner, to wall hangings and screens.

The types of stitches correspond more or less to those used in Western needlework; those more commonly used in Kyō *nui* include *nuikiri*, outline satin stitch; *matsui nui*, backstitch outline; *sagara nui*, French knotting; *sashi nui*, long and short stitching; and *komatsui*, couching. The commonest threads are yarn-dyed silk, a thread coated with *urushi* (lacquer), gold and silver threads, and also thread that has been coated with gold or silver leaf. After the design has been transferred onto the cloth, the cloth is spread out over an embroidery stand or frame to facilitate easy working.

IGA BRAIDED CORDS • *Iga Kumihimo*

Ueno and Nabari, Mie Prefecture

Decorative cords in Japan were originally used to tie sutra scrolls and on the robes of Buddhist monks. Later their primary use was for linking the components of a suit of armor and on sword hilts, but they also were an important part of court costumes as well as of various bags, such as those in which tea-ceremony caddies are kept.

Iga Ueno—known as the birthplace of the haiku poet, Matsuo Bashō and for its associations with ninja and intrigue—is also famous as one of the centers of braided cord making. Late in the sixteenth century, during the Momoyama period, specialist craftsmen were competing with each other technically in what seems to have been a golden age for braided cord. With the break-down of feudal society, there was a decline in the use of such cord, but fortunately the traditions of Iga *kumihimo* were carried on by the armor makers to the Tōdō clan.

The foundations of Iga *kumihimo* as it is known today were laid in 1892 when Hirosawa Tokusaburō established a business for producing decorative cord for tieing such things as *obi* and *haori* after having mastered the techniques in Tokyo. Although machine braiding has come into extensive use since then, Iga is particularly known for hand-braided cords and accounts for 80 percent of the country's total production, with Kyoto, Ōtsu, Tokyo and Sakura in Chiba Prefecture providing most of the remainder.

The techniques have now grown so sophisticated that almost any pattern can be produced. The essential equipment consists of a wooden stand called *marudai*, which looks like a small, round stool. The top surface is usually round with a hole in the middle. Pre-dyed raw silk, spun silk, and gold and silver thread are the usual materials. The thread is wound onto small, weighted spools that hang over the edge of the stand. The head of the braid is passed through the hole in the top plate and kept in place with a small counterweight. Braiding can now begin by crossing opposite threads or by passing one thread over or under another in a set sequence, both hands usually being used at once. There is also the *takadai*, which resembles a loom, with simple frames to the left and right of the operator over which the braiding spools are hung. The principle of braiding is basically the same as the *marudai*, except that the completed braid is reeled up on a bar located in front of the operator. A similar way of taking up the braid is used with the *ayatakedai*, but this has a series of long, projecting "teeth" directly in front of the person doing the work. These are used to separate the individual threads as they are being braided, and it produces a flat braid. The semimechanized *naikidai* was developed in the Edo period and caused something of a revolution in braid making at the time.

GLOSSARY OF TEXTILE TERMS

AOBANA: An extract from the spiderwort plant. The flower from which this fugitive liquid is made only lasts a day, hence its other name, dayflower. It is used to draw out designs on fabric.

BENIBANA: (*Carthamus tinctoric*) Safflower; produces a pink or yellow dye.

CHIJIMI: Crepe produced by the use of highly twisted wefts and/or warps in any fiber. The twist is secured by starching the yarn. When the woven cloth is washed and rubbed in hot water, the yarns pull together, producing a crinkled texture.

CHIRIMEN: Silk crepe produced by alternating weft yarns having opposite twist directions; favored for *yūzen* and stencil dyeing.

HAORI: The jacket worn over a kimono.

ITAJIME: As a dyeing process, it is used to create *kasuri* threads or patterns on cloth by tightly sandwiching lengths of yarn or cloth between wooden boards that have been appropriately gouged out. The flat parts of the boards which are retained act as a resist when the dyeing takes place. This method of dyeing is mostly used for geometric designs that repeat throughout the cloth.

KAMISHIMO: A man's formal attire consisting of culotte-type trousers and a separate vestlike top with exaggerated shoulders.

KANOKO SHIBORI: A method of tie-dyeing in miniature. Small bits of the cloth are pinched and then a thread is wound around them to create the resist. This results in what looks like an overall texture or an image expressed by dots resembling the dappling on the back of a fawn. Hence the name *kanoko* (literally, "fawn spot tie-dyeing"). Apart from this basic technique, there are many other ways in which the cloth can be sewn in order to create a variety of effects.

KARIYASU, also known as *kobunagusa*: (*Arthraxon hispidus*) A tall grass producing a vivid yellow dye.

KATAZOME: A form of stencil dyeing. Employed to a greater or lesser degree in the production of Tokyo *somekomon*, Tokyo *honzome yukata*, Kyō *komon*, and in *yūzen* techniques; the durability of the stencil and the water solubility of the rice-paste resist are of particular importance. The paper for the stencil is a kind of traditional *washi* made from the *kōfōzo*, or paper mulberry (*Broussonetia kazinoki*). Several sheets are glued together before it is coated with persimmon juice and then subjected to smoking for several days. While the paper is strengthened by the persimmon tannin and the smoke, it is still possible to cut it with razor-sharp knives and specially designed tools, to leave clean edges of the bold and sometimes highly intricate designs. The rice-paste resist is made from a mixture of rice flour and rice bran that is steamed and then kneaded into the right consistency so that it can be spread evenly. The stencil is cut and, if the design is very delicate, reinforced with silk threads or silk gauze. Before the stencil can be used it is soaked in water to make it pliable so that it will adhere more closely to the fabric. The rice-paste resist can then be applied through the stencil with a wooden spatula. After the resist has dried, the cloth is sized with an extract of soybean liquid, or *gojiru*, and then the dye can be applied. After being left for several days for the dye to cure, the cloth is soaked in water to remove the resist.

OMESHI CREPE: A crepe of pre-dyed, highly twisted yarn in both warp and weft.

ORIJIME: A way of pattern-dyeing *kasuri* threads by weaving them tightly on a loom. This technique of creating a resist is also sometimes called *shimebata* or *kariori*. Reputedly developed by Nagae Iemon in 1907 on Amami-ōshima, the technique involves the use of a special handloom to weave *kasuri* pattern-yarn as the weft, with a cotton warp to "bind" it tightly before dyeing. The number and interval of the warp threads depend on the pattern that is to be applied to the *kasuri* yarn. The cloth must be tightly beaten with the beater to achieve the resist, so this work is usually done by a man. It is possible to produce very detailed designs using this technique.

TAMAMAYU: Two cocoons that have been spun together, dupion, producing a nubby yarn when reeled.

TSUJIGAHANA: A combination of tie-dyed designs and flowers hand-painted in ink popular in Kyoto during the sixteenth century.

TSUMUGI: A rough hand-spun silk. Cloth going under this name is woven from a hand-spun silk yarn produced from imperfect cocoons. Originally this was done mostly by farmers to produce working clothes for themselves and their families. The floss from the cocoons is first degummed by immersing the cocoons in hot water containing baking soda and sulfurous acid. The floss from five or six cocoons is then combined to make it easier to work with, and after rinsing it in water, the process is repeated. The small bags that result, known as *fukuro mawata*, are then dried before being soaked in a mixture of powdered sesame seed and water in order to make the thread easier to spin. The *fukuro mawata* are then attached to a *tsukushi*, a device made of bamboo and corn or cane stalks. Several filaments are drawn from the floss at the same time and twisted into a single thread, the spinner wetting the thread with saliva. A middle-aged woman is considered best for this job, as her saliva contains just the right balance of hormones. The resulting thread is strong, elastic, and glossy and gives the cloth from which it is woven a rustic, home-spun quality, similar to that of pongee.

YŪZEN: This type of textile dyeing can be divided into two main types. The one known as *tegaki yūzen* can be called freehand *yūzen*, as both the resist paste and the dyestuff are applied to the cloth by hand. First, the design is drawn onto the fabric with *aobana*. Next, the full length of cloth to be worked on is stretched out, and tensors called *shinshi* are inserted at regular intervals under the width of the piece. The *aobana* lines are then covered with a fine line of paste resist, using what looks like an icing bag called *tsutsu*. These are made of waterproofed paper with a metal tip and come in various sizes. The juice from the persimmon is used to render the paper waterproof and to strengthen it. Having clearly defined the areas of the design to be dyed, a thin, liquid resist called *gojiru* that is made from a soybean extract is spread over the first resist and the remainder of the cloth. When dry, this will aid the absorption of the dyes and prevent unwanted running. Water is first brushed over the area to be dyed and then the dyestuff is applied with a small, flat brush. The dye is then steam-fixed and the paste rinsed off. What remains is the fine white outline of the design. A resist paste is used again if other dyeing such as the background is to be done before the final steaming and washing. The cloth is then stretched on the bamboo *shinshi* to dry in an airy place. The other type of *yūzen* dyeing is called *kata yūzen*. This is a type of stencil resist dyeing in which the design is transferred onto the cloth using the dye directly or using a dye-infused paste.

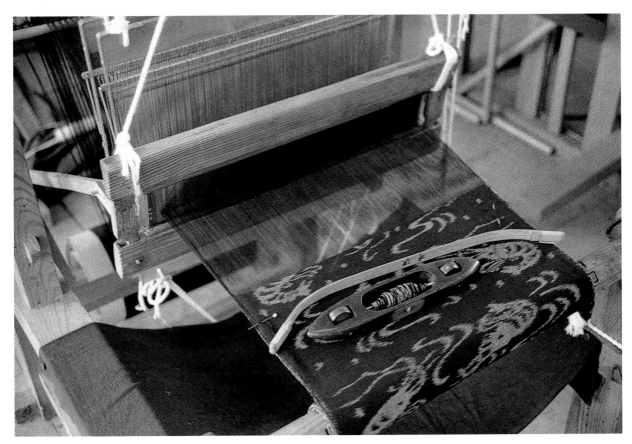

Yumihama ikat.

Lacquer Ware

Introduction

Oriental lacquer—the term evokes images of folding screens inlaid with semiprecious stones, or gold-decorated panels incorporated into baroque furniture, or those cunning little Japanese pillboxes (*inrō*) with a proliferation of intricate detail. In short, "Oriental lacquer" is usually equated in the West with decoration, particularly gold on a shining black ground. Although not strictly inaccurate, this popular image is an anachronism and does not do the lacquer craft justice.

The word "lacquer" as it is used today is itself misleading. Any glossy, hard paint can now be referred to as "lacquer"—even one made in a chemical plant and bought at the hardware store to spray-paint model airplanes or bicycle fenders. As such, common parlance creates an additional, serious stumbling block to the understanding and appreciation of Oriental lacquer.

True Oriental lacquer is an organic substance: it is tree sap that has been aged and refined. It is a paint, to be sure, but a paint with special properties. Used widely in Southeast and East Asia, and in some places in India, lacquer is derived from the sap of a variety of trees and shrubs, most of which belong to the same family. In Japan, the sap of the *urushi* tree (*Rhus verniciflua*) is used; lacquer as a substance is called *urushi*, and lacquer ware, *shikki* ("lacquer ware") or *nurimono* ("painted things").

Japan has yielded the oldest known examples of lacquer in the world—red-and-black-lacquered earthenware pots dated to around 4500 B.C., in the neolithic Jomon period (ca. 10,000–300 B.C.). These lacquered pots pose more questions than they answer. One question arises because the lacquer used on these pieces is already highly developed—it has been refined, and pigments have been added. This would argue that the origins of lacquer are to be found at a much earlier date still. Again, it has always been assumed that lacquer craft came to Japan from the Asian mainland. So far, no lacquer of comparable antiquity has been found outside Japan. The possibility of a Japanese origin of lacquer is therefore worthy of serious consideration. Furthermore, although there are scattered examples of lacquer applied to late-neolithic earthenware pots, there is no evidence of a continuity of lacquer craft into the protohistoric and historic periods. In short, there is still much to discover in this field.

The chemical processes and properties of *urushi* were not fully understood until relatively recently. This highly complex organic substance

hardens (it does not dry) when applied thinly as a coating, and this hardening occurs best in conditions of high humidity and high temperature. *Urushi* contains urushiol (the same stuff as is found in poison oak and ivy), which is responsible for lacquer's material properties as well as giving any susceptible person who enters into contact with it a month or so of severe itching. (Lacquer craftsmen are generally immune to these effects.)

Hardened lacquer forms a highly protective coating that repels water and prevents rotting in addition to resisting the action of acid and alkali, salt and alcohol. It is even a good insulator of heat and electricity. A dramatic revelation of *urushi*'s preservative qualities was the discovery in the 1970s of Han-dynasty tomb furniture in China, still in perfect condition after two thousand years of burial.

Lacquer has to be applied on something—a "core"—and more than one coating is necessary if the object is to last at all. The ways in which coatings of *urushi* are applied differ among the various local lacquer traditions in Japan.

Wood is the most common material for cores, but basketry, leather, and paper are also traditional, and plastic too has come into use, especially for drop-it-and-watch-it-bounce eatery ware. Ceramics and metal may also be coated with *urushi*. Wooden cores themselves are divided into three different types, depending on how they are made, and each method is a mature, fully formed craft in itself. The types are turnery (*hikimono* or *kurimono*; lathework), bentwood (*magemono*), and joinery or fine cabinetry (*sashimono*).

There are three types of lacquer coats: undercoats (*shitaji*), middle coats (*naka nuri*), and the final coat (*uwa nuri*). Some styles do not require a middle coat. An undercoat and middle coat may be single or multiple, but the final coat is always a single coating of the finest, most highly refined lacquer. After the final coating, the piece is decorated. Again, local lacquer traditions in Japan often have their own techniques of decoration. With the gold decoration known as *makie*, a final coat of high-gloss, transparent lacquer (*roiro*) is often applied last.

Turning the wooden base for a Yamanaka lacquer bowl.

WAJIMA LACQUER
Wajima Nuri
Wajima,* Ishikawa Prefecture

The famed durability of Wajima lacquer ware is the result of both the high quality of the lacquer refining process and the composition of undercoatings unique to Wajima. To summarize, a wooden core receives: 1) a primer and hole filler; 2) lacquer-saturated fabric strips applied to edges and seams for reinforcement; 3) the first undercoat (a mixture of burned earth, rice paste, and lacquer); 4) the second undercoat (finer burned earth, rice paste, and lacquer); 5) the third undercoat (the finest burned earth, paste, and a greater proportion of lacquer in the mixture); 6) the first middle coat; 7) the second middle coat; 8) the final (top) coat. Between all these coatings, the lacquer is allowed to harden, after which it is burnished and smoothed in various ways. (For example, the final burnishing before the top coat is applied is done only by elderly women because they have little or no oil in their hands.)

Albeit an oversimplification, this outline gives some idea as to why lacquer work remains a community craft. No single individual could possibly do all the stages of the process, from making core forms to finished surface decoration, and still earn a living.

The burned earth for the undercoatings unique to Wajima is diatomaceous earth dug from a hill in the town. This is reduction fired and sieved into three grades. This earth–rice paste–lacquer mixture is used nowhere else in Japan. Both *makie* and *chinkin* decoration are used in Wajima. *Chinkin* (see Aizu Lacquer), in particular, is traditional here and has been developed into very sophisticated decorative forms.

The origins of Wajima lacquer are still in dispute. Different authorities have also put forward conflicting theories of when lacquer first became an industry in Wajima. That folk lacquer has a long history in the Noto Peninsula is not in doubt, but it seems that the lacquer industry in Wajima is probably no more than about two centuries old.

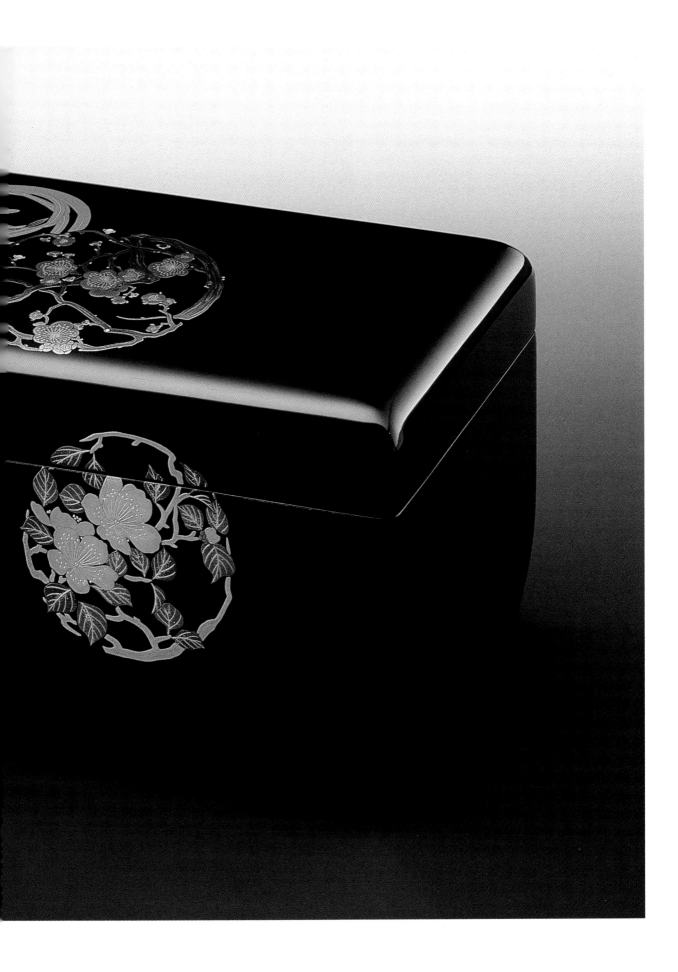

AIZU LACQUER • *Aizu Nuri*

**Kitagata and Aizu Wakamatsu,
Fukushima Prefecture**

The production of lacquer ware in the Aizu area of northern Japan got off to a solid start in the latter part of the sixteenth century. There is extensive documentation of these first flourishings. After 1599, for example, efforts were made to develop a system for cultivating lacquer trees, accompanied by efforts to improve lacquering techniques. In the eighteenth century, the use of colored lacquers and *makie* became widespread, and by the latter half of the nineteenth century Aizu lacquer ware enjoyed a veritable vogue. The year 1878 represented a peak in output. Thereafter the industry made efforts to reduce prices, but this had an unwelcome impact on quality. As the buying public lost confidence in the quality of Aizu ware, production in the area entered a long period of decline.

Despite such long-term scaling back of this once formidable industry, some 4,000 people are still engaged in the making of Aizu lacquer ware. The contemporary craft is well known for its colorful decorations. Typical products are small plates, bowls, round trays, and traditional tray-tables (*ozen*). Distinctive kinds of small boxes are made, as are the tiered boxes (*jūbako*) used for special foods during New Year's celebrations.

Two types of priming are employed. The first is known as *shibu shitaji*. Lamp black or powdered charcoal is mixed with persimmon tannin (the juice of unripe persimmons). Several layers of this mixture are applied as a primer, which is allowed to dry and then burnished. Finally, a coat of the persimmon tannin alone is applied, and after this dries the object is again burnished. The item can then be given its finishing layers of lacquer. In the other type of preparation, *sabi shitaji*, a claylike primer (*sabi*) is applied, allowed to harden, and then burnished. A lacquer undercoat follows the *sabi*, and after burnishing intermediate and final coats are applied.

Decorative techniques are particularly numerous. There are as many variations in techniques of applying colored lacquer as there are in *makie* techniques of metallic decoration (particularly those involving gold). Aizu has also developed the art of *chinkin*. This involves incising a design into a lacquered surface, applying a thin layer of lacquer into the incised lines, then applying either gold dust or gold foil over the tacky lacquer. As the lacquer dries, the gold is cemented into the incised design.

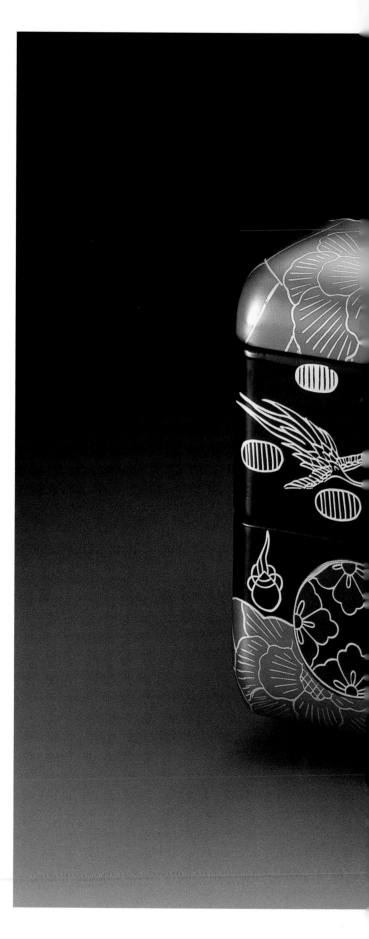

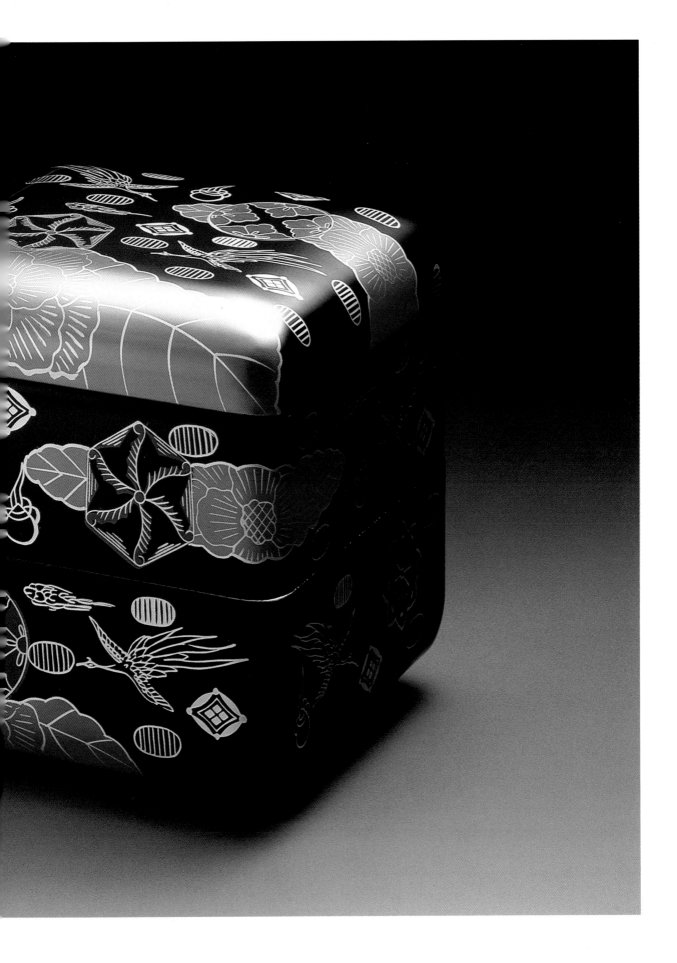

KISO LACQUER
Kiso Shikki

**Village of Narakawa, Kiso-gun,
Nagano Prefecture**

Kiso *shikki* is an attractive and resilient lacquer ware that uses a clay undercoating found in Kiso County, in the mountains of southern Nagano Prefecture. A thriving industry based in the county produces a range of Kiso wares to this day.

Lacquer ware from Kiso was originally of two different types, Hirawasa *shikki* and Fukushima *shikki*. These date from the Keicho era (1596–1615) and Ōei era (1394–1428) respectively, and were of plainly finished *shunkei nuri* and *hana nuri* styles. At the end of the nineteenth century, however, craftsmen from Wajima introduced the use of clay undercoatings to Kiso. In place of the *jinoko* powder used in Wajima, Kiso lacquerers turned to *sabitsuchi*, a fine clay from the mountains near the village of Narakawa.

When combined with lacquer, *sabitsuchi* forms a tough ground that is easily absorbed by wood. Applied as an undercoat, it provides a sealing and protective layer that guarantees really durable lacquer ware.

In addition to household goods like trays and bowls, Kiso *shikki* also includes fishing rods and other angling gear. Some small pieces of furniture are also made using *hegime* grained wood. The main woods worked are *katsura* (*Cercidiphyllum japonicum*), Japanese cypress, and Japanese horse chestnut.

Kiso lacquering is not confined to any one technique. Bentwood goods or thin boards with a *hegime* grain are produced using a technique similar to Hida *shunkei*. Kiso *kawari nuri* employs a tough ground on which several layers of colored lacquer are built up. These are then rubbed down to produce a pattern. *Nuriwaki roiro nuri* also features a tough ground and applications of different colored lacquers.

In general, Kiso *shikki* is a happy medium that retains the beauty of the wood while making an article more functional through the application of lacquer.

HIDA SHUNKEI LACQUER
Hida Shunkei

Takayama, Gifu Prefecture

Takayama, in the Hida region of central Honshū, is one of Japan's most attractive traditional towns, and the home of much woodcraft as well as a type of lacquer ware called *shunkei*. The latter involves a relatively simple lacquering technique in which wood is first lightly stained and then coated with a clear yellow lacquer to produce a resistant coating and draw out the grain of the wood. The term *shunkei* is used to describe both the ware and the technique.

At some stage in its development, *shunkei* ware became associated with the tea ceremony. During the Edo period, when the tea ceremony steadily gained ground among the general population, *shunkei* became correspondingly popular. Production in Takayama increased under the patronage and protection of the local lord, who fostered the development of *shunkei* lacquer as a local industry. Toward the end of the nineteenth century, what is now known as Hida *shunkei* started to be distributed beyond the boundaries of the province, and the craft flourished as it became more widely known.

In spite of the simple, unpretentious air of *shunkei* wares, their appeal never flags, largely because the beautiful grain and texture of the wood is visible through the lacquer. *Shunkei* tea ceremony utensils are still being produced today, along with other traditional items such as tiered food boxes (*jūbako*), lunch boxes (*bentō bako*), confectionery bowls with lids, stationery boxes, flower vases, trays, and pieces of furniture.

Wood used to make bentwood goods and objects assembled from boards or strips of wood is processed in one of three ways. In the first, wood is cut and smoothed in the conventional manner. In the second, the wood is split or cleft, thereby retaining its rough, textured grain. In the third, the wood retains some of the tool marks of the plane used to finish it. The wood for bentwood pieces is steamed, and may be scored on the inside of corners to facilitate bending. The ends are fastened by cherry-bark strips. Turned goods (*hikimono*) are produced on a lathe in the conventional way.

The wood is colored with one of two different stains. Yellow stain is obtained from gardenia seeds or from the resin of a plant that grows in Thailand. Red stain is traditionally obtained from red ferric oxide, but a synthetic substitute is now available. After staining, raw lacquer is rubbed into the wood. The finishing coat of clear *shunkei urushi* is then applied.

Being one of the simpler lacquering techniques, Hida *shunkei* is not so expensive to produce and, as a result, is not so hard on the pocketbook. Also, compared to some of the more ornate lacquer wares produced in Japan, it has a simplicity that puts it in step with modern aesthetics.

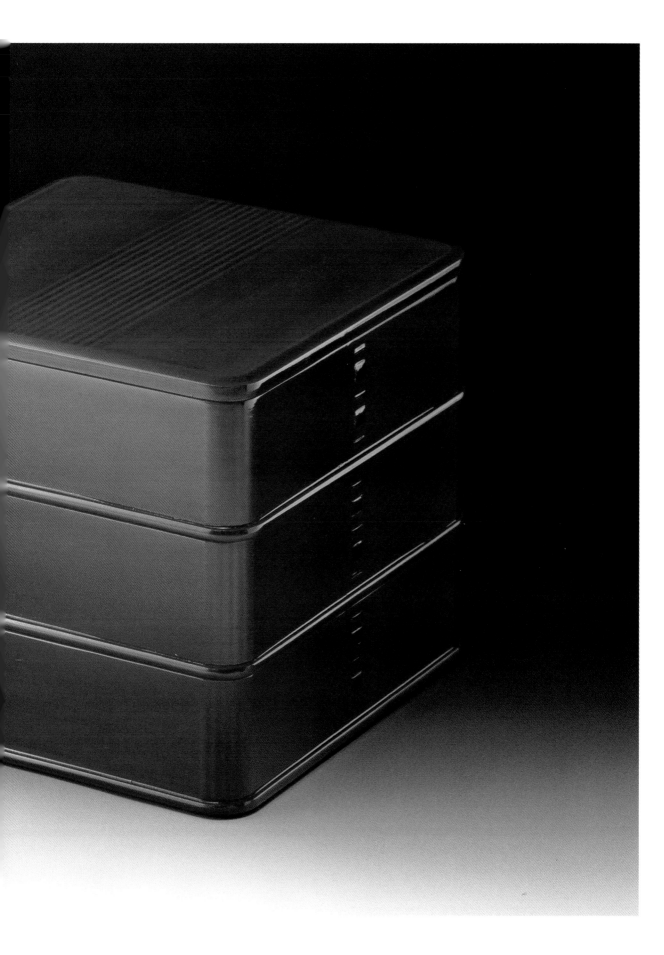

KISHŪ LACQUER • *Kishū Shikki*

Misato-chō, Wakayama and Kainan,
Wakayama Prefecture

The Kainan region is located at the end of the Kii Peninsula, jutting out into the Pacific Ocean and washed by the warm Kuroshio current. Since as long ago as the Muromachi period, the region has been producing Kishū *shikki* (also known as Kuroe *nuri*, Kainan *shikki*, and Kuroe *shikki*). Its commonly accepted point of origin is the Negoroji temple, established in 1288 in Wakayama city.

Monks at Negoroji made all their daily utensils themselves and did their own lacquering in a style known as Negoro *nuri*. Bowls and other objects were simply lacquered with a vermilion top coat on a black penultimate coat, a style known as *aka negoro*. Over time the top coat would be worn away in places to reveal the black lacquer beneath, an attribute that was particularly admired. Later, as the tea ceremony came into vogue, lacquer ware with a black finish (*kuro negoro*) was also made.

In 1585, a dispute with the abbot of Negoroji led many monks to escape to Kuro, where they turned to lacquering full-time. Thus established, the lacquer ware industry became known for producing functional items with distinctive lacquers. From the Kan'ei era (1624–44) onward, bowls were given a priming of persimmon juice. Later, a thick, tough ground called *kataji atsunuri* came to be applied.

In modern times, the area is still a major producer of everyday lacquer ware at a reasonable price. Most common are household goods and furniture, which may be bentwood, turned, or assembled (*sashimono*). The main decorative treatments are various kinds of *makie*, *chinkin*, *aogai zaiku* using mother-of-pearl, and illustrative work in colored lacquers.

At the same time as maintaining traditional techniques, Kishū *shikki* makers are adapting to modern demands. Wood composites are being used along with plastics for the base material, and the element of craft is giving way to product specialization. Yet whether traditional or modern, Kishū *shikki* remains a lacquer ware that can be used for many years until it takes on the worn appearance of its forebears.

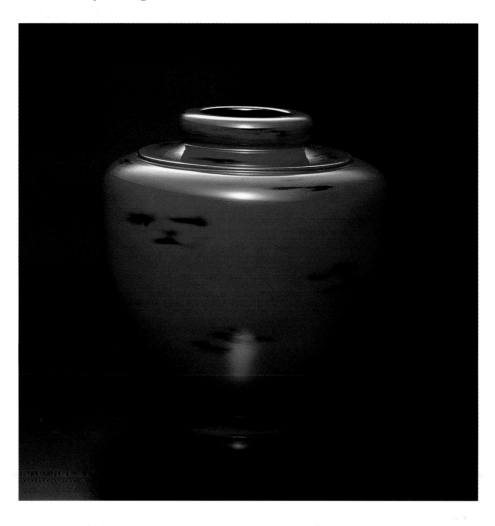

MURAKAMI CARVED LACQUER
Murakami Kibori Tsuishu
Murakami, Niigata Prefecture

Known in China as *ti hong*, the Japanese *tsuishu* is the technique of building up layer after layer of lacquer and then carving it. A related technique, *kibori tsuishu*, uses a piece of wood carving as a base on which to layer lacquer, and is associated with the castle town of Murakami, north of Kyoto.

Although the origins of Murakami *kibori tsuishu* are not clear, production is believed to have been carried out since the Ōei era (1394–1428), when lacquerers from Kyoto settled in the area to work on the building of temples. Much later on, during the Bunsei era (1818–1830), the foundations of modern Murakami carved lacquer were laid. Clan leaders traveled to Edo (present-day Tokyo) to study *tsuishu*. Distinctive carving techniques were developed by the master craftsman Ariso Shusai, and, in the Tenpō era (1830–44), Yabe Kakubei developed a method of applying lacquer with the fingertips.

The elaborate nature of the carving is one of the special features of Murakami *kibori tsuishu*. After the wood is shaped by a specialist woodworker, a carver employs small knives to depict traditional landscapes, flower-and-bird arrangements, or contemporary scenes. The lacquerer then takes over. Numerous layers of lacquer are applied, allowed to dry, and polished, prior to the final polishing of the top coat with a special oily clay.

A large range of carved lacquer articles is being produced in Murakami today. Some, such as trays, tea caddies, and coasters, are turned before carving. Chopsticks and boxes for inkstones show Murakami carving at its delicate best, while shelves, vases, and *tansu* chests gain a unique glow under the brilliance of this elaborate craft.

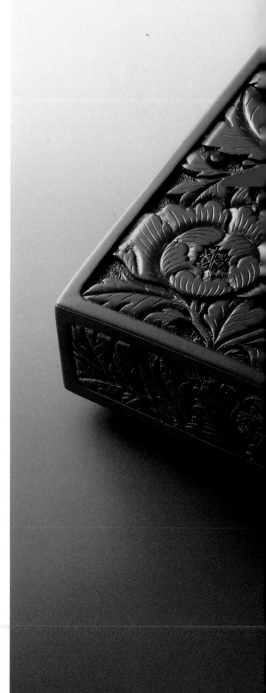

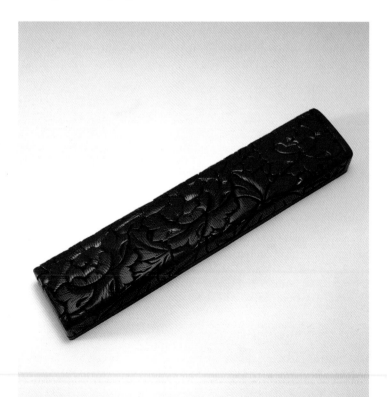

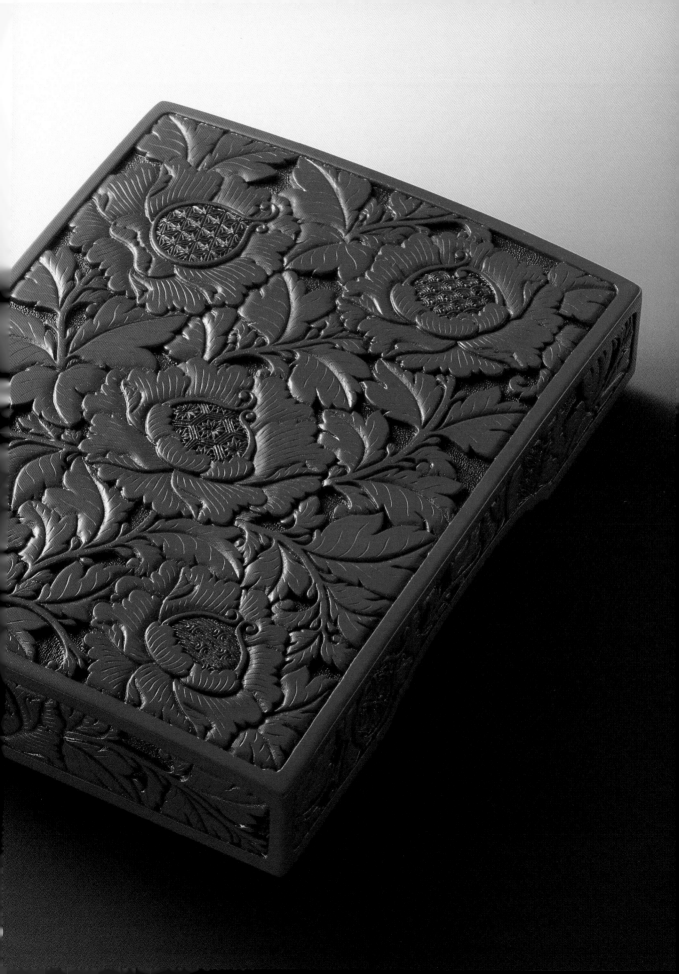

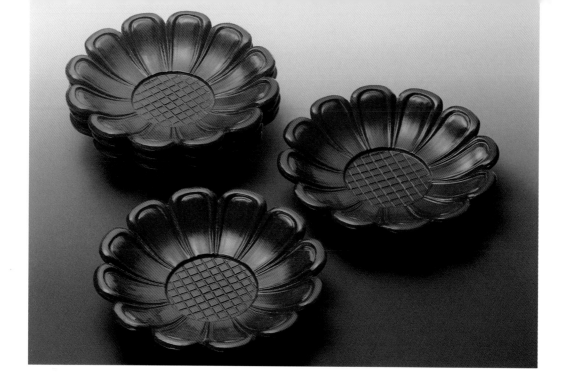

KAMAKURA LACQUER • *Kamakura Bori*

Kamakura, Kanagawa Prefecture

Kamakura was Japan's capital city during the period of the same name from the late twelfth to the mid-fourteenth centuries. Situated about 40 kilometers south of Tokyo, Kamakura is a great repository of history, famous for its many temples and shrines and its enormous *daibutsu*. Less conspicuously but of equal cultural importance, the town is also the home of Kamakura *bori* lacquer ware.

Kamakura *bori* is essentially a highly developed type of wood carving, the quality of which is enhanced by a coating of lacquer. Traditional work of this kind is found not only in Kamakura. Nikkō *bori* comes from the famous town of Nikkō in Tochigi Prefecture, Murakami carved lacquer ware from Niigata Prefecture, Takaoka carved lacquer ware from Toyama Prefecture, and Kagawa carved lacquer ware from Kagawa Prefecture in Shikoku.

Kamakura *bori* appears to have originated in religious carving done by specialist woodcarvers during the Kamakura period. (Original examples of this type of woodcarving can still be seen at two temples in Kamakura today—on a desk at Enkakuji temple and on a Buddhist image dais at Kenchōji temple.) Descendants of Buddhist sculptors who had come from Nara formed a group of skilled craftsmen in Kamakura, where they set about producing things needed at the great temples, including small pieces of furniture. Such work was to become prized for gifts among the upper classes in the late fifteenth century. The techniques used then have been handed down to the present day in two families of craftsmen

engaged in religious work—the Gotō family and the Mihashi family.

Originally, Kamakura *bori* was something that specialist woodcarvers engaged in during their spare time. But during the latter part of the nineteenth century and the beginning of the twentieth, it became a full-time job, and this laid the foundations of the industry. While each family of lacquerers has its own particular way of carving and applying lacquer, there are many people today who are attempting to use modern techniques—particularly since Kamakura *bori* is currently a popular hobby practiced throughout the country.

Although small pieces of furniture may be embellished by this technique of carving and lacquering, it is more commonly used for still smaller items. Trays, plates, coasters, hand mirrors, writing boxes, and inkstone boxes are the mainstays of production.

Several kinds of wood are used, including *katsura* tree (*Cercidiphyllum japonicun*), *hōnoki* (*Magnolia obovata*), Japanese cypress, and ginkgo. Carving is done with chisels and sculpting knives. Before undercoats are applied, the carved wood is primed with either raw lacquer alone or a rice paste. Two different kinds of undercoat are used—one a mixture of *urushi* and powdered charcoal, the other of *urushi* and clay (*tonoko*).

There are eight different kinds of final coat. The technique most often used today is called *hikuchi nuri*, whereby lamp black is sprinkled over wet vermilion lacquer to give an antique effect.

YAMANAKA LACQUER • *Yamanaka Shikki*

Kaga and Yamanaka-machi, Ishikawa Prefecture

All the principal types of lacquer ware in Japan have wood as their base material, and Yamanaka lacquer is no exception. In fact, Yamanaka ware began as uncoated woodcraft; only later did it develop into lacquer ware.

Woodcarvers settled in this part of Ishikawa Prefecture during the Tenshō era (1573–92), and began selling unlacquered ware to visitors to Yamanaka spa and Ioji temple. The technique of *sujibiki*—turned goods with uniform parallel lines—emerged in the mid-seventeenth century. In the Hōreki era (1751–64), lacquering techniques began to be introduced from other parts of Japan, and by the beginning of the twentieth century, Yamanaka *shikki* was well established as lacquer ware.

Since the end of World War II, competition from plastic goods has caused a decrease in production of most lacquer ware. In an attempt to compete, Yamanaka's lacquerers have pioneered the use of synthetic lacquers and fiberboards. But it is still the traditional techniques that attract the greatest following.

Most Yamanaka *shikki* are turned goods in the *sujibiki* style. There are four main types: *sensuji*, produced with a two-edged chisel; *inahosuji*, a series of lozenge shapes produced with a special plane; *tobisuji*, a series of nicks also shaped by a plane; and *hirasuji*, a line of projecting or receding wave forms.

Using various combinations of colored lacquers and undercoats accentuates the effects of turning. Common lacquering techniques include *mokumi tamenuri*, which enhances a wood's grain, and the colored applications *kuro nuri*, *shu nuri*, and *bengara tamenuri*. Woods that are suitable for turning are favored: zelkova, pine, birch, and Japanese horse chestnut.

Some *makie* is used for Yamanaka *shikki*. Yet in general most of this lacquer ware is simple in its feeling and enhances the natural beauty of the woods used.

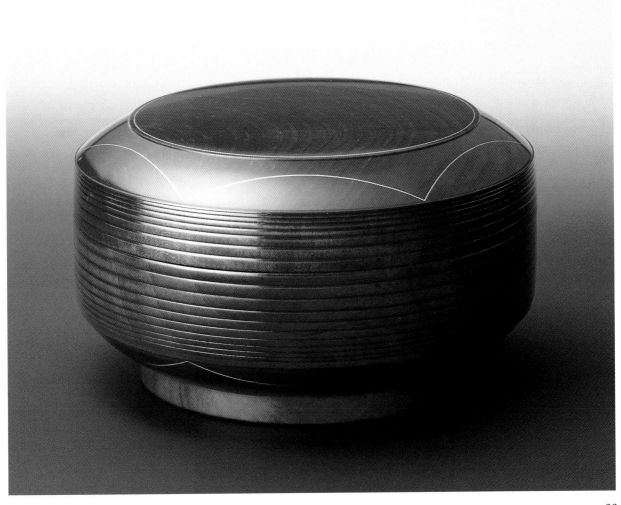

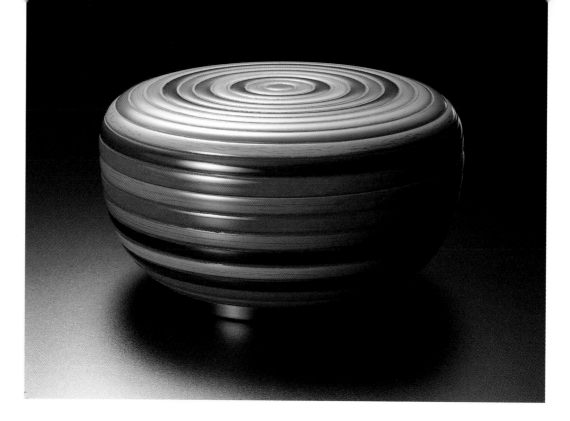

KAGAWA LACQUER
Kagawa Shikki

Takamatsu, Kagawa Prefecture

This lacquer ware from the island of Shikoku is also known as Sanuki lacquer. Whatever the name used, it refers to a number of types of lacquer ware produced in and around the city of Takamatsu—all of them somewhat different from the other types of lacquer art to be found in Japan.

The origins of this foreign-influenced lacquer ware go back to the year 1830. The lacquerer Tamakaji Zōkoku, who was then in the employ of the Takamatsu domain, completed a study of the lacquer ware of Thailand and China. Thereafter, he developed the decorative techniques that came to be known in Japan as *kinma*, *zonsei*, and *zōkoku nuri*. However, it was his brother, Fujikawa Kokusai, who succeeded in putting these wares into production during the latter half of the nineteenth century. At about the same time, Gotō Tahei developed the Gotō lacquer style.

Both *kinma* and *zonsei* wares are made with cores of woven bamboo—basketry, as it were. A variety of goods are produced in this fashion, including low tables, shelving, trays, various containers both for foods and flowers, and some decorative items. Wares made in the conventional manner are also produced.

Kinma is a kind of colored lacquer inlay common in Thailand and Myanmar. The undercoating process is complex, since many coats are needed to provide durable means of smoothing over the irregularities of a woven bamboo core. Undercoats of paste, *urushi*, and rough sawdust are applied. The final coat is covered with paper after it has hardened. To this paper covering is applied a layer of paste, lacquer, and fine sawdust. Fabric is spread over joints and edges for strengthening in the conventional way, and conventional undercoats of lacquer and whetstone (*tonoko*) are applied. These are burnished and then covered with a layer of raw lacquer, followed by a layer of black and various layers of colored lacquer. Only at this point are designs incised into the lacquered surface; these incised lines are later painted with colored lacquers. When it has hardened, the surface is burnished. Commonly, a *kinma* design is expressed in vermilion and perhaps yellow on a black ground.

The basic lacquering of *zonsei* is the same as for *kinma*, since it uses a woven bamboo base. The design is painted on the colored lacquer surface in black. After burnishing, "shadows" are painted into the design with colored lacquers. Clear lacquer is then applied. Parts of the design, such as outlines and veins of leaves, are highlighted by shallow incisions with a sharp tool. Gold is often used for emphasis. A final coat of clear lacquer is standard.

In the case of *zōkoku nuri*, the wood is carved and a primer of black lacquer is applied; this is then sprinkled with *makomo* (rice powder). After this is dry, lacquer is rubbed into the surface.

For the colorful *chōshitsu* technique, several layers of different colored lacquer are applied. The design is then carved into the lacquer to expose the different layers of color.

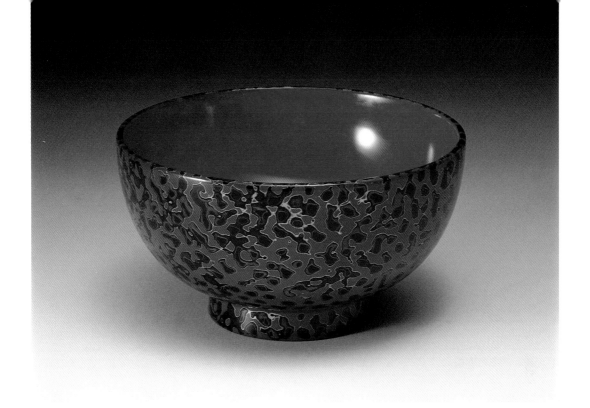

The Gotō lacquer effect is achieved by patting the surface of tacky vermilion lacquer with such objects as a sponge, a brush, or a tiny soft bag, or just the tips of the fingers. This textures the surface in an interesting manner. Another coat of lacquer is applied with a cloth.

Takamatsu itself, both when it was under the feudal system and since, has always afforded the lacquer ware industry much support, encouragement, and understanding. There is a publicly funded crafts school as well as a research and testing facility in the city. In 1950, the Takamatsu region received official designation as an important lacquer producing area, along with Aizu Wakamatsu (Fukushima Prefecture) and Wajima (Ishikawa Prefecture). Today, the Takamatsu region is producing some of the nation's very best lacquer ware, on a par with the excellent products of Wajima.

TSUGARU LACQUER
Tsugaru Nuri
Hirosaki, Aomori Prefecture

Layers of lacquer that create polychrome patterns are the signature of lacquer ware from the Tsugaru district of Aomori Prefecture, in northern Honshū. The style, which dates from the Edo period, is most frequently seen today in the spotted *kara-nuri* style.

The origins of Tsugaru lacquer ware can be traced to the second half of the sixteenth century and are attributed to the lacquerer Seikai Genbei. Sometime between 1661 and 1704, Genbei made a chance discovery. While burnishing down a work table on which various colored lacquers had accumulated, he noticed that a mottled pattern appeared. Thereafter Genbei worked to create the effect intentionally; objects displaying this polychrome mottling became known as Tsugaru *nuri*.

Various kinds of Tsugaru ware have developed over the years, yet the process remains the same as that discovered by Genbei. Several layers of different-colored lacquer, to which egg white has been added, are applied to the chosen surface using a perforated spatula. Rather than spreading the lacquer on as is the convention, Tsugaru craftsmen pat the lacquer on with the spatula, thereby creating different patterns and textures. The layers of lacquer are then burnished down to produce the characteristic mottled patterning.

Alternatives to this basic *kara nuri* process—still the most popular Tsugaru style—make use of millet, rape, or hemp seeds. In *nanako nuri*, the seeds are sprinkled over the still-tacky lacquer, and removed after one day. A different-colored lacquer is then applied to produce a pattern of small rings. Polychrome "brocade" patterns can be formed by painting frets or arabesques over these rings, in the technique known as *nishiki nuri*.

When it originated, Tsugaru ware was confined to such luxury items as scabbards and gifts for the shogun. Some lower-ranking samurai even took up the craft themselves during the late Edo period. Following industrialization during the Meiji period, Tsugaru techniques are now applied to a broad range of everyday items, including trays, bowls, chopsticks, and small pieces of furniture.

Bamboo Craft

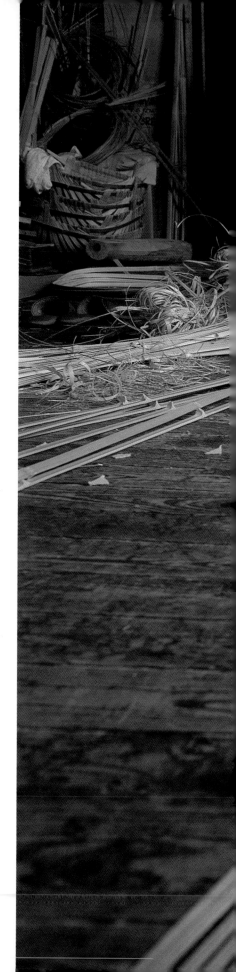

CHIKKŌHIN

Introduction

Bamboo could almost be called the perfect material. It is light, strong, extremely flexible, and has a hard, smooth outer skin. It is easy to work, and grows in abundance in many parts of Southeast Asia. Japan is particularly fortunate in having more than six hundred varieties, the many of which are well suited to basketry. The particular characteristics of bamboo make it difficult to craft and weave by mechanical means, so most of the work is still done by hand with simple tools. Although the work as such is relatively simple, it takes skill and experience to produce objects of beauty.

There are various kinds of bamboo crafts. Some depend on a particular type of bamboo; others depend on a particular way of processing. Generally speaking, however, basketry is the first thing that comes to people's minds. Baskets are woven from flat, narrow strips or constructed from round splints of bamboo. The skin is usually left intact, but material obtained from the thicker varieties can be used without the skin. In its familiar forms as cages for birds, stag beetles, and other insects, bamboo craft is relatively simple. However, the potential to form beautiful shapes and graceful curves is enormous, and innumerable things apart from baskets and cages can be made from it. "The question is, rather," as Basil Hall Chamberlain said, "what does it *not* do?"

Splitting the bamboo.

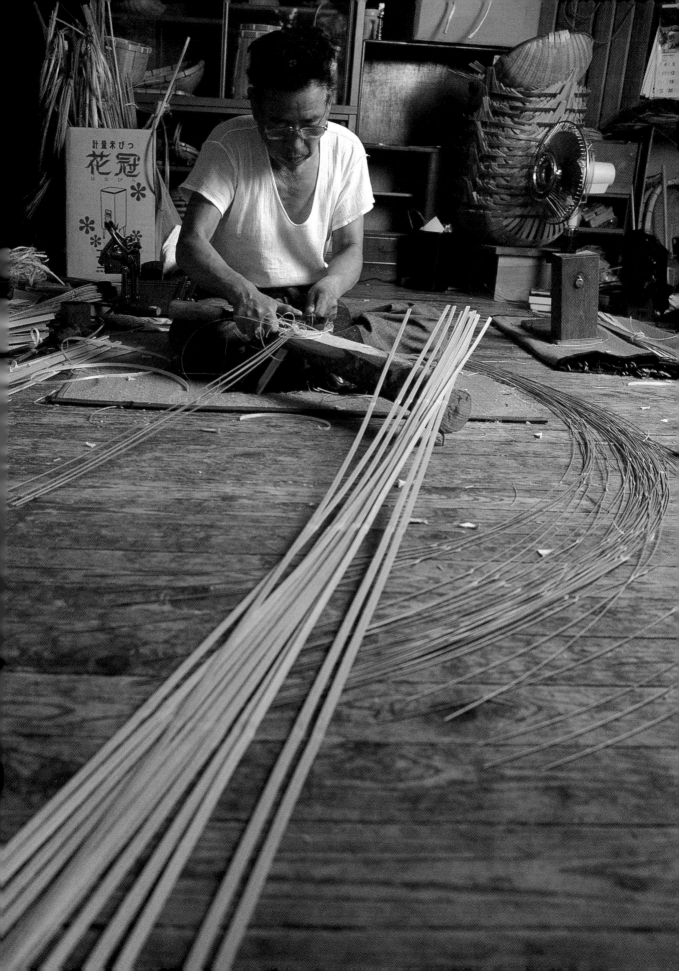

SURUGA BASKETRY
Suruga Take Sensuji Zaiku
Shimizu, Shizuoka Prefecture

In contrast with much of Japan's basketry, which is made from flat, narrow strips of bamboo (*hira higo*), Suruga basketry employs round splints without the skin shaved off (*maru higo*). The origins of bamboo craft in Shizuoka Prefecture can be traced back to ancient times, but what is known today as Suruga basketry got its start in the Edo period when samurai took up the craft to supplement their incomes. They made insect cages and confectionery containers to sell as souvenirs to the travelers who passed through Shizuoka on the Tōkaidō, the main route between the capital, Edo (now Tokyo), and the imperial seat in Kyoto. During the succeeding Meiji period the production of basketry developed into a major industry. Suruga bamboo ware was exhibited and highly praised at the 1873 World's Fair in Vienna; the attention it attracted led to the export of basketry to Europe. Today, modern articles such as lamp shades and other light fittings have assumed places alongside traditional items such as household basketry and bird and insect cages.

The main species of bamboo used in basketry are *madake*, *mōsōchiku*, *hachiku*, and *kurochiku*. The technical process comprises five principal steps: the making of the round splints, the forming of the framing rings, the bending of the splints, the assembling and gluing, and the finishing. To make the round splints characteristic of Suruga basketry, thin strips of shaved bamboo are pulled through a steel plate with a hole in the middle. After they are boiled and dried, the round splints are coerced into graceful curves by applying a heated iron—a technique that requires years of expertise. The bent round splints are then connected to bamboo framing rings in bird-cage fashion, but with a great deal more artistry. Sometimes the design calls for rows of delicate splints that overlap one another, but there is always rhythm and movement in the final form.

Bases and lids for Suruga basketry, if needed, are usually woven from flat strips of bamboo. The weave patterns most commonly used are a plain "twill" weave (*ajiro ami*) and one based on the hexagon (*nankin ami*). Lacquer or Japanese tallow is used for the finish.

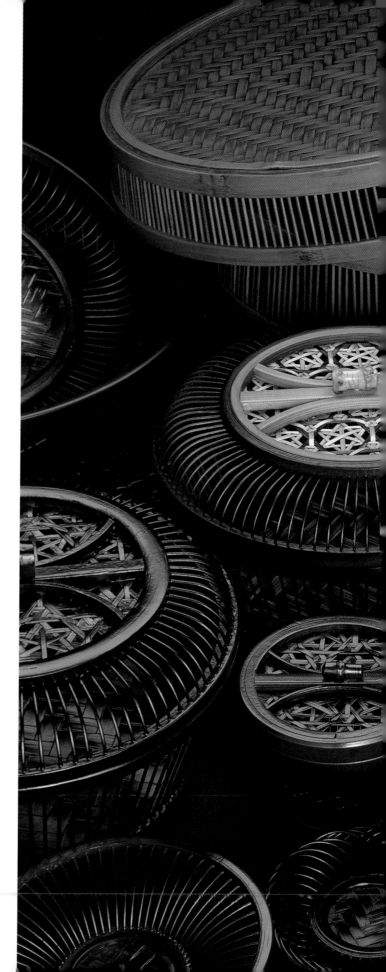

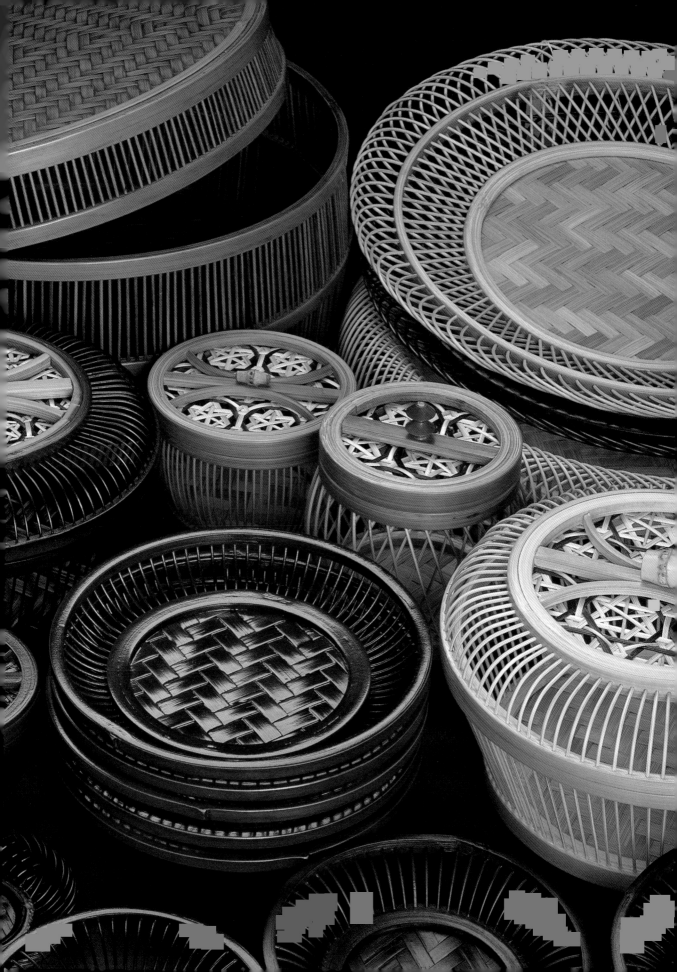

BEPPU BASKETRY • *Beppu Take Zaiku*

Beppu, Ōita Prefecture

Situated on the island of Kyūshū, Beppu has an abundance of raw material at hand. Basket-making in Beppu existed in ancient times, but it was the patronage of visitors to the local hot springs that stimulated craftsmen and provided an outlet for their work, which included household basketry as well as more artistic pieces. Over time, Beppu became widely known for its basketry, and what had started as a side business for farmers gradually grew into a full-fledged industry. This in turn led to the creation of some exquisite work by artists and highly skilled technicians. Great efforts were made to raise standards of design as well as to develop new products, and presently Beppu is the country's leading producer of bamboo goods.

Beppu bamboo ware can be generally classified into two groups: natural ware, which highlights the colors of the skin and black ware, which is dyed and lacquered. A tremendous variety of bamboo objects are being made in Beppu today, the largest proportion consisting of basketry that uses flat splints. The processing of the bamboo differs according to the article to be made, but with most baskets, the oils are removed by boiling the bamboo in a caustic soda solution, then the bamboo culms are sun-bleached, seasoned, and cut to appropriate lengths. The most prominent parts of the nodes are removed and, in some cases, the skin is scraped off.

The culms are then split lengthwise, sometimes with the aid of another piece of bamboo, but usually with a hatchetlike tool having a long, narrow blade. The internal membranes at the nodes are then removed. Flat strips of the required thickness are obtained by repeated splitting, and adjustments in width are made by drawing a strip between two blades stuck into a block of wood, or by using a special tool. In some cases the initial steps of splitting the bamboo can be done by machine, but the final splits can be done only by experienced craftsmen.

Apart from a plain weave, there are many other styles of weaving: hexagonal, octagonal, mat, chrysanthemum, wickerwork, and numerous combinations and variations of these. When the weaving is complete, the ends of the woven strips are finished off in one of three different ways: splitting the ends and forming an edge (*tomo fuchi*); fixing the ends from both sides (*ate fuchi*); or concealing the ends of the woven strips of bamboo by wrapping split rattan around them (*maki fuchi*). Feet or handles are attached as necessary, and baskets made of bamboo without its skin are often coated with natural lacquer after priming. The finest basketry from Beppu exemplifies the skill with which material of little intrinsic value can be converted into objects of extreme beauty.

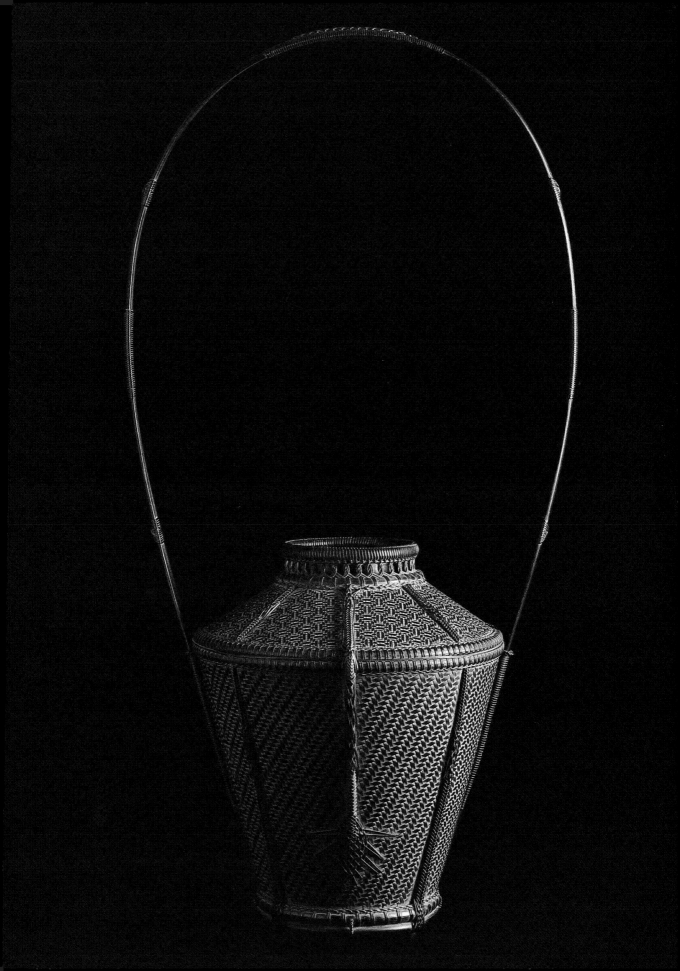

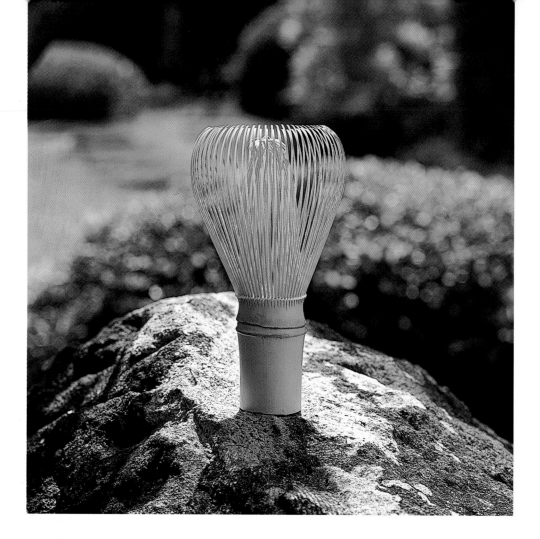

TAKAYAMA TEA WHISKS • *Takayama Chasen*

Ikoma,* Nara Prefecture

The adaptability of Japan's bamboo combines with the dexterity of its craftsmen to produce in the *chasen*—the whisk used in the tea ceremony to whip powdered green tea into a frothy, hot brew—one of the most exquisite types of bamboo ware in existence. It is not only beautiful to look at but superbly functional as well. A good tea whisk, for example, should produce a good froth on the surface of the tea; it should not splash the precious liquid; and it should by no means damage prized tea bowls.

Each school of tea has its own traditions and procedures calling for slight variations in utensils. In the case of *chasen*, differences are found in the length of the handles, the length and number of the splines, and the shape of the heads.

Chasen are made in Kyoto and Nagoya, but those made in Ikoma fill nine-tenths of the country's demand. There are four basic types of *chasen*, each for a different type of tea. The number of the splines ranges between 60 and 120, and the bamboo is either the light cream, sun-bleached type (*shiratake*) or the "smoked"

susudake variety, which is usually of *madake* bamboo that has also been bleached. After sun-bleaching and the removal of oils, the well-seasoned bamboo in its untreated state is cut to a particular size according to the type of *chasen* to be made. The skin of the portion that is to form the head is scraped off, then split into between 12 and 24 splines. These are then split again into alternating thick and thin splines, forming an outer ring (*sotoho*) and an inner ring (*uchiho*), respectively. The numbers of outer splines and inner splines are usually in a ratio of 6:4. Next, the splines are carved so that they are thinner toward their ends—a delicate process, peculiar to the *chasen*, known as *aji kezuri* (literally, "flavor-whittling"). A thread is then tied around the base of the outer splines, and the inner splines are arranged together in the center of the whisk. Finally, the ends of the splines are made to curl inward and adjustments are made to produce a perfect shape.

The *chasen* illustrates well the dilemma that a fine object of Japanese craftwork often presents—whether to use it, or just to admire it as a work of art.

MIYAKONOJŌ BOWS • *Miyakonojō Daikyū*

Miyakonojō, Miyazaki Prefecture

Bows have been used in Japan for many centuries, indispensable as weapons and symbols of power. The making of bows in Miyakonojō began when this old castle town came under the rule of the Shimazu daimyo family, which governed Satsuma from the end of the twelfth century. Local artisans began making bows to supply the constant demand from warriors who enjoyed *kyūdō*, the art of archery that is still practiced today. These craftsmen developed a tradition that subsequently became known throughout the country. After World War II, when the teaching of martial arts was banned at schools, the making of bows ceased almost completely. Today, however, *kyūdō* is viewed as a sport, and with the establishment of new archery grounds there is a steady demand for this traditional type of bow.

There are four types of plain-finished *shiraki yumi*, graded for use ranging from beginners to the most skilled archers. The main material is bamboo, but *hazenoki* (sumac) wood is also used. The bow itself is laminated, composed of a core and outer layers. In the first stage of production, the bamboo is prepared by being split into flat strips of the required width and having its oils removed. Once it is thoroughly seasoned, the skin is removed from the bamboo to be used for the outer layers. The surface of the bamboo for the core is then burned on both sides and planed to a standard thickness. The sumac for the core is seasoned, then similarly planed. Two strips of the charred bamboo are placed between three strips of sumac to form the core, and then laminated together with a glue made by boiling deerskin. Final adjustments in the thickness of the core are made by using a special hand plane before the outer layers of bamboo are laminated to the core with the glue. To finish, a plane is run over the surfaces to render them smooth, and if necessary a grip of rattan is wound around the bow in the appropriate place.

There are at present twenty-three master bow-makers at work in Japan, nineteen of them in Miyakonojō. While their customers are no longer the warriors and noblemen of old, popular interest in the art of archery will certainly keep them busy for many years to come.

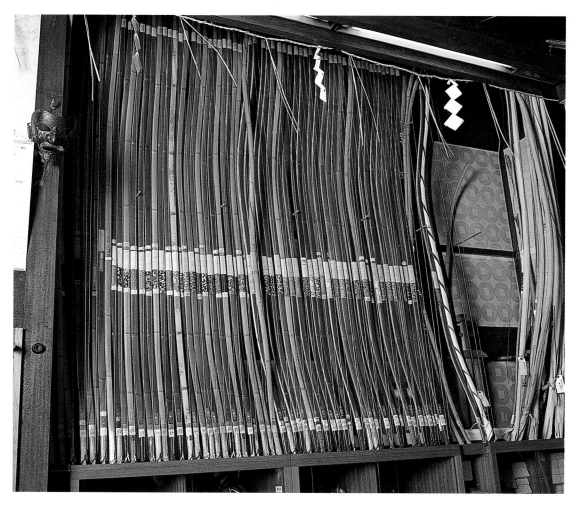

Japanese Paper

Introduction

The traditional handmade papers of Japan are collectively called *washi*, literally "Japanese paper," to distinguish them from papers produced elsewhere. Paper was invented in China, and the technology was introduced to Japan via Korea by the sixth, perhaps as early as the fifth, century. At first, production was centered in the capitals to meet the growing demands of Japanese government officials and Buddhist temples, but from the eleventh century on it shifted to those rural provinces where abundant supplies of the necessary raw materials were available. Much of Japan's *washi* continues to be made in historic papermaking regions.

Papermaking has long been a family occupation in Japan, and in some areas entire villages are involved. It was traditionally carried out during the winter months, in between the harvesting and planting seasons. Paper is made in many different areas of Japan, with only slight variations in the basic methods. The principal raw materials are bast fibers, taken from the inner bark of the *kōzo* (paper mulberry), *mitsumata*, and *ganpi* shrubs, although hemp, bamboo, and rice straw are also sometimes used. Western-style papermaking using wood pulp was not introduced to Japan until the second half of the nineteenth century.

Ganpi bark can be stripped directly from the branches, but *kōzo* and *mitsumata* must be steamed before the bark can be removed. The bark is then dried for storage. To prepare the bark for papermaking, it must be soaked in water and the dark outer bark scraped away. The bark is then cooked in a strong alkaline solution to release the starches and fats. The fibers are next washed until clean and impurities are meticulously removed. The resulting white fiber is beaten to further loosen and separate the fibers, which are then put into large papermaking vats filled with water. A formation agent (sometimes referred to as mucilage) is normally added. This serves to keep the fibers suspended in the water, to slow down the drainage of water from the mold, and to allow newly formed sheets to be stacked, pressed, and separated without the use of interleaving felts as in Western papermaking. The most commonly used formation agents are extracted from the *tororo-aoi* (*Abelmoschus manihot*) and *nori-utsugi* (*Hydrangea paniculta*) plants.

The Japanese papermaking mold generally consists of a hinged wooden frame enclosing a removable screen of bamboo splints, although molds can also be made of reed, metal, or gauze. Many papermakers employ the *nagashisuki* method in which the contents of the vat are

stirred until the fibers are evenly dispersed. The mold is dipped into the vat and then lifted out and rocked rhythmically back and forth so that the fibers intermesh as the liquid drains away. Thin, even sheets are particularly difficult to form. Further dips of stock may be added to increase the thickness of the sheet, and excess stock can be thrown out of the mold when the required thickness has been achieved.

Another method called *tamesuki*, similar to that used in Western papermaking, is employed less frequently. The mold is first dipped into a vat and lifted out full of stock. The papermaker then skillfully shakes the mold, causing the water to drain off and the fibers to settle evenly on the screen. In both methods, the screen is removed from the mold and the tender, wet sheets are placed one on top of another in a stack. The stacks are then slowly pressed to drain away excess water, after which the sheets are separated and dried by one of two methods. In the method called *itaboshi*, the wet sheets are brushed out on wooden boards, which are then stood outside to let the paper dry in the sun. The other method is called *teppan kansō*, whereby the sheets of paper are brushed onto hot metal plates that are then heated with steam or electricity.

In addition to paper for writing and painting, *washi* is used for a diversity of things including fans, lanterns, toys, sliding *shōji* panels, and even clothing. Unlike most mass-produced Western-style papers, it has a subtle beauty and tactile richness that have earned it international acclaim. Over the centuries, papermakers in different prefectures have developed local variations of *washi*, some of which are discussed below.

Dipping the mold into a vat of stock.

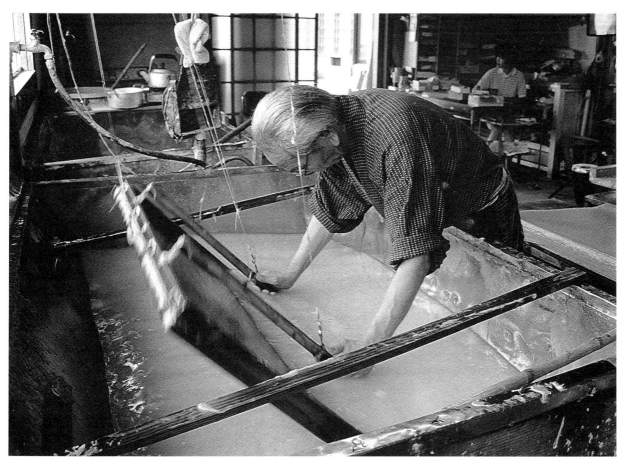

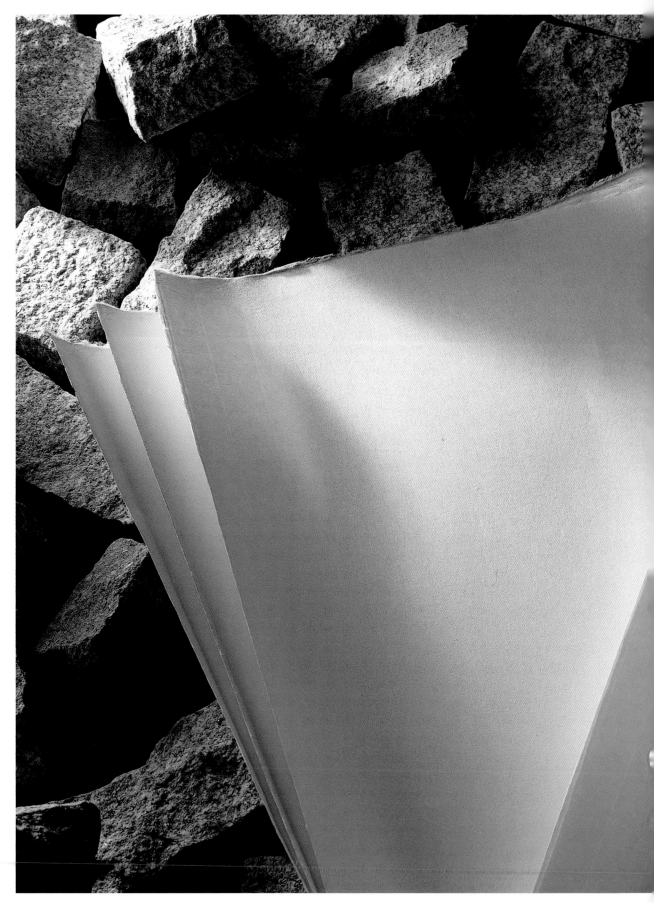

ECHIZEN PAPER
Echizen Washi
Imadate-chō, Fukui Prefecture

Papermaking in Fukui Prefecture historically has been closely connected with the ruling authorities, perhaps because of its proximity to Kyoto. The *Engishiki*, a collection of fifty volumes on official procedures and ceremonies compiled in 927, records that paper from Echizen was at that time being supplied to the court. By the Muromachi period, much of the paper on which official orders (*hōsho*) were written was made in Echizen. Paper-making came under the protection of Ōtakiji temple, and a *kamiza*, or paper guild, was established. Some of the region's most distinctive papers were developed during the feudal period. As official ties continued, the Tokugawa government gave its approval for paper from Echizen to be stamped with a seal signifying that it was used by the shogunate. At the end of the nineteenth century, paper for official bank notes was made in Echizen, and during the late 1920s and early 1930s, Imadate-chō also supplied paper for the bills of the Joint Chinese Reserve Bank. In 1951, the Ministry of Finance began to commission paper for bank notes, and to this day, paper from Echizen is still part of the country's official operations.

The wide range of *washi* currently produced in Echizen includes paper for sliding door panels (*fusuma*) and wallpaper, special papers for calligraphy and painting, fine-quality papers for official documents such as bonds and checks (*kyokushi*), and various other forms of stationery and envelopes. Decorated papers dyed a range of colors and patterns—some displaying designs harking back to the Heian period—are also made in Echizen.

Echizen papermakers employ all of the traditional raw materials: *kōzo*, *mitsumata*, and *ganpi*. No formation agent is used in the production of the *kyokushi* official papers, which are produced by the *tamesuki* method in molds with metal net screens. The *nagashisuki* method is employed for all the other papers. The formation agent is *tororo-aoi* and the screens are made of either bamboo or gauze.

Because of its long history of association with Japanese authorities, Echizen *washi* could almost be called part of the establishment. It nevertheless produces a fine range of Japan's most traditional papers.

AWA PAPER • *Awa Washi*

Yamakawa-chō, Tokushima Prefecture

It is said that the origins of Awa *washi* can be traced back to the Nara and Heian periods, to the paper made by people of the Inbe clan who inhabited Tokushima at the time. This clan was in charge of imperial court ceremonies. There is a shrine in Tokushima today named Inbe Shrine in which Amenohiwashi no Mikoto is enshrined as an ancestral god of paper. A document dated 774 records that Awa had failed to make a payment of some 40 *kin* (approximately 24 kilograms) of hemp, which was used for making paper. It is therefore assumed that papermaking was being carried out in this region by this time.

Papermaking seems to have spread rapidly along the banks of the Yoshino River after the construction of two temples near the river's mouth. As one of the earliest centers of production, the paper industry here seems to have contributed to the advancement of papermaking further afield in Shikoku. In an effort to develop agriculture in his domain, the feudal lord of Awa encouraged the cultivation of *kōzo* for papermaking along with tea, indigo, and mulberry for silkworms. Under strict regulation, the manufacture and retailing of paper in this area continued to develop, bringing an increase in the variety of papers available.

The raw materials used for Awa *washi* are *kōzo*, *mitsumata*, and *ganpi*. The formation agent is *tororo-aoi* or *nori-utsugi*. The mold screens are made of either bamboo splints or reeds, and the paper-forming method is *nagashisuki*. If a paper is to be dyed, the paper stock is put into a dye vat before being formed.

Some calligraphy, craft, and painting papers are being made today, yet much of the production in the Saji mills consists of printing, publishing, and wrapping papers. The indigo-dyed paper of Awa, however, is definitely the most distinctive of the Yamakawa-chō output.

TOSA PAPER • *Tosa Washi*

Ino-chō, Kōchi Prefecture

Of all the traditional craft papers in Japan, Tosa *washi* is perhaps the most famous. As in the case of other Japanese papers, its origins are unclear, but the *Engishiki* relates that paper for religious purposes (*hōsho gami*) and a similar *kōzo* paper named *sugihara gami* were supplied to the court by this region. It therefore seems safe to assume that paper was being made here by the tenth century at the latest. The origins of colored Tosa paper are better documented, for it is recorded that Akı Saburōzaemon successfully produced some dyed papers around 1592. Recognizing the importance of the local papermaking industry, Yamanouchi Kazutoyo, who became daimyo of Tosa in 1601, lent his protection and actively encouraged its production as the "clan paper." The export of colored paper outside the domain was prohibited.

Papermaking continued in the traditional vein until a method of producing large sheets was invented in 1860. This led to the making of paper in large quantities and the creation of various other papers, including a resinous paper for writing with fountain pens that does not smudge, paper for postage stamps, and a paper suitable for map making. The techniques developed in Tosa were passed on to papermakers in other regions. Tosa is also the hub of papermaking machinery and tools, as well as a supplier of the raw materials needed for making *washi*. In addition, more than half of the people presently producing screens and molds work in Kōchi. The thread and the bamboo splints necessary for making the screens are made nowhere else. In sum, Tosa has played a major role in the development of Japan's papermaking industry, and seems likely to lead the way for many years to come.

All the paper made in Tosa is characterized by its fine-quality *kōzo*. *Kōzo* is not the only raw material used, however. In addition there are *mitsumata* and *ganpi*, as well as hemp, bamboo, and rice straw. The formation agent is either *tororo-aoi* or *nori-utsugi*, and the screens are made of bamboo, reeds, or gauze. Tosa paper is formed by both the *nagashisuki* and *tamesuki* methods.

A vast range of papers is still being produced in the area. Some, like *shōji* window-screen paper and calligraphy paper, are of a traditional nature. Others are designed for more contemporary uses, such as fine-quality printing and gift wrapping.

UCHIYAMA PAPER • *Uchiyama Gami*

Iiyama, Nagano Prefecture

The history of making Uchiyama *gami* extends back to the late seventeenth century. By 1698 there were already more than twenty papermakers in the area, and the numbers increased steadily to the beginning of the eighteenth century. The method of production remained more or less unchanged up until the end of the Edo period, but in 1872 bamboo screens came into use, and from 1902, paper-forming techniques introduced from Tosa (Kōchi Prefecture) were applied for making sheets two and four times the size of a standard sheet. Further improvements during the 1920s made it possible to form sheets six and eight times larger. The introduction of such machinery as stampers, hollander beaters, and compressed air machines started before World War II, and after the war papermakers began to use chlorous acid ($HClO_2$) in bleaching.

Uchiyama *gami* is particularly noted for its strength. Only *kōzo*, which grows profusely in the surrounding mountains, is used. Iiyama's abundant streams, clean air, cold winter temperatures, and heavy snowfall also play important roles in the formation of this paper, which is made by the *nagashisuki* method. Techniques unique to the papermaking of this region include freezing the bark fibers by laying them out on the snow, and snow bleaching (*yukizarashi*), which imparts a soft whiteness to the sheets. Iiyama's white, translucent *shōji* paper is perhaps the best known, but paper for important records and documents is also produced in this region, along with special papers for calligraphy and accounting books.

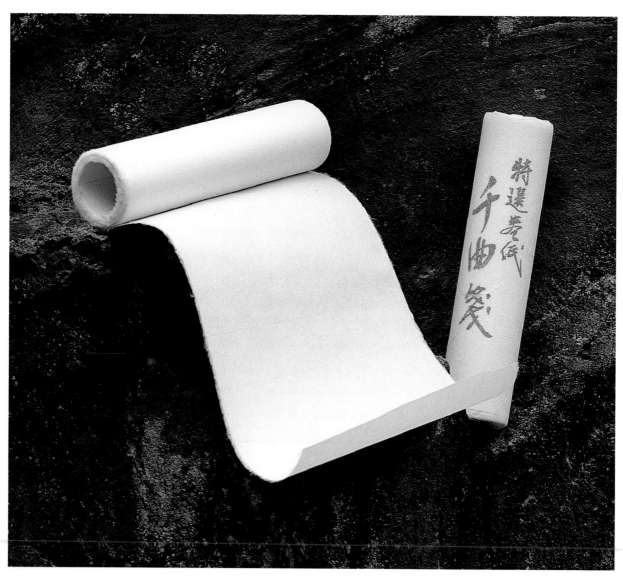

INSHŪ PAPER • *Inshū Washi*

Village of Saji, Yazu-gun, Tottori Prefecture

Although the *Engishiki*, the tenth-century publication on official protocol, recounts that the court was being provided with Inshū paper, the early history of papermaking in this region is not completely clear. According to Edo-period records, paper was made here for the local feudal lord—first at Aoya-chō from 1624, then in the village of Saji from 1726. The range of Inshū papermaking expanded during this period by adapting technologies introduced from Echizen (Fukui Prefecture), Mino (Gifu Prefecture), and Harima (Hyōgo Prefecture). Production continued to increase, and at the beginning of the twentieth century the prefectural government moved to develop the local industry further by inviting a papermaking specialist from Tosa (Kōchi Prefecture) to provide instruction in new techniques. As papermaking became modernized, Inshū *washi* won recognition as a fine-quality paper. Some mechanized equipment was introduced after World War II, but papermakers switched to making fine-grained artists' papers in 1954.

Inshū papermaking employs the basic raw materials of *kōzo*, *mitsumata*, and *ganpi* and the *nagashisuki* method. The formation agent is *tororo-aoi* and either bamboo splints or reeds are used for the mold screens.

In addition to art and craft papers, special papers for important records and documents as well as wallpaper, paper for *fusuma* sliding screens, translucent paper for *shōji*, and some colored papers are produced. Calligraphy paper as well as regular stationery and envelopes are made in the mills in Saji. Among these it is the artists' papers that are the most distinctive, especially one known as Inshū *mitsumata* paper.

Woodcraft

Introduction

There is a uniquely unpretentious textural quality to Japanese wood, especially when compared to some of the figured hardwoods from Southeast Asia. As a material, Japanese wood has an unmatched warmth and responsiveness, and the large number of traditional woodcrafts it has inspired have found a correspondingly special place in the Japanese heart.

A number of distinct ways of handling wood can be singled out for attention. What are known as *sashimono* (literally, "assembled items") are, in the broadest sense of the term, small pieces of furniture and other household articles assembled by jointing together a number of components. By a stricter definition, *sashimono* are objects assembled from boards of wood, rods of wood, or combinations of the two. The craftsmen who make *sashimono*, known as *sashimonoshi*, were originally makers of standard pieces of furniture. During the second half of the seventeenth century they came to be recognized as a distinct group, separate from the craftsmen who made architectural fittings such as *fusuma*, windows, and other removable items, or from the architectural carpenters such as the *miya daiku*, who were mostly concerned with building wooden temples and shrines. More often than not, the term *sashimono* is used today in its more narrow sense, but in the case of Kyō *sashimono* the more general meaning is understood.

Other techniques include *hikimono*, articles that are mostly turned on a lathe, and *magemono*, which are produced by bending wood. At a more conventional level, many woodcarvers produce what are known simply as *horimono*, or "carved goods."

The techniques used to carve sculptures and patterns in wood probably developed in Japan following Korean models. By the beginning of the Heian period, the carving of wooden statues in Japan was being carried out as a matter of course. Over the centuries, the art and techniques of woodcarving developed and expanded to include such items as *netsuke* and Noh masks, as well as architectural decorations. Like other crafts, carving too had its master craftsmen. In recent years, however, demand for quality craftwork has decreased as new and economical materials have become more readily available. Most of the work done in wood today is thus of an artistic nature: other than the repair of old pieces and the making of religious statues and other paraphernalia, contemporary craft-oriented woodcarving is applied to things that will

become forms for lacquer ware, ornaments, or decorative architectural fittings. The last-named most frequently involves the carving of *ranma* (transoms).

While most techniques of tree conversion and many ways of finishing wood used in Japan are similar or identical to those used in other parts of the world, one method of preparing wood is worthy of special mention. Called *masame dori*, it is roughly equivalent to quartering or quartersawing. Put simply, this yields wood with straight grain. Boards and planks of wood are usually obtained by plainsawing across the grain, exposing the annual rings as wavy lines on the surface of the cut pieces; in Japan this method is known as *itame kidori*. By contrast, *masame dori*, or *masame kidori*, produces wood in thin and relatively narrow strips by cutting or splitting them in a radiating pattern, quite often from a short log. The word *masame* itself really refers to the close, straight grain obtained. Such quartersawn or split wood expands and contracts equally in all directions and is therefore less likely to warp.

Joinery, as practiced by the cabinetmakers, woodworkers, and carpenters who construct buildings in wood, is almost an art in its own right. There are literally dozens of ways of joining wood, some of which produce what look more like puzzles than joints. In reality these are ingenious adaptations of the same or similar kinds of joints used by craftsmen the world over.

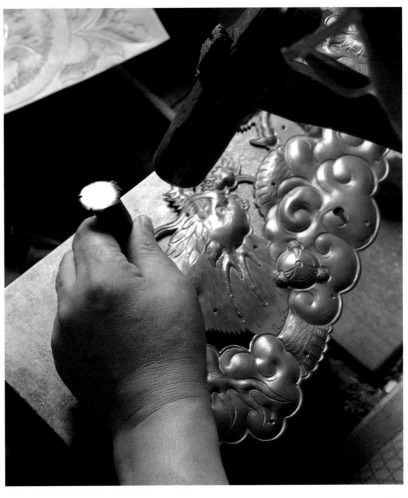

Hammering out the design on metal fittings for an Iwayadō chest.

IWAYADŌ CHESTS
Iwayadō Tansu
Morioka and Esashi, Iwate Prefecture

Japanese furniture as a whole is not especially well known abroad, however the traditional *tansu* is not only known but eagerly sought after. Iwayadō *tansu* are particularly prized for both the beautiful grain of the zelkova wood and the lacquer-coated metal fittings on their surface.

Such *tansu* were originally used as safes, and even today they have a lock. In the past, the chests would have occupied the lower compartment of the special cupboard where foldaway bedding was stored during the day. Another type sat firmly on a palette fitted with wheels so that the chest and its contents could easily be

wheeled in and out of a storehouse, or moved to a safe place in the event of fire.

The Iwayadō-style *tansu* is said to date back to the end of the eighteenth century, around 1783. Until the end of the nineteenth century, the same style continued to be made in this northeastern corner of Japan in the traditional manner, with one person doing all the woodwork and metalwork necessary; after this, there was some division of labor between metalwork and lacquerwork specialists. Production, mainly for the agricultural community in the southern part of the prefecture, reached its highest levels in the first two

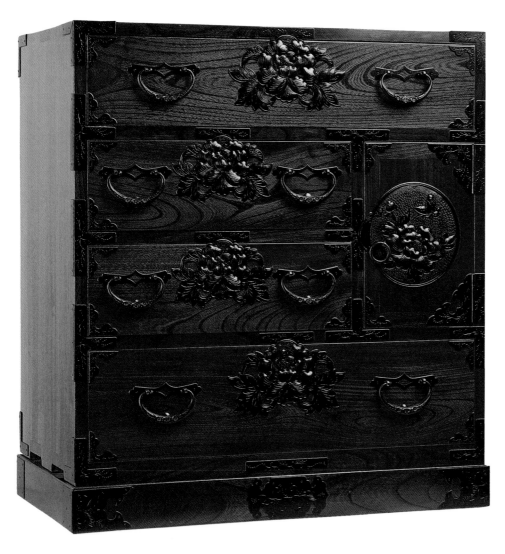

decades of the twentieth century. Since then, Iwayadō chests have been in demand throughout Japan and, more recently, have been exported.

Although similar in feeling to those made in Sendai, in neighboring Miyagi Prefecture, the chests of Iwayadō are simpler in appearance, as are the other pieces of furniture produced today such as sideboards, tables, and ornamental shelves. Nevertheless, the chests in particular retain their strong-looking metal fittings and all-round solid appearance.

Zelkova and paulownia are used for drawer facings, doors, tops, and visible panels; cypress and paulownia for other, less visible parts. Instead of metal nails, wooden pins are employed. The wood is finished with lacquer. The metal fittings are cut and shaped by hand from steel, sometimes from sheets no more than a millimeter thick. They too are given a coat of natural lacquer, which is warmed until it smolders and turns black to create the vivid contrast so characteristic of these appealing chests.

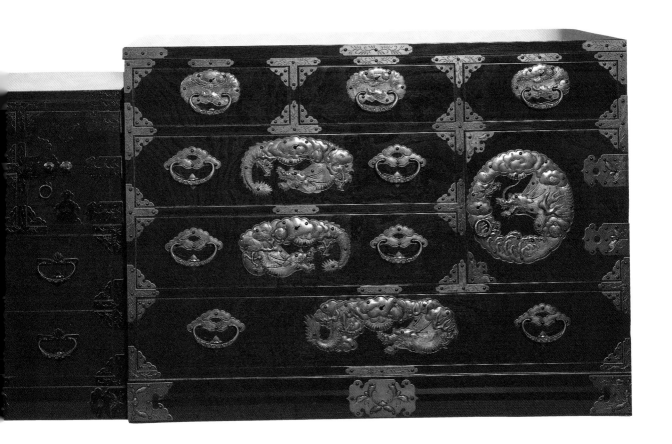

KAMO PAULOWNIA CHESTS
Kamo Kiri Tansu
Kamo, Niigata Prefecture

For many Japanese, paulownia wood (*kiri*) is synonymous with traditional chests. In the past, a paulownia *tansu* was an essential part of a bride's dowry; indeed, it was customary to plant a paulownia sapling when a baby girl was born to ensure that she would have a *kiri tansu* when she became a bride.

Paulownia wood is blessed with a beautiful, straight grain, together with a warm color and appealing texture. Particularly light in weight, it is not subject to warping like some other woods, and is also easy to care for. What is more, old wood can be restored so that it looks as good as new—a definite advantage in the case of an expensive and perhaps sentimentally valuable *kiri tansu*.

Kamo, a city in the center of Niigata Prefecture with a traditional atmosphere sometimes likened to Kyoto's, is the country's number-one production center for *kiri tansu*. It has always had an abundance of natural paulownia to support the industry, which started in the late eighteenth century but only became known nationwide toward the end of the Edo period. By the end of the nineteenth century, the industry was thriving, and during the 1910s and 1920s production reached unprecedented levels.

The boards chosen vary in thickness, but all are of solid paulownia. Since *kiri* boards are narrow, they must be jointed together to achieve sufficient thickness for building a chest. To do this, Kamo craftsmen use pins fashioned from the stem of the Japanese sunflower, *utsugi* (*Deutzia scabra*), which are driven in at an equal depth to both boards being joined. The tops and shelves are usually more than 19 millimeters thick, but back panels and the bottoms of drawers are normally no thicker than 7 millimeters. Depending on the pieces of the chest to be joined, a variety of joints are employed: ox joints, tenon joints, and wooden pegs, but never nails. Fittings of copper, copper alloy, or steel are attached. To finish, the surfaces are polished with an *uzukuri*, the end of a bundle of straw, then the wood is given a coating of *yashabushi*, a liquid made by boiling the seeds of the *yamahan* (Alder family; *Alnus hirsuta* var. *sibirica*). Finally, the wood is polished with wax—ending a processing of surprising simplicity for what is, when completed, one of Japan's most refined pieces of furniture.

KYOTO WOODWORK • *Kyō Sashimono*

Kyoto

This beautiful work, closer in feeling to an artwork than to a simple piece of furniture or joinery, can be broadly divided into two types. *Chōdo sashimono* includes various types of furniture and household goods, such as chests (*tansu*), shelving, desks, storage for stationery, various kinds of boxes, trays, freestanding screens, and light fittings. The other group, *sadō sashimono*, comprises a number of small items of furniture and utensils used during the tea ceremony. This group in fact comprises objects that are true *sashimono*, such as shelving, simple boards, and trays, water containers, and other items made of wood bent into shape (*magemono*), and some turned items (*hikimono*). There are also carved articles (*horimono*) and similar items called *kurimono*.

Typical woods used are Japanese cypress, zelkova, paulownia, mulberry, cherry, and Japanese cedar. It can take anything from two to ten years to naturally season and process the wood. Particular care is taken to ensure that paulownia is rid of all its impurities before it is used.

Methods of jointing and decoration employed for *chōdo sashimono* are largely laid down by convention. In the case of *magemono* posts and bowls, wood with a fine, straight grain is needed. It is bent either by making a series of saw cuts in the back of the part to be bent or by steaming the boards first to render them flexible. Carved pieces (*horimono, kurimono*) are fashioned from one piece of wood. In the case of *sadō sashimono* bowls, bamboo is used for pinning joints; otherwise Japanese sunflower (*utsugi*) is used. Metal fittings are of copper, copper alloy, gold, silver, or steel.

The finish applied to *sashimono* depends partly on the type of wood used. Chinese wax (*ibotarō*) is used to polish pieces made of paulownia. With mulberry, however, the color is first brought out with lime, then the wood is wiped with oil or lacquer. Lacquer is also used for zelkova, but for other woods either scouring rush (*tokusa*) or the leaf of the *muku* is used to polish the wood. Decorative techniques employed include painting with lacquer or pigments, *makie*, marquetry, gilding, and the use of gold and silver powders or gold and silver paints.

Undoubtedly, the influence of the tea ceremony and its aesthetics on *sashimono* has been considerable. These finely crafted pieces of furniture are in a sense an expression of the tea spirit and sensibility, reminiscent of the controlled stylization of the ceremony itself.

ŌDATE BENTWOOD WORK • *Ōdate Magewappa*

Ōdate, Akita Prefecture

Generally speaking, the natural plasticity of wood can be increased either by steaming or by making a series of cuts with a saw on the inside of the section that is to be bent. In Japan, the former technique is usually applied. Some *magemono* (bent pieces) are used for furniture, but more often they are small pieces that make use of the attractive grains and textures of Japanese cedar, Japanese cypress, white cypress, and fir. When preparing *magemono* the wood is first quartersawn or split into narrow boards to expose the straight grain. Each board is immersed in boiling water for up to ten minutes, then removed and bent around a template of firm canvas. The process is repeated many times before the board is pegged into shape and left to dry. After several days, the bentwood is able to be worked.

The *magemono* from Kiso (in Nagano Prefecture) and Akita are very well known. Ōdate, in particular, is famous throughout Japan for its *magewappa*. *Wappa* is a local variant of *menpa* or *meppa*, the word for a bentwood lunch box. The elegant simplicity of Ōdate lunch boxes is enhanced by the scent of the wood, which mingles with the aroma of rice to create a very special meal.

In Akita, this particular style of bentwood box is believed to have been in existence for more than a thousand years. The abundant local supply of cedar has always sustained a lot of woodcraft, work that can be done during the long, cold winters when labor outside becomes impossible. From the early seventeenth century, however, the lower-ranking samurai of the clan were encouraged to take up the making of these bentwood boxes as a way of supplementing the rather meager budget of this rural province. Eventually, instruction in the making of *magewappa* came to be given with the full support of the clan, and in the early nineteenth century, the making other products began.

Demand for *magewappa* dropped after World War II, but it gradually recovered as a result of efforts to modernize production methods without destroying the handmade quality of the goods. Other goods being made today that utilize the bentwood principle are a kind of slop basin (*kensui*) used in the tea ceremony, a basket (*seiro*) for steaming rice and other foods, a container for saké known as a *tokkuri hakama* used on official or auspicious occasions when saké is presented as a gift or offering, and a variety of trays, coasters, and bowls with lids for small Japanese-style cookies and cakes. The *magewappa*, however, remains the most representative and sought-after example of Ōdate bentwood.

AKITA CEDAR BOWLS AND BARRELS
Akita Sugi Oke Taru
Akita, Akita Prefecture

Taru—barrels or kegs—are containers for storage, usually of liquids such as saké and soy sauce. *Oke*—tubs, bowls, or pails (often with a handle)—are frequently used for making Japanese pickles or as general kitchen utensils; they are washed out after use and put aside until needed again.

Both the bowls and the barrels are round and made from a number of narrow slats of wood fixed on a circular baseboard; both also use the same essential technique for assembly. Without use of any adhesive, a number of staves (*kure*) are bound tightly together with a *taga* or band, which is made either of interwoven strips of bamboo or of copper. Two or more bands are necessary for an *oke*, four or more for a *taru*. The bottoms of the *kure* are simply slotted into the baseboard: a perfect fit is essential if the finished article is not to leak.

Despite the similarities in assembly, there are significant differences in the choice and preparation of woods used for *oke* and *taru*. The Japanese cedar chosen for the former is usually of the fine-grained *masame* type, while that for *taru* is of the *itame* type. When they are cut, the staves for *taru* are made to taper at both ends, providing the requisite strength in the middle of the barrel; staves for *oke* are of uniform width. Finishing varies according to the craftsman's preference. The most usual finish is a light coating of wax, but sometimes persimmon juice is used, or *urushi* is applied in the *tame nuri* method.

Even though many of the bowls in particular have a utilitarian purpose, the cedar used in Akita woodcraft has a lovely grain and a scent that flavors the stored objects, endowing these containers with a lasting aesthetic appeal.

HAKONE MARQUETRY • *Hakone Yosegi Zaiku*

Odawara and Hakone-machi, Kanagawa Prefecture

The art of marquetry has a long tradition in Japan. Wood craftsmen living in the area of Yumoto, in the foothills of Hakone, have been carrying out the art for hundreds of years. The mountains of Hakone rival Arashiyama in Kyoto or Hōki-daisen in Tottori Prefecture in the abundance and variety of trees that they offer craftsmen. Marquetry pictures and other small items have over the years become a valued purchase for passing travelers or visitors to the local hot springs. The craft, originally known as Yumoto *zaiku*, has been loosely referred to as Hakone *zaiku* since the end of the nineteenth century.

Hakone marquetry is based on geometric designs that can combine upward of fifty patterns of different-colored woods. After selection, these woods are sawn or split, then thoroughly dried and seasoned over a period of months. Various of these sheets are next bonded together with a synthetic or animal glue to make unit patterns, then cut and reassembled in a block to form *taneita* mosaic patterns. By planing extremely fine cross sections from the block—a delicate and demanding process—the craftsman obtains the end-grain veneers (*zuku*) for the marquetry. Once they have been backed with paper, these veneers are applied to the base wood of the utensil or accessory.

The geometric line patterns on the *taneita* can be either bilaterally symmetrical or spread out in a patchwork of totally symmetrical forms. Apart from *taneita* that have been made by joining pieces of wood together at a chosen angle, less systematic effects are also possible. *Midare yosegi* has pieces joined at various angles at random, while *suji yosegi* is the reversal of pieces in a line. Typical patterns used are a check (*ichimatsu*), a twill-like weave (*ajiro*), grinds (*kōshi*), boxes (*masu*), scales (*uroko*), and a hemp-leaf pattern (*asanoha*), but these are only a few of the many hundreds of variegated patterns that can be created in this intricate and appealing craft.

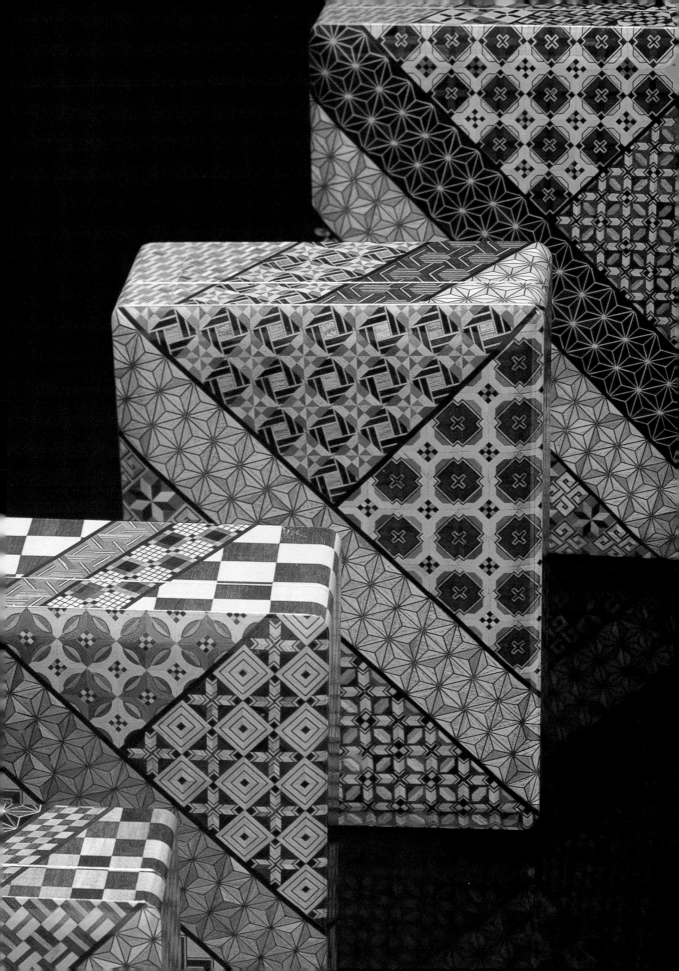

NAGISO TURNERY • *Nagiso Rokuro Zaiku*

Nagiso-chō, Nagano Prefecture

Flanked by well-forested mountains, the old Kiso Highway allowed access to timber of the Kiso region in Nagano Prefecture. Nagiso lies toward the southern end of this region, where forestry was promoted by the Owari clan throughout the Edo period. Records tell of plain wooden trays and bowls made by woodworkers in the village being sent to Nagoya and Osaka around the beginning of the eighteenth century. At the end of the nineteenth century, the woodworkers were joined by craftsmen skilled in the use of *urushi*, and the production of turned lacquer ware began. At the time, the lathes were, of course, driven by hand, but later the water wheel, then electricity, were to provide new sources of power, and the work of making these turned goods became more efficient. The introduction of inexpensive plastic products after World War II had a damaging effect on woodcrafts generally and turned goods in particular, but more recently renewed popular interest in the "real thing" has restored Nagiso turnery to some of its former glory.

The turned goods now being made in Nagiso include salad bowls, mixing bowls, tea caddies, and containers for Japanese-style confectionery, as well as smaller items such as coasters. All possess a natural beauty enhanced by the way the grain has been drawn out by the craftsman, the inherent warmth of handmade objects, and the appeal of simple, unpretentious forms.

The first stage in creating Nagiso turnery is selecting just the right wood; this is effectively a craft in itself,

acquired through years of experience. Japanese horse chestnut, zelkova, castor arabia, katsura tree, and birch are most commonly used. Logs are cross-sawn, split, shaped, and then dried for up to a year prior to turning. Once the wood is ready, blocks of the required size are roughly turned on a lathe to give them their basic form. After further drying, the craftsman returns the block to the lathe for the turning proper, cutting with as many as twenty turning chisels, which he constantly sharpens while working. The chisel is held at right angles to the body and worked from the center of the wood to the rim and then back to the center. Both choice and application of the chisels are mastered only after a long apprenticeship.

At the completion of turning, the piece is finished off with sandpaper. Articles where the wood is to be left in its natural state are polished with *tokusa* (scouring rush; *Equisetum hyemale*) or the straw of the *suguki* (a type of turnip) and water: these provide a natural sheen. On other articles, natural *urushi* is used, the lacquer being repeatedly rubbed into the wood and wiped off until a characteristic gloss is achieved.

Similar turned goods are made in Imaichi in Tochigi Prefecture, Hitoyoshi in Kumamoto Prefecture, and Inabu in Aichi Prefecture, but the work of Nagiso, because of the area's long association with wood and woodcrafts, still retains a special place in the hearts of the Japanese.

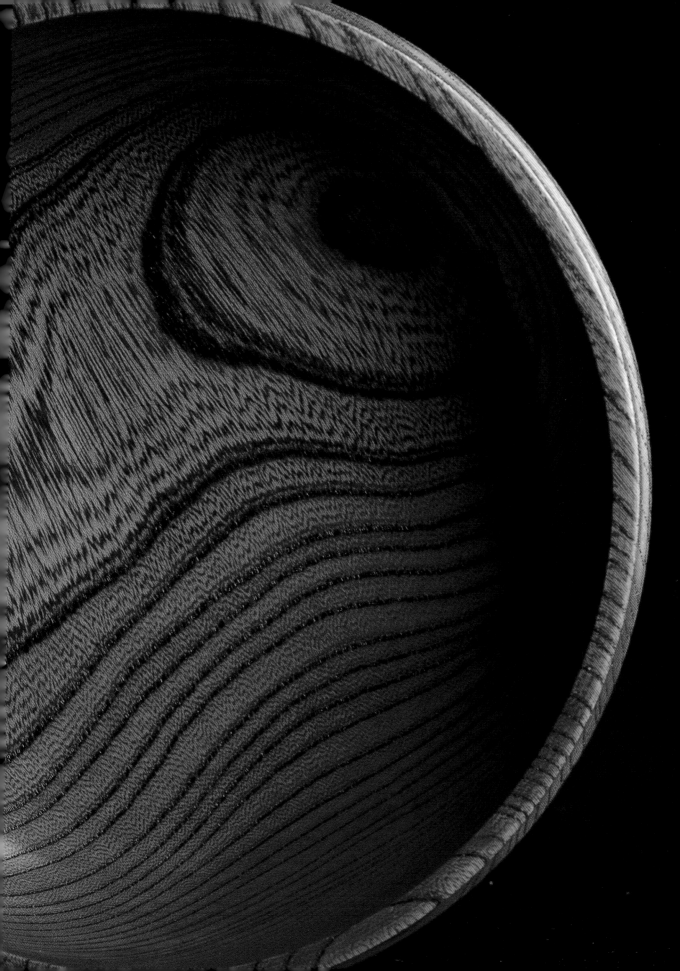

TAKAYAMA WOODCARVING
Takayama Ichii-Ittōbori
Takayama, Gifu Prefecture

The type of woodcarving known as *ittōbori* has been practiced for many centuries. The better-known kinds include Sasano *ittōbori* from Yonezawa (Yamagata Prefecture), Nara *ittōbori* from the city of the same name, Sanuki *ittōbori* from Takamatsu (Kagawa Prefecture) on the island of Shikoku, and Ise *ittōbori* from the city of Ise in Mie Prefecture.

The history of woodcarving in the Hida area where Takayama is located, almost due west of Tokyo, also dates back many centuries. In the seventh century, the Hida officials, instead of paying taxes, would dispatch ten skilled craftsmen to the capital of Nara, where they made a significant contribution to the building of large temples undertaken during the Nara period and the succeeding Heian period. Some of these men—unusual for an artisan at the time—even became famous enough for their names to be remembered by posterity. During the Edo period, the area produced a number of famous carpenters who dedicated themselves to the building and decoration of shrines and temples. Among the most celebrated of these carpenters was Hidari Jingorō. In addition to such craftsmen, who were both carpenters and sculptors, others from the area specialized in wood sculpture alone. One such was Matsuda Ryōchō (1800–71), who went to Edo (now Tokyo) and worked under one of the most famous *netsuke* craftsmen, Hirata Ryōchō. On his return to Takayama, he too began to produce fine *netsuke*, but at the same time he revived the *ittōbori* technique of carving using *ichii*, a type of Japanese yew, to carve masks, elephants, and other ornaments in a characteristically direct and simple style. It is this work that is thought to have marked the beginnings of the craft and style of carving.

The wood is obtained either locally or from Hokkaido. Japanese yew, with its beautiful grain, is particularly good for carving: being neither too hard nor too soft and containing a lot of oil, it is much easier to carve than some other kinds of wood. The wood is thoroughly dried and seasoned before the initial rough carving (known as "trimming"). In a process demanding unbroken concentration, the craftsman studies the natural form of the wood until he settles upon a design, which he draws in pencil. A rough carving is made following these outlines. For the final carving, which is also done by hand, the craftsman selects from as many as one hundred different chisels. The choice is significant, it being a characteristic of *ichii-ittōbori* that the carver aims to leave deliberate traces of the chisel behind on the finished work. Throughout, care is taken to bring out both the natural form of the grain and the contrast between the reddish heartwood and the lighter sapwood that surrounds it.

The masks, tea-ceremony utensils, animal carvings, and other ornamental pieces of *ittōbori* are all refreshingly simple and, with time, acquire a natural gloss, a credit to the craftsmen and to the fine wood from which they are made.

INAMI WOODCARVING
Inami Chōkoku

Inami-machi, Toyama Prefecture

The traditional style of Japanese house is still being built today. Some modern techniques and mannerisms have of course been adopted, but the general style can be traced back over four hundred years. One of the major decorative features of this style—which on the whole avoids decoration—is the *ranma*. More or less equivalent to the transom, these decorative screens have a special place among the various types of woodcarving done by the craftsmen of Inami.

The sponsorship of powerful Buddhist authorities gave a strong impetus to the advance of Inami woodcarving. Particularly during the peaceful years of the Edo period, there was much work to be done not only for Buddhist temples but also for their associated shrines and other independent shrines. Inami woodcarvers were therefore guaranteed a livelihood and were able to develop their craft with relative freedom. Over the years, their repertoire expanded to include pieces of domestic carving such as *ranma*, the freestanding screens know as *tsuitate*, and carvings of animals, *daruma*, and mythical figures. Today, when demand for *ranma* is steady though limited, the craftsmen are thus able to supplement their incomes by making more domestic-oriented pieces such as ornaments and *shishi* (carved lion heads), as well as commercial items like picture frames.

The designs for the *ranma*, traditionally based on the wall paintings of the Kanō school and the landscapes of the Shijō and Maruyama schools, become grand, elegant pieces of interior decoration, sometimes enhanced by a technique known as *fukurin* whereby the relief is made to appear to be deeper than it actually is by extending the carving outside the frame.

For the *ranma*, woods such as camphor and zelkova are used, and for the ornaments paulownia is used as well. The boards from which *ranma* are carved are usually at least 45 millimeters thick. The wood is cut to size and seasoned naturally for between six months and a year, then the design is drawn on the wood and those parts not needed are cut out. Carving is first rough and then more detailed, the board being carved from both sides until the wood is cut through. The final detailed work is done with a sculpturing knife.

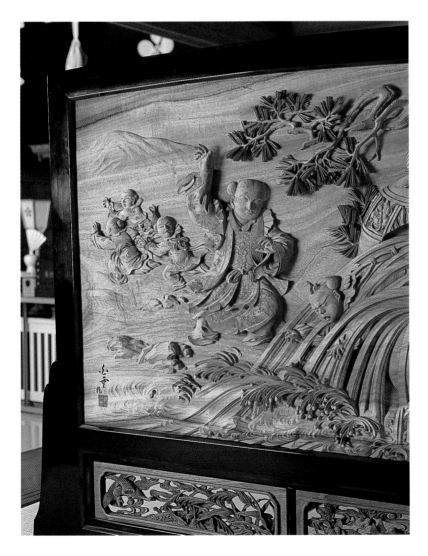

The carving of *ranma* is also carried out in the Osaka area. Together, Inami and Osaka contribute significantly to the continuance of a craft that over the years has adorned the places where the Japanese worship and that continues to grace many homes.

KISO OROKU COMBS
Kiso Oroku Gushi

Village of Kiso,* Kiso-gun, Nagano Prefecture

In Japan *kushi* (*gushi* in some cases) or combs, have traditionally been used not just to comb the hair but also as a hair ornament. Originally they had long teeth and were made of bamboo, but during the Nara period, more conventionally shaped combs were introduced from China. During the Heian period, the characteristic Japanese half-moon comb became the norm, and from about the same time, boxwood was a common material. By the beginning of the Edo period, however, combs made of other woods—rare woods from abroad and homegrown paulownia—came into favor, especially among the prostitutes, who were in a sense leaders of fashion at the time. The combs they used were rounded at the top, straight at the sides, and thinner than conventional combs of the period. Subsequently, combs of various shapes appeared, including some with a large flat area above the teeth that provided space for decoration in materials such as mother-of-

pearl or in *makie*. Combs of tortoiseshell and ivory also appeared, but were mostly used by the women of samurai families.

Until the years preceding World War II, Oroku combs, the most representative of all the combs made in the Kiso area, could be found in almost every home in the country. Although less widespread today, they are still being made, often with material imported from Thailand. Large pieces of timber are first cut to a manageable size, then dried naturally for one to three months. The comb-shaped pieces of wood are then trimmed to the correct thickness and size by machine and, in the case of Oroku combs, the teeth are cut by hand. This is no easy task—there are ten to fourteen teeth per centimeter, which means that unless the comb is held up to the light, they cannot be clearly distinguished. The back of the comb is then shaped before the combs are buffed and finished to a natural sheen.

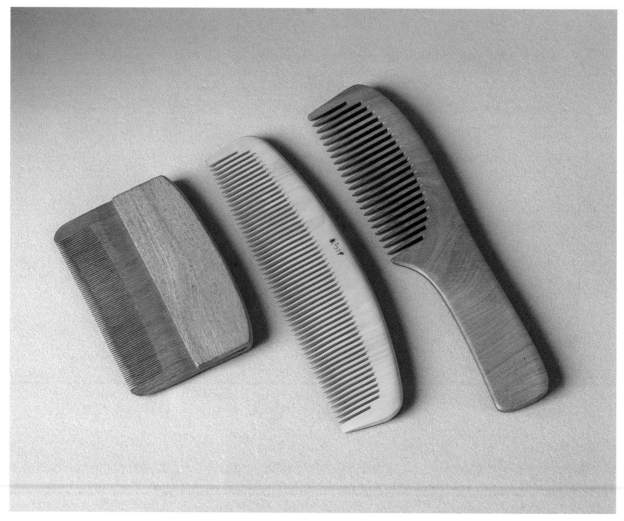

AKITA CHERRY-BARK WORK
Akita Kabazaiku

Kakunodate-machi, Akita Prefecture

The wild mountain cherries that eke out an existence in the poor soil among the cold rocky crags of Japan develop a tough fibrous bark. Although the bark can easily be peeled off in strips around the trunk of the tree in a horizontal direction, it is extremely strong in a vertical direction, and is also impermeable to air. These are the properties exploited in *kabazaiku*, cherry-bark work.

In the past, this type of work was produced around Hida Takayama in Gifu Prefecture, in the vicinity of Kōfu in Yamanashi Prefecture, and in various places in both Iwate Prefecture and Akita Prefecture. Even now, cherry bark is still used to "sew-joint" bentwood goods, and to make sheaths and handle covers for large mountain knives used in the lumber industry. But Kakunodate is the only place where cherry-bark work is still carried on in earnest.

The techniques of *kabazaiku* did not originate in Kakunodate, but were introduced in the 1780s from the

Ani area north of the town. Developing into a side business for lower-ranking samurai, *kabazaiku* became widely known during the early part of the nineteenth century, and cherry-bark craftwork was often bought as a gift item. With major technical developments toward the end of the nineteenth century, it became an industry in the real sense of the word. In the years before World War II, the idea of using slivers of willow as a base on which to veneer cherry wood bark emerged, and in time even the use of tin became acceptable in the attempt to produce cheaper and more practical goods.

Today, a number of goods are being made alongside the more traditionally produced pieces. The work falls into the following basic categories: objects that use a tin or willow-sliver form, notably tea caddies, cigarette cases, and *natsume* (special small tea caddies for the lighter powdered tea of the tea ceremony); those relying on a wooden base, and including such objects as stationery boxes, jewelry cases, tables, small cabinets, and trays; and objects without a form such as *netsuke*, pendants, and brooches. Whatever the technique, these products have a durability and charm stemming from the strength, impermeability, and natural patina of the bark, which deepens with use.

A number of different woods are used for the bases, including cucumber tree, magnolia, Japanese cedar, Japanese cypress, white cypress, and paulownia. Before application of the cherry bark, the wood is covered with an animal glue. Cherry bark is applied to the inside surfaces of boxes and other articles; the outside is then veneered with one or more layers of the bark.

In the case of *katamono*, which use a tin- or willow-sliver form to make such items as tea caddies, the material is first bent into the required shape and fitted to a circular wooden base and top. The form is then veneered with the cherry bark, again using an animal glue as an adhesive. *Tataimono* are made from between ten and fifteen layers of cherry bark, bonded together with an animal glue and then carved into the required shape.

There is little doubt that on the trees, the bark will always be overshadowed by the cherry blossoms. But this relatively new craft is still thriving and producing forms that could one day rival the beauty of the blossoms.

KINKŌHIN

Metalwork

Introduction

Having had its foundations laid in antiquity, metal craft using both precious and nonprecious materials has achieved a high degree of refinement in Japan. This superb quality notwithstanding, metalwork does not enjoy the renown of other Japanese crafts. Yet it is well worth closer consideration.

From the representative metalworking techniques in Japan, two stand out as warranting special mention. In the technique of *hera shibori*, the base metal is placed against a wooden form and shaped to it by hammering with a short staff, normally of wood, as the form is turned. In *kirihame*, a design is drawn on the base metal, cut out, and then inlaid with a gold-copper alloy.

The techniques and styles discussed here represent some of the best examples of contemporary metalwork in Japan and cover a range of different metals and regions.

Kyoto metalwork.

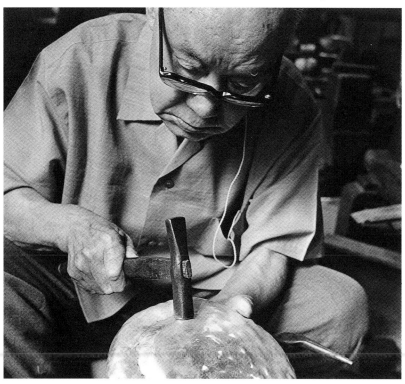

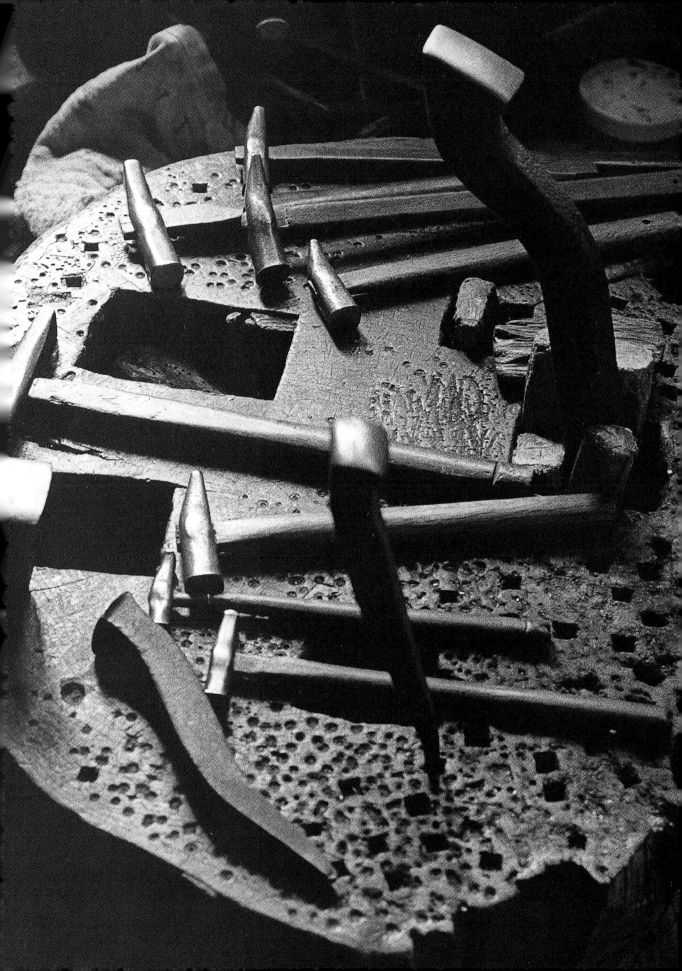

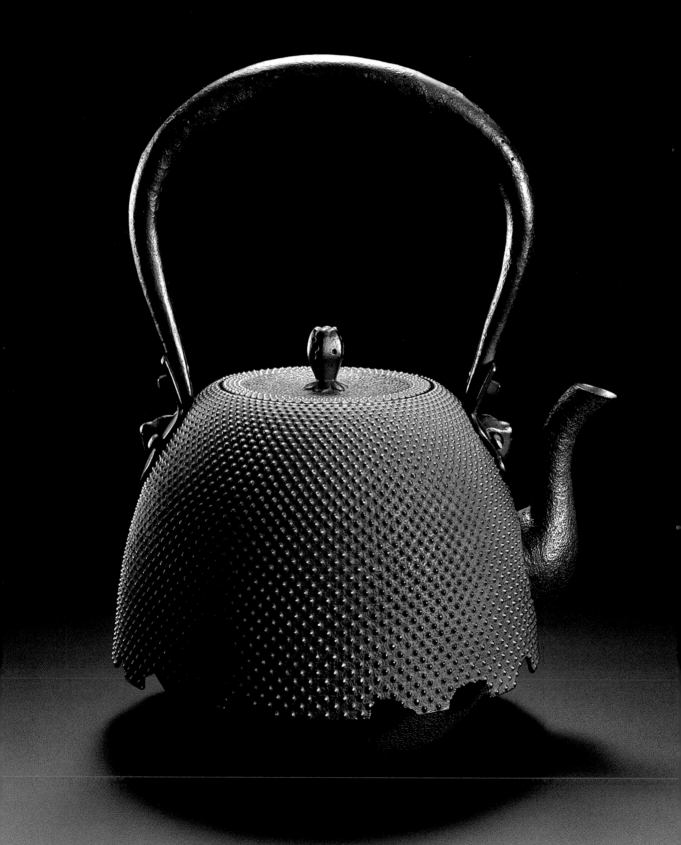

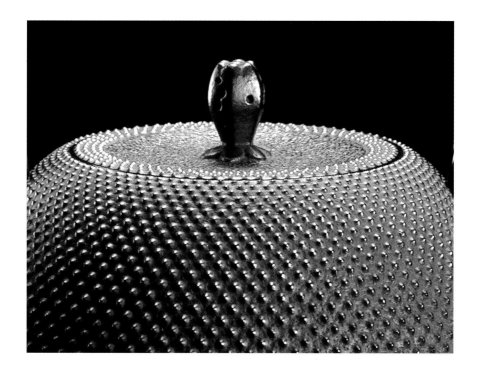

NANBU CAST IRONWORK • *Nanbu Tekki*

Mizusawa and Morioka, Iwate Prefecture

Iwate Prefecture possesses all the main ingredients necessary for casting—iron sand, sand, clay, and charcoal. The area has thus been known for its casting skills for many hundreds of years. Nanbu *tekki* is just one example of the traditional casting techniques extant today.

The beginnings of Nanbu *tekki* are said to date back to the Momoyama period, when the feudal head of the Nanbu clan invited some craftsmen skilled in the techniques of casting to come to Morioka from Kyoto. There they produced *chagama*, or pots in which to heat water for the tea ceremony. Some time later, in 1626 (Kan'ei 3), the famous *Kan'ei tsūhō* was made in the region. Later, four more skilled craftsmen were invited to the area from Tokyo (then called Edo) and elsewhere. Descendants of these four jealously guarded and preserved the traditional skills and techniques of casting. However, in 1645 (Shōho 2), the local administration invited other metalworkers and casters from Tamoyama (now Ōfunato) to come to Mizusawa, which was then part of the Daté clan. A large amount of metalwork was produced here during the Tenna era, between 1681 and 1684. The design of the *chagama* was revised and more conventional-looking teakettles were made, along with cooking pots. The production of such items continued almost unabated until after World War II, when a drastic change in the lifestyle of the Japanese meant that iron teakettles and other traditional metal pots were no longer in such great demand. Diversification of production was therefore pursued, including decorative items, ashtrays, and wind bells.

Present-day Mizusawa is best known for the production of machine parts and for its wind bells. This does not mean, however, that metal cooking pots have disappeared. Apart from the wind bells, traditional metal teakettles, *chagama*, and sukiyaki pans are still being produced, along with some smaller decorative items. Many of these products are characterized by the raised spot pattern known as *arare moyō*, the dull luster of the metal, and a feeling of strength and substance.

The production techniques have changed little over the years. Iron sand or casting pig iron is poured into the cast. When it has cooled the cast is split open and the casting removed. The making of casts themselves is worthy of note. Clay that has been fired is pulverized and kneaded together with clay slurry. The design is put on the inside of the cast, which is then fired and hardened. The core is made in the same way as the mold. Placed within the outer mold, it leaves a ridge on the casting. Because the parts of the cast must be made each time, this method is not suited to mass production. Dry molds are therefore employed for mass-produced items. In order to make one of these, the original form is first made from stone chips. An outer cast is made by using a mixture of sand and clay slurry and is then put into a drying furnace. The same method and casting process are employed to make the core.

Nanbu *tekki* is found in use all over Japan. It brings an air of quality and tradition to many meals, not the least of which is sukiyaki, one of Japan's foremost contributions to the dining tables of the world.

TSUBAME BEATEN COPPERWARE
Tsubame Tsuiki Dōki
Bunsui-machi and Tsubame, Niigata Prefecture

Beating a metal sheet into shape with a hammer or staff is a technique that can be found in most parts of the world. It is known alternatively as raising or sinking; in Japan it is called *tsuiki*. Copper is the preferred material as it is extremely malleable.

The art of metal forming was brought to Tsubame in the 1760s from Sendai, the provincial capital of what is now Miyagi Prefecture. The techniques were mastered by the craftsman Tamagawa Kakubei, whose work remains the basis for today's craft. Although production first centered on utilitarian items such as cooking pots and water pitchers, as the craftsmen acquired more expertise, they gradually began to create pieces of a refined and elegant nature. Plating and the technique of inlaying gold and silver were introduced at the end of the nineteenth century, and these served to popularize fine copperware.

In the 1920s, however, the introduction of aluminum goods severely eroded the market for copperware. The situation declined further with the outbreak of war. The price of copper soared, and most of the skilled staff left or were conscripted. Fortunately, since the end of the war, demand has returned more strongly than ever. Tsubame copperware is much loved for its beautiful coloring and marking, as well as for its durability. There is a greater emphasis now on decorative items, yet finely crafted household goods and tea-ceremony utensils remain the mainstay of production.

After the copper has been heated so as to anneal, it is formed with a hammer or wooden mallet either by sinking (*uchiage*), in which the copper is beaten to conform to a sunken form made of zelkova wood, or by raising, in which the metal is gradually reduced by beating it around a steel form (*toriguchi*). A third technique is *itamaki*. The metal is bent into a cylindrical shape, and the bottom and side seams are fastened by a claw joint or by soldering. Decorations, if any, are either beaten into the metal, chased, or inlaid (*kirihame*). The surface of the copper is treated in order to prevent oxidation. It is possible to color the metal a warm yellow, scarlet, or amethyst by soaking it in solutions mixing copper, copper sulfide, and calcium sulfide, with burnishing or polishing to determine the final hue.

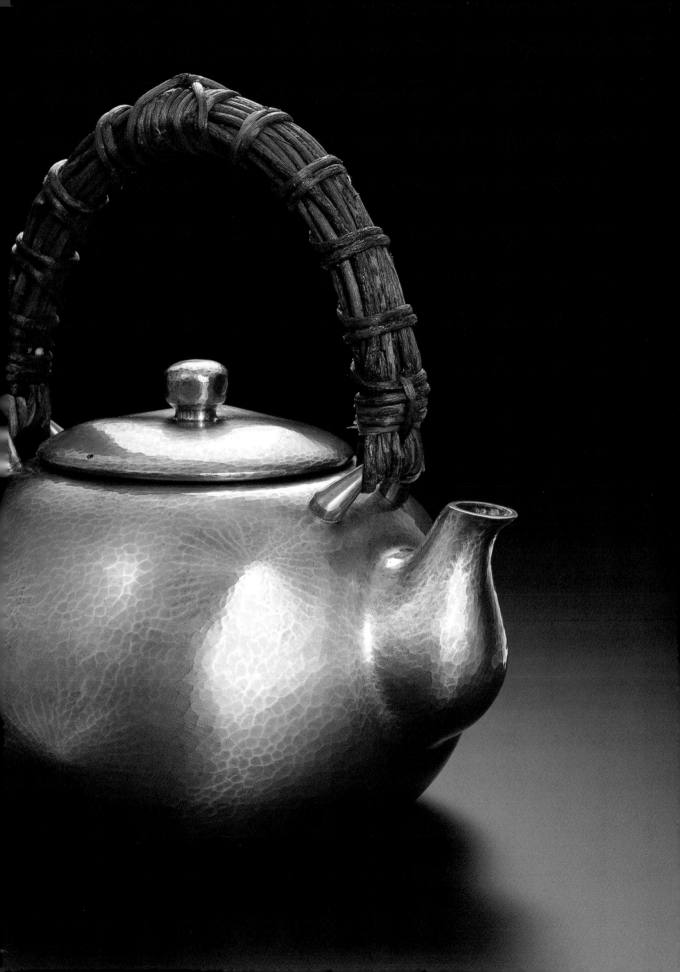

TAKAOKA CASTING • *Takaoka Dōki*

Takaoka, Toyama Prefecture

The primary material for casting is bronze, but because it is an alloy of copper, articles made of bronze and other copper alloys are categorized as *dōki* (copper articles). Copper itself is often referred to as *akagane*, meaning "red metal," or simply as *aka*. On the other hand, bronze, which has a somewhat greenish cast, is called *seidō* (green copper).

Located in Toyama Prefecture not far from the Japan Sea, Takaoka is the nation's top producer of cast bronze. Casting began around 1611 when the Takaoka clan summoned seven casting experts from the Kawachi area of Osaka Prefecture, where casting had first developed, in order to set up an income-producing industry for this rather poorly endowed castle town. In its early days the foundry produced cast-iron kitchen ware and other household articles as well as agricultural equipment such as plows (*suki*) and hoes (*kuwa*). Later, religious articles, incense burners, vases, and other finely crafted items were cast in bronze. Although demand for these bronze pieces rapidly increased during the thirty-year period from 1751, production remained a cottage industry until 1819, when a distribution system was organized. Specialization resulted in a greater division of labor, which in turn led to larger and more efficient production. After World War II, factory-style management was introduced, and production was mechanized.

The *karakane* (Chinese metal) alloy that is used for these decorative objects contains copper, zinc, lead, and 10 percent or less tin. By contrast, temple bells are made of bronze having 15 to 20 percent tin. Casting is done with either a dry-sand mold, another type of dry molding material, or lost-wax. Molds for round objects are called *hikigata*, those for irregular shapes *komegata*. The metal chasing is all done by hand. The coloring of the metal is achieved by immersion in a chemical bath or by painting a mixture of saltpeter and rice bran onto the surface and then heating it in a furnace. Although cast bronze industries also exist in Niigata, Yamagata, and Hiroshima Prefectures, Takaoka is noted for being able to cast exceptionally large pieces as well as delicate work.

OSAKA NANIWA PEWTER WARE
Osaka Naniwa Suzuki
Osaka

Tin is easy to work and neither corrodes nor tarnishes. In Japan it is reputed to improve the taste of water and saké, and is for this reason considered an ideal material for teapots and vessels for serving Japan's national liquor.

The earliest tin artifacts to have been found in Japan date back thirteen hundred years and are kept at *Shōsōin*, the imperial repository in Nara. The pieces are of Chinese origin, however, and this would have made them too precious for use by anyone not of a privileged status. Indeed, it was not until the eighteenth century that tinware came into general use.

Tin mining in Japan began in 1701 at Taniyama in Kagoshima. The Taniyama tin was of good quality, and rather than being processed locally, a large proportion of it was sent for sale in Osaka. Tinware had already become a viable industry in Osaka by 1679 at the latest and in Kyoto by 1690. In the second half of the nineteenth century, a way of purifying tin was mastered and lathes were improved, enabling great advances in the craft. In 1872, the *ibushi* method of coloring the metal was discovered. This popular effect is achieved by exposing the formed piece to the smoke of smoldering wood.

The tin that is being used today is 97 parts pure; lead is added to bind and strengthen the material. Molten tin is poured into molds and cast. Some of the articles are turned on a lathe while others are beaten and polished. The body, lip, and base are either welded together or joined using a solder known as *rogane*. Designs or motifs are painted on in natural lacquer, which acts as a resist, and then the surface is etched with nitric acid. Lacquer is rubbed into the surface, and final finishing is carried out.

Tinware is now being produced only in Osaka and Taniyama, where it was first mined. Competition from other materials is such that most contemporary pewter ware is turned, since mass production is easier by this method. Product ranges have also expanded to include jugs, tumblers, coasters, and novelty items.

TOKYO SILVERSMITHERY • *Tokyo Ginki*

Tokyo

Tokyo is one of the few places in Japan where silverware is made. The craft took root and developed in Tokyo just as the city was beginning to grow as the military capital of the country in the early seventeenth century.

Historical records of the period between 1624 and 1644 tell us that silver items made in Edo (present-day Tokyo) were presented to the emperor and the shogun. They also describe the types of tools being used in the silver craft. Although at first only the higher-ranking members of the warrior class could afford articles made of this precious metal, by the end of the seventeenth century the clientele had grown considerably.

Three of the techniques still in use today—*kirihame* inlaying, *chōkin* chasing, and metal forming—can be traced back to individuals who worked during the Edo Period. They are employed for a large range of accessories and household goods. The silver is a very pure 925 parts to 1,000. It is formed by either raising and sinking, in which case the surface is always decorated, or by spinning (*hera shibori*). Parts are joined by soldering with silver, fusing, or riveting.

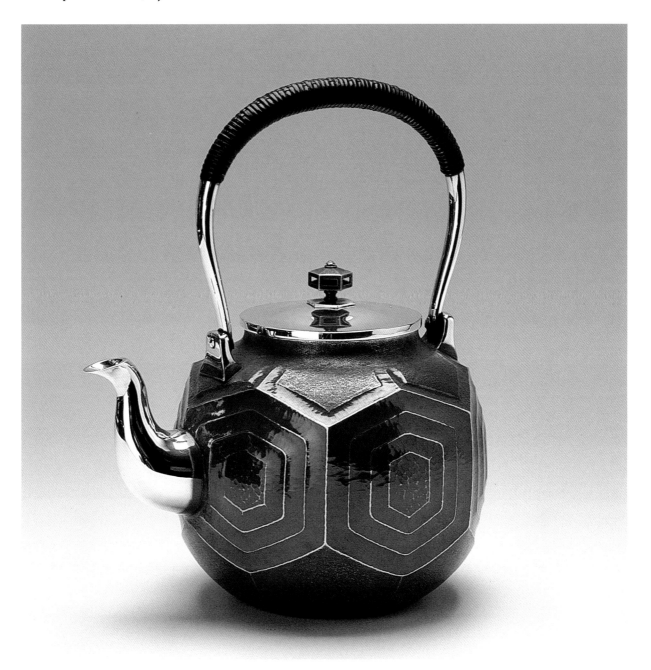

SAKAI FORGED BLADES • *Sakai Uchi Hamono*
Sakai and Osaka, Osaka Prefecture

In Japan the techniques of forging became increasingly sophisticated from the eighth century onward. Those of the Osaka area were known as Kawachi forging, after the name of that district. The import and export of iron and steel itself was being handled through Sakai, which was a prosperous port doing trade with other Asian countries. Then, in 1543, an event occurred that changed not only the forging industry in Sakai, but the whole history of the country. A Portuguese ship arrived at Tanegashima Island at the tip of Kyūshū, bringing with it the first firearms known to the Japanese. Among the metalworkers who made copies of these weapons was a man from Sakai. He returned to Sakai and with the financial backing of one of the wealthy Sakai merchants began producing firearms, which came to be known as Sakai *teppō*.

The skills and techniques used in the production of Sakai *teppō* were later put to use in the making of knives and other blade tools. The first of these was a tobacco knife introduced between 1570 and 1590. It was given the name *okata* (after the wife of the metalsmith) *hōchō* (knife). The general name for the blade tools of Sakai was Sakai *uchi* (forged) *hamono* (blades). The techniques were based on those employed by swordsmiths, but in the first half of the eighteenth century a blacksmith created a very sharp knife called *yamanoue hōchō*, literally "mountaintop knife." This led to the production of various other knives for cooking and carving, scissors, razors, sickles, and a wide range of carpentry tools. To this day, the sharpness of the Sakai blade tools sets them apart.

The base metal is a very soft steel, and the cutting edge is a high-quality blade steel. The two are forged together with the hard blade steel sandwiched between the soft steel that forms the back of the blade. The method of tempering is unique to Sakai. The blades are first completely covered with mud, then placed in a furnace. When the red-hot blades are removed, they are immediately plunged into water and cooled. The blades afterwards are sharpened and fitted with wooden handles.

Miki and Ono, both also in Hyōgo Prefecture, produce more knives and blade tools than Sakai, yet the city maintains a thriving industry renowned for high-quality goods.

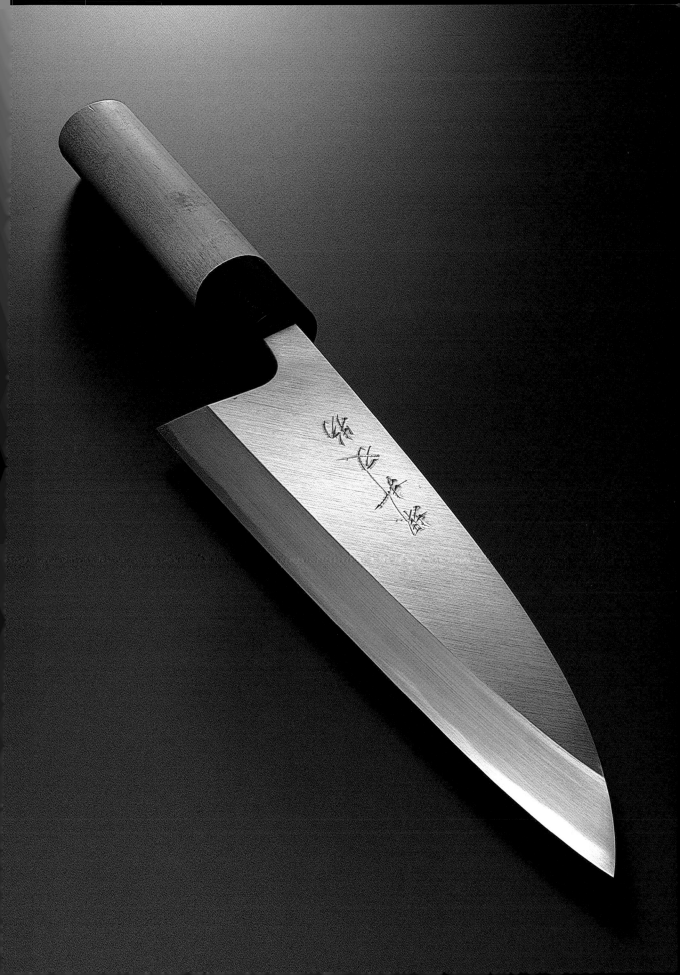

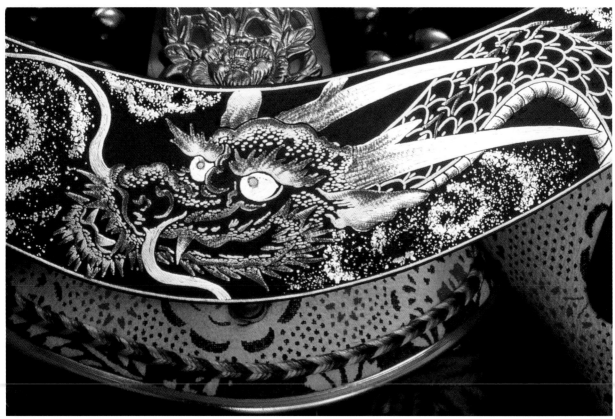

KYOTO METAL INLAY • *Kyō Zōgan*

Kyoto

The technique of inlaying metals was probably brought to Japan from Korea with the great influx of continental culture during the Asuka period, which lasted from the late sixth century to 710. In the eighth century metal inlaying was already taking place in Kyoto.

Two families of metalsmiths, the Shoami and the Umetada, had become the leading experts in the craft by the time the provinces of Japan fell under the control of powerful feudal lords in the sixteenth century. Craftsmen who had been apprenticed to these two families attached themselves to these feudal lords, and in this way the techniques of *Kyō zōgan* spread throughout the country. Although inlaying was first employed for decorating religious objects, sword hilts, and other articles for the nobility and warrior class, the prosperity and peaceful environment brought by the consolidation of Japan at the beginning of the seventeenth century saw *zōgan* also being used for objects of everyday life such as hibachi braziers, the thin tobacco pipes called *kiseru*, and purse closures. Toward the end of the nineteenth century, almost all the metal inlaying and cloisonne was being done for export. Today, 80 percent of Japanese *zōgan* is produced in Kyoto, with the remainder being made in Kanazawa in Ishikawa Prefecture and Kumamoto on the island of Kyūshū.

Some *zōgan* still is employed on work for religious purposes; however, there is a greater demand for its use in accessories such as brooches, tiepins, buckles, and badges.

The techniques are the same as those once used to decorate the samurai swords: *ito zōgan* which resembles a fine thread; *nunome zōgan*, which resembles a rough weave; *hira* (flat) *zōgan*; and *taka* (relief) *zōgan*. The base metal is usually polished steel; the engraving tool is called a *tagane* or a *burin*. The engraved lines are filled with gold or silver that has been hammered into thin sheets or cut with a die. This inlay process involves some sixteen, painstaking stages. Corrosion is prevented by immersing the metal in a bath of hot tannin obtained from Japanese tea. Natural lacquer is then applied to the surface and warmed to fix it before the piece is polished to its final sheen with wood charcoal or a metal spatula.

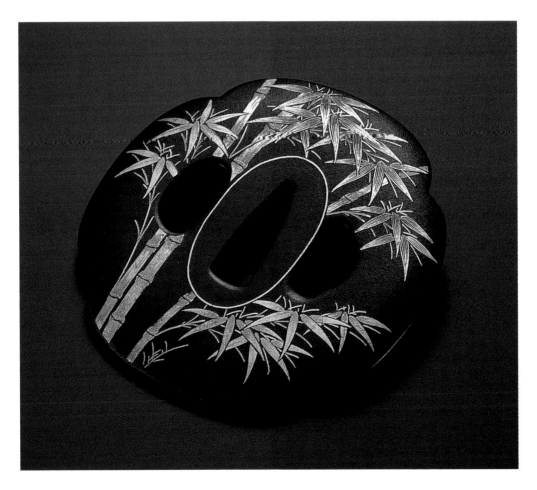

Other Crafts

Introduction

Of the vast array of crafts still being made in Japan, a number of them fall outside of the major material categories presented in the previous pages. Ogatsu inkstones and Izumo stone lanterns represent the stone-carving crafts, and the luxurious lacquered work of Kōshū deerhide pouches constitutes a rare example of an object fashioned from animal products.

Many of the crafts in this section rely on more than one material. Such traditional objects as brushes, fans, umbrellas, and lanterns require a second material to be used in tandem with a skeletal base of bamboo, a material that found its way into all walks of life in olden times. Other objects, most notably the portable shrine and the Buddhist altar, require a team of skilled craftsmen working in various genres to complete.

Trimming the hair of a Nara brush.

A Miyagi *kokeshi* doll on the lathe.

154

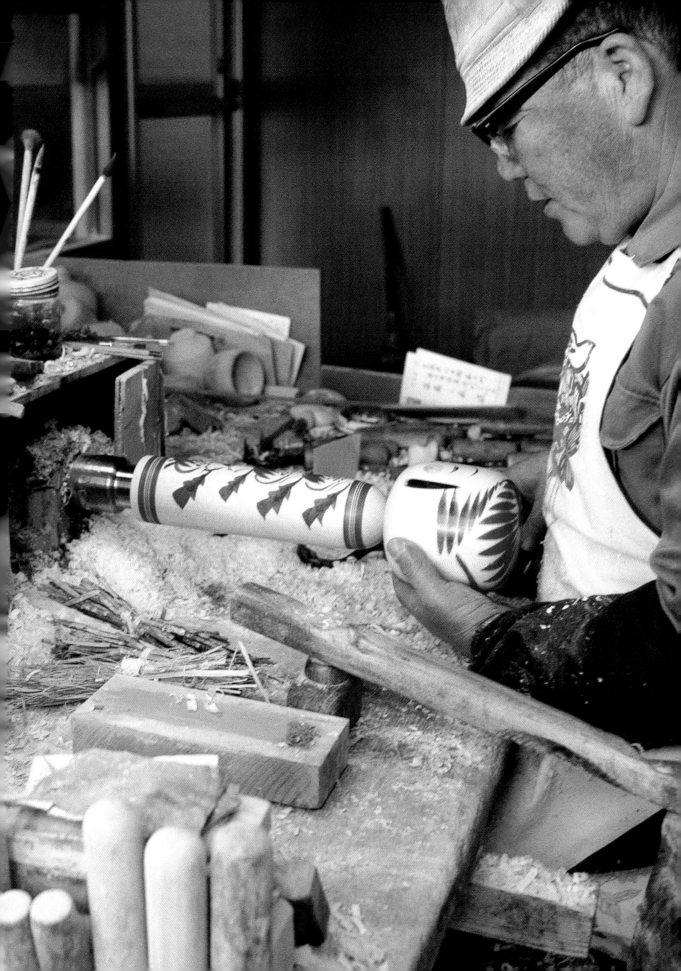

BANSHŪ ABACUS
Banshū Soroban
Ono, Hyōgo Prefecture

As a way of making calculations, the abacus is one of mankind's most ancient instruments, and only in recent times has it been superseded by the electronic calculator. A good abacus operator in Japan can beat someone using a calculator, a feat that has been demonstrated on several occasions in competition. Demand for the abacus has certainly dropped as electronic calculators have become cheaper and more widely available, yet it is still used to teach children the principles of mathematics, something that has caused great interest in America, Europe, and Russia. Even today, many shopkeepers and accountants still use an abacus to double-check their electronic calculations.

It is thought that the abacus reached Japan during in the 1590s via China. Having been introduced, it was adapted to meet local requirements, the form it took being the one that is used to this day. It was the settled Edo period that saw the generalization of their use for everyday calculation and, particularly in Western Japan, the *soroban* became known as both the "life" and "spirit" of the tradespeople who prospered during this peaceful time.

Making a good *soroban* is, of course, an intricate job requiring much patience. The frames are made from a variety of woods, including ebony, oak, and birch. The shafts for the beads are generally made from bamboo, and the beads are fashioned from such woods as boxwood, birch, or holly. The beads are usually polished, but if they are made of birch they are stained. The bamboo shafts are also stained, unless they are made from *susudake*—a type of smoke-stained bamboo traditionally obtained from inside the roofs of old dwellings. A small white dot, called a *hatome* (literally, a "pigeon's eye"), is added to the upper edge of the top and bottom frames as a guide in calculations. The frame itself is then jointed together using either round or triangular mortise and tenon joints. These are employed because they tend not to loosen as the abacus is used.

Banshū *soroban* now account for approximately four-fifths of national production, the remainder coming from Unshū in Shimane Prefecture and Ōsumi in Kagoshima Prefecture. It is difficult to say how long the *soroban* can hold out against the electronic revolution, although it is interesting to note that at one time it was possible to buy a combination abacus-calculator, an attempt to combine the best of both worlds.

FUKUYAMA PLANE HARPS
Fukuyama Koto

Fukuyama,* Hiroshima Prefecture

The *koto* appears simple and unassuming when compared to its upright Western cousins; it is somehow so characteristic of Japan, yet it is not originally a Japanese instrument. Its prototype was Chinese, and only after a long and gradual period of adaptation and development has it become, along with the *shakuhachi* and the *shamisen*, one of Japan's representative musical instruments. During its history, the *koto* has taken various different forms: a 25-string instrument called a *hitsu*, a 13-string *so*, a 7-string *kin*, and the 6-string *wagon* (sometimes also called the *yamato goto*). But since the Kamakura period, the 13-string *sō* has become the instrument known under the generic term of *koto*.

Production of *koto* started in Fukuyama in the Edo period, but large quantities were not made until the beginning of this century. The city has subsequently become Japan's center for production of *koto* of the highest quality and now produces four-fifths of all these instruments.

Basically speaking, the *koto* is composed of a bowed and barreled wooden soundbox over which silk strings are stretched and raised on individual bridges. The upper part looks something like a flat, upturned U-shape in section, being cut from a log of paulownia (*kiri*). The original cutting from the log is done with sophisticated circular band saws, and it is then primitively hacked and mostly planed into shape. After this sounding board has been thoroughly dried, a herringbone pattern known as *aya-sugibori* is carefully inscribed across part of the back with a chisel, the effect being to improve the quality of its acoustics. This painstaking work becomes more or less hidden, as a similarly well-seasoned board of the same wood is attached behind it, with spacers known as *seki-ita* and *hari-ita* fitted between. Next, all the surfaces are charred. A red-hot iron heated to 1800° F (1000° C) is dragged across the surface of the wood, which immediately flares and is naturally extinguished. The required degree of charring can only be obtained by carefully controlling the pressure applied to the iron as it cools. The final finishing of the surface to give it a "salt and pepper" hue is done with a wire brush called an *uzukuri*, made of a bundle of roots from the Japanese yew, and a light polishing is done with a beetle wax. The wax is put into a bag of loose material, dusted onto the surface of the wood, and then polished up with a cloth. To complete the instrument, decorations of ivory and rare wood are added.

While there are two basic types, the only real difference is that the Yamada *koto* has a slightly more swelling body than the dead-straight Ikuta *koto*. Both have the same gently bowed form when seen from the side. What they also share, of course, is an elegance and enigmatic air fostered by years of development. The end result of this truly Japanese mix of techniques—from the highly crafted yet usually concealed pattern on the back of the sounding board to the simple, almost primitive finishing with fire and beetle wax—is an instrument as sophisticated as those in the West, but unmistakably Japanese in character and musical tone.

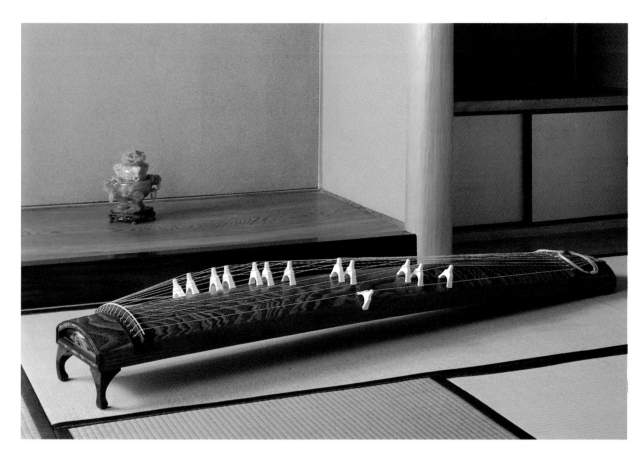

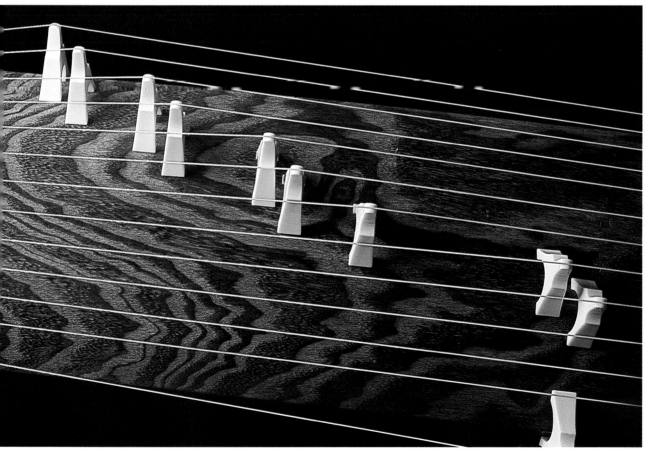

159

KŌSHŪ LACQUERED DEERHIDE
Kōshū Inden

Kōfu, Yamanashi Prefecture

Situated off the eastern edge of the Asian continent, Japan has inevitably been a cul-de-sac for various customs and technologies originating elsewhere. Even today, Japan is widely regarded as the best developer of ideas in the world; Kōshū *inden* is but an ancient example of this phenomenon.

Thought to have originated in India, Kōshū *inden* is basically a technique of coloring and applying a pattern to deerskin. According to the *Engishiki*, an ancient book on official protocol, the process by which the skin is dressed was brought to Japan by Korean tanners in the Asuka period. Much later, a monk from Kyoto's Myōshinji temple brought back a tiger-skin accessory from India for the feudal lord, Takeda Shingen, and this triggered the production of a bag made from deerskin. During the civil war period from 1490 to 1600, the Kōshū *inden* technique was utilized on the armor, helmets, and other military goods of the warriors. This gave way in the Edo period to its use on some formal pieces of clothing and especially on pouches, money belts, and tobacco pouches, since many people were moving about the country and needed small, light, but durable receptacles for their possessions. Nowadays, its use has been extended to such things as belts, ladies' handbags, and business-card holders, all of which take ample advantage of its ability to breathe, water resistance, durability, and almost ever-lasting softness and smooth texture.

As with many other traditional techniques, the process of preparing the hide relies on both simple methods and the effects obtained by using natural materials. After the hide has been tanned, any remaining hair or other extraneous matter is removed by singeing it with a hot iron, and the smooth, suedelike hide is smoked or stained with a ground color by using straw and pine resin. To soften it further, it is rubbed down with pumice (a sander is normally used nowadays). Next, the hide is cut into appropriate sizes. The application of the pattern is mainly done using natural lacquer into which a fine-powdered polishing stone (*tonoko*), pigment, and egg white have been mixed. This mixture is applied to the prepared hide with a stencil and squeegee. Various patterns are used, most of them small, overall repeats, featuring wave motifs, chrysanthemums, small cherry flowers, and geometric designs.

The products utilizing Kōshū *inden* have the kind of appeal that transcends cultural and generational barriers with the agility of the deer from whose hide they are made.

NARA SUMI INK • *Nara Zumi*

Nara, Nara Prefecture

A good ink stick may be as highly treasured by calligraphers and artists as the ink stone on which it is ground. The ink is made by pressing the stick onto the surface of the stone and moving it back and forth in a small pool of water. Nowadays, traditional ink comes in stick, liquid, or paste form, and in black or red.

The actual origins of Nara *zumi* go back to the ink made at Kōfukuji temple in the city of Nara between 1389 and 1427. The year 1739 was a turning point: with a view to raising the quality of the ink, further instruction was given on production methods by some Chinese living in Nagasaki at the time. Ever since, Nara *zumi* has been well known.

Even to the uninitiated, production is simple. First, soot is collected from smoke deposits left by burning oil or pine logs. Some scent, such as musk, is added along with an animal glue, and the mixture is kneaded into a paste that is then pressed into molds. Traditionally, the sticks are hung out to dry for two to four months indoors, in low temperatures. The dried sticks, which become very hard, are then polished with a shell to bring up a gloss. Lastly, gold, silver, and colored powders are applied over the embossed characters and designs on the sticks. The result is a highly crafted object that is nonetheless fated to disappear, worn away to nothing as it is ground down for another work of art, or just a letter to a friend.

NARA BRUSHES
Nara Fude

Nara, Nara Prefecture

The writing brush, or *fude*, became an essential writing tool on the Japanese archipelago during the Kofun period, when there were active dealings with China. The origins of Nara *fude* are said to go back to the eighth century, when the introduction of Buddhism led to the establishment of places to copy the sutras. Brushes were essential for the many students of Buddhism to reproduce the holy scriptures, which were the essence of their teachings and devotions. The Matsunaga Revolt of 1567 caused an abrupt drop in demand for brushes from temples and shrines alike, obliging the brush makers themselves to take to the roads and travel the country selling their wares. Stability returned in the Edo period, and *fude* came into general use with mandatory education. They have, however, fallen into relative disuse since the end of World War II. At present, production figures for Kumano *fude* from Hiroshima Prefecture are the high-est in the country, but Nara *fude* are the oldest and, together with those produced in Toyohashi, in Aichi Prefecture, they are acclaimed as brushes of the highest quality by specialists both in Japan and overseas.

The hair for these brushes is taken from lambs, horses, the Japanese raccoon (*tanuki*), or even cats. The shafts are usually made of bamboo, but are sometimes fashioned from wood. The selected hair is first boiled to remove any kinks and to soften it. Enough hair—according to the type of brush to be made—is cut to the same length and bound at one end with a linen thread. This bundle of hair is then introduced into its shaft and fixed with an adhesive. The tip of the brush is either left as it is or is given a coat of gum or funorin to bring the hairs together into a point.

Each kind of brush, be it wide or narrow, has a purpose in calligraphy or painting. But whatever its purpose, it becomes an extension of the hand of the person using it, giving expression to their words and thoughts, and lending a distinctive style and expressive quality to the characters and images that it is used to write or draw.

OGATSU INKSTONES • *Ogatsu Suzuri*

Ogatsu-chō, Miyagi Prefecture

For better or worse, word processors are the writing tool of the age. But in days gone by it was the writing brush, inkstone, ink, and paper that were the essential tools of the written word in Japan and other Asian countries. The inkstone, in particular, was considered of great importance in Japan, being likened to the sword of the samurai and the mirror of a lady, according to one old saying.

Apart from the Ogatsu inkstone—the most well known in Japan—the Amahada *suzuri* from Yamanashi Prefecture and the Akama *suzuri* from Yamaguchi Prefecture are of particular note. Those from Ogatsu are first mentioned in records from 1396. After 1591, the techniques of making the stones were handed down from father to son as a trade secret by the Okuda family, who were the recognized craftsmen (*suzuri kirikata*) of the times. In the later Edo period, the Daté family took over as the keepers of this art. The number of places making them increased as the literacy rate rose, yet today Ogatsu alone produces 90 percent of the country's natural stone for *suzuri*. Of course, it must be said that ever fewer inkstones are in daily use.

The slate used for Ogatsu inkstones is prized for its luster and grain quality. It is resistant to extreme temperatures, wear and tear from long usage, and warping. In addition, the copper, iron, and quartz in the stone create the ideal surface on which to rub ink sticks.

After the slate is mined, the substandard stone is discarded. The remainder, about 10 percent of the total, is separated sheet by sheet and cut to the required size and thickness. The surface is then smoothed out with sand and water and the inkwell is carved. Once the carving is concluded, the polishing commences. The interior is done first, followed by the exterior, and a final polish brings out the stone's color and sheen.

Some Ogatsu *suzuri* are collectors' items; others are in general use. They are prized equally by those who actually use them and by those who just admire them for their deep, dark indigo or sooty coloring, their smooth surface, and their hardness, which makes them ideal for preparing ink. The better-carved examples are considered works of art.

GYŌTOKU ŌKARAHAFŪ PORTABLE SHRINE
Gyōtoku Ōkarahafū Mikoshi

Ichikawa,* Chiba Prefecture

While the Japanese are not usually considered to be a devout race of people in the Western sense of monotheistic belief, they are nevertheless religious believers. There is a type of religious "parallelism" in Japan: the actual population is outnumbered by the official number of believers, possible only because so many people recognize at least two religions. This mania for religious adherence helps to sustain a number of highly refined craft items, particularly those associated with the main beliefs of Shintōism and Buddhism. The portable shrine and the household altar are two significant examples. As anyone visiting Japan quickly realizes, the Japanese like festivals. Originally, festivals were religious rituals at which offerings were made in a ceremonial manner to welcome divine spirits. Although their religious significance may have dimmed, these festive occasions are still begin held up and down the country and are attended by hundreds of people celebrating and commemorating a particular event or happening.

The carrying of a *mikoshi* is just one of the things that constitute such a religious festival. A *mikoshi* is a portable shrine in which the embodiment of a god or a divine spirit is enshrined. They are carried enthusiastically by young men and women who were born in the area where the enshrined god or spirit resides. The *mikoshi* are carried around the immediate neighborhood while bearers chant "*wasshoi*," a word that according to one explanation, was simply a greeting to the gods in the past. In the grounds of the shrine where the festival begins, there is chanting (*kagura bayashi*) and dancing to music played in praise of the god. On the streets the sight and sound of the *mikoshi* bouncing in time with the chanting draws onlookers away from the real world and into another bound by a common spirit of participation. While many modern Japanese consider festivals simply as an excuse for a lot of noise and merrymaking, the events still foster a sense of community.

Historical records tell us that the first use of a *mikoshi* was in 749, a purple-colored palanquin that was used to carry the divine spirit of the Usa Hachiman shrine at the time of the founding of the great temple of Tōdaiji, in Nara. Not until sometime later, during the middle of the Heian period, were *mikoshi* used at festivals dedicated to local gods in small settlements and villages. By the end of the twelfth century, references were being made to *abare mikoshi*. This is the raising and lowering, or bouncing, of a *mikoshi* as it is being carried. Prior to this they had simply been carried in a solemn and dignified manner. This more boisterous style of festival became increasingly popular during the Edo period.

The Gyōtoku *ōkarahafū mikoshi* are characterized by the brave, elegant line of the gable. This is just one of the elements that is borrowed from architecture in the construction of what is essentially a miniature building. The kind of gable employed on these particular *mikoshi* was derived from Chinese architecture. These often form the end of a "porch roof," or secondary gable set into the sweep of a main roof.

The woods generally used to make *mikoshi* are Japanese cypress, evergreen oak, and zelkova. The zelkova is used for the posts and beams; oak and zelkova are used for those parts of the construction that need to be strong; and the cypress is used for those parts that are coated with lacquer. All the wood is well seasoned; heartwood is avoided.

Most of the pieces are made individually and then assembled. Construction begins by building a frame onto which four posts are erected. These support the body and roof of the *mikoshi*. Fences and *torii*, or characteristic Shintō shrine arches, are then fixed. The roof is decorated with such things as the mythical *hōō*, or phoenix. All of the woodwork requires frequent use of various kinds of chisels, saws, and planes. Moreover, the entire work—carving, woodwork, lacquering, and application of decorations—is done by either one person or a small group of people, and therefore demands strong all-round skills.

One of Japan's major festivals is the *Sanja Matsuri*, which is held every May in the Asakusa district of Tokyo. Hundreds of people are involved in the bearing of the one hundred *mikoshi* that are paraded over three days and, as can be expected, this draws huge crowds of onlookers. Latterly the festival itself has become quite international, having been held in such places as Venice, Hawaii, Düsseldorf, Nice, and Cannes. Yet whether the festival is held in some small mountain village or in some far-flung corner of the world, it would be nothing without the *mikoshi*.

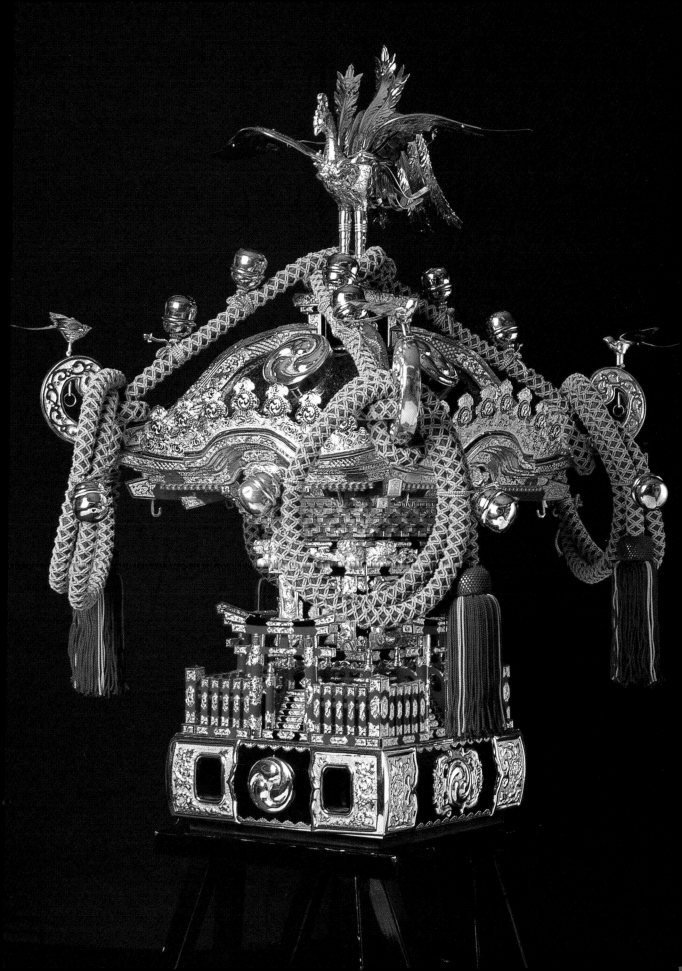

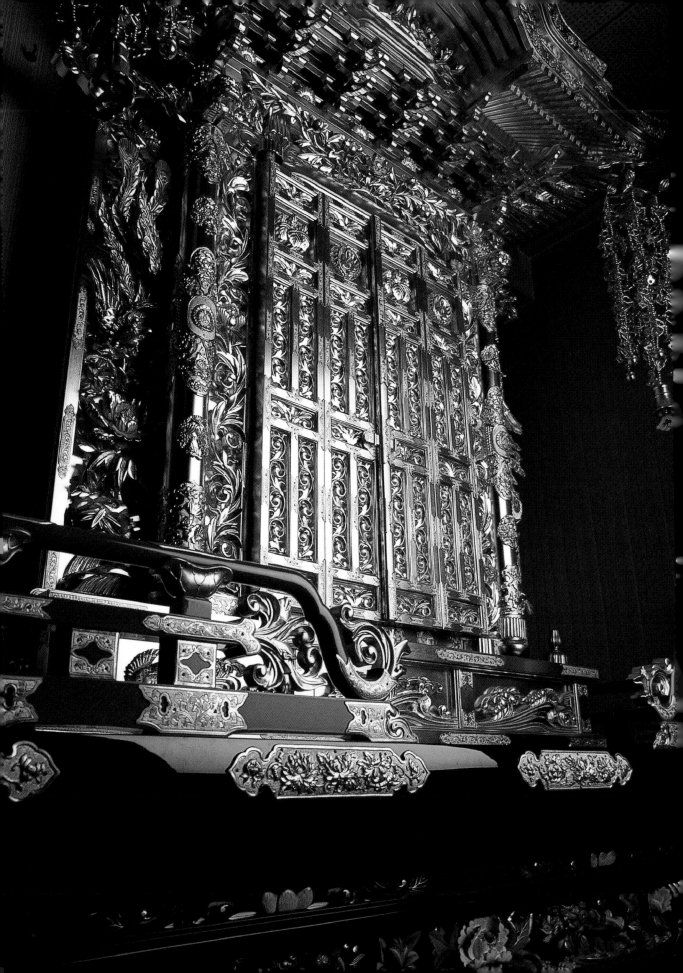

KYOTO HOUSEHOLD BUDDHIST ALTARS, FITTINGS
Kyō Butsudan, Kyō Butsugu
Kyoto

Buddhist family altars and altar implements are ordinarily considered separately. The essential difference is that family altars are used in the home, whereas the other items are used at official places of worship. In the simplest possible terms, the cupboard-like *butsudan* is used to house memorial tablets inscribed with the secular names of ancestors. There is also usually an image of the Buddha so that worship can take place in front of a *butsudan* on a daily basis.

The making of implements used on Buddhist altars in Kyoto dates back to the very introduction of Buddhism, sometime around 552. During the second half of the Heian period, the building of esoteric temples and the making of religious articles was being actively pursued, nowhere more so than in Kyoto, which was already the center of religious crafts. The Kamakura period was to see a further increase in the making of Buddhist statues and metalwork altar fittings. It was not until the beginning of the seventeenth century, however, that home altars came into use. The catalyst for this change was a declaration of faith made obligatory at the time of a census in order to suppress the Christian religion, and sometime after 1641, the altars found a place in every home as proof of religious belief.

Today, home altars are made in various places, each with their own particular characteristics. Gilded altars from such places as Nagoya and Hikone (Shiga Prefecture) are known as *nuri butsudan*. Rare wood altars (*karaki butsudan*) are made in Tokyo. Those fashioned in Tokushima are known for their large size. Conversely, the number of locations in which articles for altars are being made is rather small. In fact, Kyoto produces 85 percent of the country's total requirements, mostly for use at temples and monasteries.

An extensive range of religious paraphernalia is produced in Kyoto. Used when the sutras are chanted, the *mokugyo* is either a wooden board shaped like a fish or a hollow, shell-like piece of wood decorated with fish scales. It is struck rhythmically with a stick, the end of which is covered by a piece of cloth or leather. Placed in front of the Buddha, the *takatsuki* is a long-legged disk in which fruit or confectionery are offered. Looking something like a string of precious stones, the *yōrai* are placed around the neck, on the arm or at the elbow,

and on the leg of a Buddha statue as a form of decoration. Made to hold the incense that is burned at Buddhist services, metal and pottery *kōro* are produced in a number of styles. Called a *kin* but usually known as a *rin*, this metal chime is struck as a sign that a *gongyō* service is going to begin. Again struck like an instrument, the *dora* is used at a *hōyō* memorial service. Decorative in nature, the *keman* are used to create an air of solemnity in the grounds of the temple. These flowerlike garlands made of various materials are hung over railings and other appropriate places. In addition, there are the statues of the Buddha and paintings depicting Buddhist subjects. But whatever the article, all are instilled with an essence of Buddhism and a sense of Kyoto craftsmanship.

The making of a *butsudan* involves a number of specialized craftsmen. There are woodworkers who cut and prepare the necessary material, woodcarvers, craftsmen who deal with the decorations, lacquerers, gilders, and specialists in the art of *makie*. Even the final assembly of a home altar is left up to a skilled person.

The fabrication of a *butsudan* is a process of assembling parts that in many cases have been finished beforehand. The woods used are Japanese cypress, zelkova, pine, and Japanese cedar. Such woods are used for the making of the roofs, doors, plinths, and inner sanctuary. After the wood has been carved it is coated with natural lacquer. Decorative applications such as *makie* and gilding are then carried out as required. Next the copper fittings are attached. The whole thing is then assembled and the final finishing is done.

Lacquer is used for most of the coloring and decorating of the metal and wooden articles produced, and the latter in particular are often gilded. Some of the articles carved out of wood are made by laminating several pieces of wood together (*yosegi*), whereas others are carved directly from a piece of wood (*ittōbori*). Copper or a copper alloy are often used for the metalwork. Casting, forging, and metal carving are the principal modeling techniques employed.

The artistry and craftsmanship that are exercised on these religious items are of the highest quality and yet are executed with apparent ease. The end result is a work of stature that still manages to glow from within.

KYOTO CANDLES • *Kyō Rōsoku*

Kyoto

Since time immemorial, people everywhere have sought a reliable source of artificial light. In Japan, the candle represents just one stage in this quest. Probably the first light sources used in the country were pitch-pine torches. Then came pine branches (*shisoku*) that had their ends scorched and soaked in oil. Later, tapers of paper were twisted up into a type of string and soaked in oil to form *shisoku*, which functioned much like a modern wick when lit. These in turn evolved into lanterns, themselves the precursors of the electric light.

Compared with other early light sources, candles have a long and unbroken lineage in Japan. They were first introduced into Japan mainly for religious purposes, although some were also used in upper-class households. These candles were made with imported beeswax until imports ceased sometime during the Heian period, when pine resin came to be used instead. Imports of beeswax resumed during the Muromachi period and, since the method of producing the wax was also introduced, greatly increasing the quantity of material available, the use of candles expanded to include the general populace. By the middle of the sixteenth century, both candles and candle wax were in production around Japan. The increasing use of candles spawned a variety of accessories for interior use, among them candlesticks (*shokudai*), small candlesticks (*te shoku*), and lamp stands (*bonbori*). Special candles decorated with festive scenes or flower designs were used at the Hina Matsuri (the girls' Doll Festival) or for ceremonial occasions with a religious significance.

Today, the ready supply of electricity has almost totally done away with the need for candlelight. The use of candles is mostly limited to Buddhist and other religious services. Yet so long as temples are functioning and these services are being held, there seems certain to be a demand for Japanese-style candles.

In fact, the candles that are being made in Kyoto today are almost exclusively for temple use, although some are also used for the tea ceremony. They do not produce soot, they last a long time, and they actually produce a lot of heat. Most come in one of two colors: white or deep vermilion. They are either conventionally shaped or of the distinctive *ikari* form. Described as "anchor" shaped, this means that they gradually become narrower toward their base and therefore present a tapering silhouette. The basic materials are *mokurō* or a vegetable wax sometimes known as Japanese wax.

Kyoto candles employ two methods of production. For the method known as *namagake*, the wicks are either *washi* paper or a reed known as *igusa*. To make a reed wick, the outer layer is peeled off and thoroughly dried; the paper wicks are made by coiling narrow strips of paper into a tube. One end of the finished wick is then pushed into a narrow bamboo tube so that most of its length remains exposed. Holding a bundle of these stuffed tubes in the right hand, the candlemaker steadies them against a stand and rolls them while, with the left hand, applying wax to the wicks. The bundle of tubes is then hung up to dry and the next bundle is treated in the same way. Once several bundles have been treated in this way, the candlemaker reapplies wax to the wicks of the first bundle, continuing this process until the required thickness for a candle is achieved. The number of applications needed to achieve the same thickness depends largely on the air temperature. Five or six coatings are generally sufficient, but fewer may be necessary in winter when the wax adheres better, and conversely, more may be required in summer.

The other way of making a candle is with a mold. Wax is simply poured into a wooden mold. Deep vermilion–colored candles can be made by mixing a pigment with some wax and applying it as a finish. Candles are also sometimes decorated by applying gold or silver leaf with natural lacquer. Molds are used for straight candles and for the "anchor" type, which can only be made in this way. For large candles too, a mold is required.

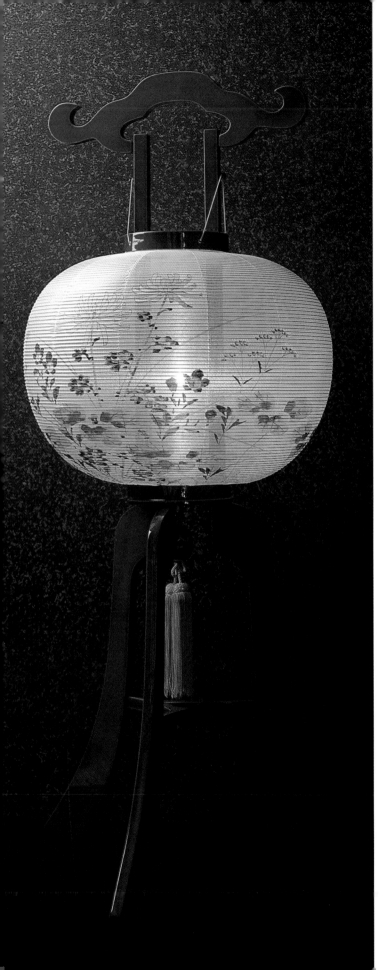

GIFU LANTERNS
Gifu Chōchin
Gifu,* Gifu Prefecture

To many people, paper lanterns are a symbol of the East, particularly of Japan. Their origins and first use, however, are not clear. Originally it seems that only fixed lanterns provided light. Lanterns that could be carried outside probably developed from a type of lamp called an *andon*. These were interior lamps that could be made portable by attaching a handle. (This development probably took place sometime after the Muromachi period.) In fact, it is difficult to distinguish between an *andon* and a *chōchin* of the times. But once lanterns made by covering baskets with paper entered into use, the *andon* became exclusively an interior lamp. The "basket lanterns"—as these early *chōchin* were known—were really improvised affairs, but toward the end of the sixteenth century, more substantial lanterns, foldable and made of narrow strips of bamboo covered with paper, were introduced. This type of *hako chōchin* was the first real portable lantern. During the peaceful Edo period, the making of lanterns became one of the jobs to which the lower ranks of warriors turned, along with the making of paper-covered umbrellas. Gradually such work was taken up by ordinary people and various shapes and sizes of lanterns were created. These lanterns remained a primary source of artificial light throughout the period. The practical need for lanterns almost disappeared toward the end of the nineteenth century, however, with the introduction of gas and electricity for street lighting. Nevertheless, this did not signal the end of the lantern. Elegant lanterns, to be hung rather than carried and decorated with painted flowers and grasses, began to be made. These decorative lanterns are used at the summer Festival of the Dead (Obon) and still form part of the everyday scene in Japan.

There are several explanations as to exactly how and when Gifu *chōchin* were first made. The generally accepted version attributes their creation to the lantern maker Morioka Jūzō and his son, who were supplying lanterns to the Nagoya clan during the second half of the eighteenth century. During the first twenty years of the next century, the skills of this craft became firmly established. It was not until the end of the nineteenth century, however, that distribution was expanded, especially after the

opening of the Tōkaidō rail line running between Tokyo and Osaka. At this stage, the lanterns were still being made in workshops operated by the wholesalers, albeit with a good deal of organized division of labor. From 1919, however, craftsmen themselves started to specialize. Some prepared the bamboo, others applied the paper, and still others painted on the decorations.

Of all the lanterns being made today, the egg-shaped ones decorated with the "seven grasses of autumn" are the most distinctive. Other types are either round, cylindrical, or *natsumegata*. This is a shape similar to the egg-shaped lanterns but with a more swelling form; its name is derived from the container used for powdered tea in the tea ceremony. Today, the uses of these lanterns are mostly decorative, but some are still used in the traditional way, for example to light the way for guests through a tea garden.

To make a lantern, strips of the bamboo are first wound round a wooden form. This is composed of eight or ten crescent-shaped segments that are put together to form a set. Following the shape of the form, threads are attached to each ring of bamboo and small pieces of paper are applied for strengthening. The whole form is then covered with either a plain paper or a woodblock-printed paper. After the whole thing is dry, the wooden form is collapsed and removed. Any hand-painting or touching up is then done, and rings of tin or pine are attached to the top and bottom. In appropriate cases, painted or unadorned wooden handles and stands are then fixed and the tassels are attached to finish.

The main areas in which lanterns are currently being produced are Gifu, Yame (Fukuoka Prefecture), and Nagoya. Lanterns of various kinds are also being made throughout the country. The decorative charm of Gifu *chōchin* stands out, however, adding a soft, ephemeral quality to Japan's hot and humid summer evenings that somehow makes the heat that much easier to bear.

IZUMO STONE LANTERNS • *Izumo Ishidōrō*

Shinji-chō, Shimane Prefecture

The notion that the light of a candle is symbolic of life must be at least as old as civilization itself. Placing that light in a form sculptured in stone not only serves to keep the flame alive and safe from the wind but also emphasizes its presence. The stone lanterns found in gardens in Japan are a fine example of this ancient practice.

They did not start life as such familiar garden accessories, however. The lanterns—said to have been introduced into Japan in the eighth century together with Buddhism, which arrived from China through the Korean Peninsula—were originally set up in front of the main buildings of worship at Buddhist temples. Their religious function was to provide a living light at a Buddhist memorial service, although more simply they were seen as items dedicated to the temple as part of the act of worship, and on a still more practical level, they provided illumination. During the Heian period, such lanterns began to appear in the grounds of Shintō shrines as well. With the rise of interest in the tea ceremony during the Momoyama period, they became a feature of tea gardens. This idea was expanded on in the following Edo period, when stone lanterns of various shapes and sizes were used as features in almost any kind of garden.

Lanterns from Izumo, a town in the southwest of Honshū facing the Japan Sea, made their appearance in the eighth century. Their golden age did not come until the Edo period, when the leader of the locally supreme Matsue clan prohibited the removal from his province of the type of sandstone tuff from which the lanterns and some other articles were made. Having therefore created a kind of "closed shop," he made efforts to protect and develop the processing of the stone.

Izumo sandstone is soft and easily worked. It is particularly appealing to the Japanese eye because of its clear, blue-gray coloring and the fact that in Japan's humid climate, moss will grow on it quite happily; this adds an aged look to the stone, bringing it closer to in its natural state. Although soft, the stone usually used stands up well to heat and cold, making it both functionally and aesthetically the most suitable stone for the job.

Initially, the processing and sculpting of the stone is done with a number of different tools, including a hand ax, a small pick, and a tool known as a *sanbonba*. Used simply to hack away at the stone, the *sanbonba* is a flat, bladelike hand pick, with three 5-millimeter-square steel teeth welded to the end of the blade. Finer work is done with chisels.

Individual types of lanterns illustrate particular aspects of Japanese aesthetic thinking. The *rokkaku yukimi* type is short, squat, and hexagonal, but can be made with a wide, spreading roof, used principally in gardens as an accent. Its form is perhaps shown to best advantage after a fall of snow, as suggested by the name *yukimi*, or "snow viewing." The *nuresagi* type gets its name from the image of a heron standing characteristically on one leg with snow piling up on its back. The bell-shaped top of the lantern is vaguely reminiscent of the shape of the bird in this pose, suggestion coming close to reality when the lantern actually has snow on it. Playing on the Japanese fascination with the rustic, the *kusaya* type of lantern is made to resemble a traditional farmhouse in model form, something that can look almost kitsch unless well crafted. The Oribe type takes its name from Furuta Oribe, a master of tea in the Momoyama period, and looks like the lantern that was placed over his grave. This is doubtless a measure of the lantern's subsequent strong connections with "the way of tea." Much more indicative of the craft's origins, however, is the pagoda type of lantern, mimicking one of the essential buildings in a temple complex, but again scaled down so as to look like a pagoda in the miniature landscape of a Japanese garden.

Not only lanterns but also such artifacts as stone basins for rinsing the hands, found specifically in tea gardens, or the guardian dog (*komainu*) statues used at Shintō shrines, as well as various other garden ornaments, all seem to be a quintessence of Japanese aesthetic thinking, and therefore deserve a closer inspection than they are usually afforded.

GIFU UMBRELLAS • *Gifu Wagasa*

Gifu, Gifu Prefecture

Traditionally, an umbrella, or *kasa*, was not the only thing to keep off the rain and snow or the rays of the sun. One early type of *kasa* was worn on the head! The word *kasa* is used for both this hat and an umbrella, although the characters are, of course, different.

The origins of Gifu *wagasa* date back to the beginning of the Edo period. In 1639, Matsudaira Tanbanokami Mitsushige, a member of a family directly related to the ruling Tokugawas, moved from Akashi in Banshū province, west of Osaka, to the castle town of Gifu. He took with him some of the *kasa* makers who had been working in Akashi, and it was these artisans who laid the foundations of umbrella-making in the town. In 1756, when the local Kanō clan found itself in some financial difficulties, the lower-ranking samurai were encouraged to start making umbrellas at home in order to alleviate the situation. Umbrella-making flourished, but rather than actually covering the umbrellas, it seems that these samurai were engaged in making the struts and hubs, something that was more difficult for ordinary people to do themselves. Such work became a living for these warriors, who were to all intents and purposes out of a job in these peaceful times. Yet money was not their sole incentive. They were also practicing the craft as a discipline to which they could completely devote themselves, rather as if training themselves for battle. Consequently, they become quite skilled and the quality of the craft steadily improved.

The basic materials for making *wagasa* are the same as they have always been: *madake*, a type of bamboo, and Mino *washi*, a type of handmade paper. After the skin is taken off the bamboo and its nodes are removed, it is initially split, then split again to the required width. The main struts are warmed over a fire and straightened. The secondary struts are then dyed and holes are made in them. When the nodes are removed from the shaft, the hub and end can be fixed. All the struts are then attached to the hub. Paper is fixed around the end and four pieces of fan-shaped paper are laid on the open struts and glued. An undercoat of persimmon juice is now applied, after which the paper is painted with a mixture of paulownia seed oil, clear kerosene, and linseed oil in the proportions of 2:2:6. The umbrella is then put outside in the sun to dry. Thereafter, the secondary struts are joined together with thread, the umbrella is folded, and the outside is coated with natural lacquer. A grip is made by winding rattan around the bamboo shaft, and lastly, the metal fittings are attached.

One of the most characteristic of the Gifu *wagasa* is known as a *janome gasa*. This is a red umbrella with a white "snake-eye ring" (*janome*) on it. These are often very large and act as sunshades outside traditional refreshment places in parks. Other more conventionally sized ones can be found at traditional inns for the use of the guests, and still others are used in classical dancing. Whatever their use, the *wagasa* will always be one of the most compelling manifestations of traditional Japan.

MARUGAME ROUND FANS • *Marugame Uchiwa*

Marugame,* Kagawa Prefecture

Marugame has always been famous for its *uchiwa*. In the past these rigid, nonfolding fans were made only of paper and bamboo. But today the majority are made of plastic and are of a quality that leaves much to be desired. Nonetheless, two traditional types of *uchiwa* are still being made. One is the round-handled *maru-e*, and the other, more commonly seen type is the flat-handled *hira-e*.

The port of Marugame was one of the places at which pilgrims to the famous Kotohiragū Shrine disembarked. Located more or less in the center of Shikoku, Kotohiragū has been one of Japan's most popular shrines for many centuries and is dedicated to a god who is believed to give protection to seafarers and voyagers. In 1633, the local Ikoma clan invited some skilled artisans from Yamato, on the Kii Peninsula, to come to the area to make *maru-e* fans using one of the robust varieties of "male" bamboo found locally. The *uchiwa* they made were decorated with the character for money (*kane*), which is also the first character for the name of Kotohiragu. These fans, sold to the pilgrims, are thought to mark the beginnings of the Marugame *uchiwa*.

Most of the *uchiwa* being produced in Marugame toward the end of the nineteenth century were little more than skeletons that were shipped elsewhere for finishing. However, from about 1897, the fans were completed before being distributed. After the Russo-Japanese War of 1904–1905, *uchiwa* began to be extensively used for advertising and other promotional purposes, and this stimulated the mass production of flat-handled *hira-e* fans. The invention in 1913 of machines to shape and cut holes in the fans increased productivity and led to a further lowering of prices. The *hira-e uchiwa* thus became the main product.

In traditional fans, the ribs are made of a bamboo called *madake* and the paper is good-quality *washi*. To make a flat-handled fan, the bamboo is first cut to length, then the part that will form the ribs is thinned. A hole is made in the handle and a piece of fine bamboo is passed through it and bowed. Both the handle and the ribs are then fixed with thread. The ends of the ribs are cut to follow the shape described by the bowed loop of bamboo, and the paper is glued on. After the edge has been finished off and strengthened with a narrow strip of paper, a rubber roller is used to press the paper down tightly so that the ribs are expressed.

Given the high level of craft needed to produce them, it is inevitable that the traditionally made *uchiwa* are more appealing than the plastic alternatives. Marugame fans have a practical and unaffected elegance that befits such an article and ensures them a lasting place in the Japanese summer.

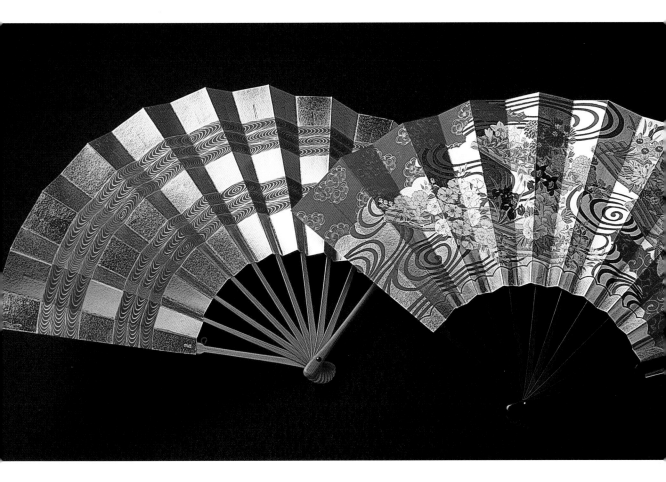

KYOTO FOLDING FANS • *Kyō Sensu*

Kyoto

The type of folding fan (*sensu*) that is available today was first made in the Gojō district of Kyoto during the 1190s. Originally made with leaves of cypress, it was used only by courtiers, people of noble birth, and the upper echelons of society. It was not until the twelfth century that ordinary people began to use them. After the Muromachi period, fans developed in step with the fashions of ikebana, dance, the tea ceremony, and *kōdō* (the pastime of incense smelling).

Sensu are made with a variety of end uses in mind. Some are for use in the summer (*natsu ōgi*), others are made especially for use at the tea ceremony (*cha ōgi*), and still others are associated with incense smelling (*kō ōgi*). One type is used for traditional dance and Noh. Further variations are miniature folding fans (*mame ōgi*) and *sensu* used for ceremonial purposes (*shūgi ōgi*).

The five-step process of constructing a fan begins with the making of the bamboo ribs. Bamboo is cut, split, then trimmed to the desired length. A hole is drilled through the ribs for the rivet, then the ribs as a block are planed and shaped. The bamboo is then dried in sunlight, polished and, if called for, lacquered on the bottom. The portion of the ribs to be slid between the two layers of paper is next shaved until it is wafer thin.

The paper mounting is of several layers, with inner pockets to accept the ribs. Decoration is done beforehand: gold or silver leaf or powders can be used to express a design. In the technique called *sunago furi*, glue is first painted on the paper and then the powders are sprinkled on. Another decorative technique is known as *bunkin*. For this the covering paper is folded, the paper is slightly stepped, and glue is rubbed into either the top or the bottom. Gold leaf or powder is then applied later. Designs or pictorial motifs are sometimes painted on by hand, sometimes printed. In the final step, the paper is folded and the ribs are inserted into the pockets with a good deal of speed and dexterity, then the paper is secured to the ribs. The fan is now finished.

Even though the advent of air conditioning has displaced the need for fans in some cases, fans of all kinds are still in constant use. Many stores give away rigid fans to their customers during the hot, humid summer months, and folding fans are still part of the summer scene even in the main urban conurbations. It seems, therefore, that the useful life of the fan is far from over.

EDO "ART" DOLLS • *Edo Kimekomi Ningyō*

Tokyo and Iwatsuki, Saitama Prefecture

With their colorful past, fine details, and relatively complex process of fabrication for something of this size, it seems a gross understatement to call these exquisite ornaments "dolls." But this is the only appropriate word in English to describe anything from the simplest of rag toys right up to something as sophisticated and refined as the Edo *kimekomi ningyō*. In any case, the Japanese *ningyō* (or *hitogata*, as the same characters are sometimes pronounced), which literally means "people model," is equally broad in its usage and is similarly used as a tag for this type of principally ornamental doll.

The Edo "art" doll probably started life when a craftsman in Kyoto made a figure from wood scraps. Having therefore most likely originated in a similar way to the *kokeshi*, it took the name of the location where it was first made, namely near the Kamogawa River, hence the initial name Kamo *ningyō*, or even Kamogawa *ningyō*. Because the clothes were tucked into grooves in the body, it later became known as a *kimekomi ningyō*, *kime* referring to the grooves in the wood made to accept the ends of the fabric of the clothes, and *komi* meaning in this instance "to tuck in."

Such was the movement of people during the Edo period that these ornaments soon found their way to Edo (present-day Tokyo) and it was not long before the technique, too, was conveyed to this thriving center of civilization. The greatly increased demand for the dolls in Edo stimulated further developments in the fabrication process.

It was in Edo that the *tōso* technique came into use, although its exact origins and date of development are not clear. Simply speaking, this involves combining fine paulownia sawdust with fresh funorin and pressing the mixture into a mold, thereby making it possible to produce larger numbers of dolls more quickly. The production process is somehow typical of the Edo craftsman's skill and flare for inventive development. First, clay is used to make the heads, bodies, hands, and feet, from which a pair of molds are made using sulfur or aluminum. The resulting molds are then filled with the sawdust and funorin mix. When dry, the parts are removed from the molds, pieced together, and have their join lines tidied up. The heads, for which unglazed pottery is sometimes used, are painted with a ground, and then the eyes, nose, and mouth are shaped with a knife. A final topcoat of color is applied, the eyes and eyebrows are painted in, and color is added to the cheeks and lips. Finally, the head is completed by implanting silk hair. As in the original method using a solid wooden body, so with the wood-composite body grooves are cut to accept the ends of the dresses, some adhesive having first been set into the grooves. The dresses are made from woven silk or cotton cloth that is cut from a pattern. As can be imagined, this way of dressing the doll gives the illusion that the clothes are being worn and adds significantly to the overall charm of these figures, which also display fine facial features and delicate detail.

The types of dolls made are mainly Kabuki and Noh theater figures, those displayed at the Doll Festival (Hina Matsuri) for girls held in March, figures called *gogatsu ningyō* associated with the Children's Day (Kodomo no Hi) for boys in May, and portrayals of characters from traditional stories or simply people of the moment. The continued existence of the Edo *kimekomi ningyō* must have something to do with the fact that at the end of the nineteenth century, two competing factions became established, handing down the artistry and techniques associated with each style of doll-making from one generation to the next. What started in an odd moment has evolved into a highly developed object, which in itself is a story particularly representative of the Japanese way of doing things.

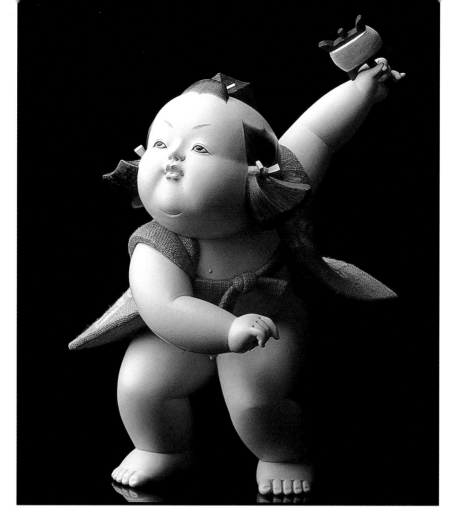

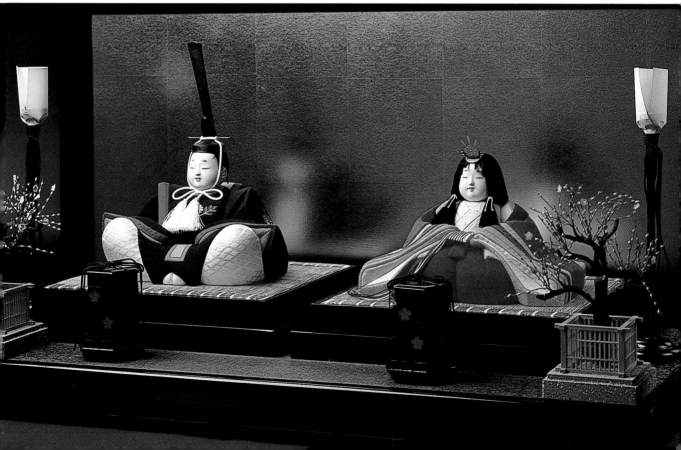

EDO BATTLEDORES • *Edo Oshie Hagoita*

Tokyo

Battledore and shuttlecock, or *hanetsuki*, is one of the more charming traditional games of Japan. The object is simply to hit the shuttlecock back and forth, and the loser has their face smudged with charcoal or white powder as a penalty. This can become very amusing when the game is played by young girls dressed in their finest kimono at the New Year. The game seems to have originated as a charm to protect children from evil and the mosquito, a prevalent pest through the hot, humid summer months and into the autumn. The *hane*, or shuttlecock, is said by some to represent the dragonfly, which eats these insects.

The history of the *hagoita* itself can be traced back through records to the fifth day of the first month in 1432, when the imperial family, court officials, and ladies employed at the court were divided into teams of men and women to play a game called *kogi no ko shōbu*. This was the old form of *hanetsuki*. At the time, there were several types of battledore: some to which illustrations were applied directly; some with raised images using paper, fabric, and a white paste-like pigment; and others with gold and silver leaf.

The Edo *oshie hagoita* seems to have appeared sometime at the beginning of the nineteenth century, a period in Japan when the merchant classes were in ascendance and *ukiyoe* woodblock prints were widely admired. Battledores adorned by the *ukiyoe* artists with images of the Kabuki actors in their stage roles were particularly sought after. Come the end of the year, people would vie with each other to obtain these depictions of popular performers, which were sold at the Battledore Market (*hagoita ichi*) held in the grounds of Tokyo's Sensōji temple. These decorative battledores, which even today depict famous Kabuki characters and geisha as well as contemporary popular singers and personalities, are made to be admired rather than played with, although some still are made for that purpose.

The paddle-shaped battledore is made of the very light, close-grained paulownia wood (*kiri*). To make the padded images, silk and cotton are usually employed, pieces of fabric being cut to match thick paper patterns. The fabric is attached to these

and then cotton wadding is inserted between the two before a rice paste is applied, using an iron to form the required three-dimensional effect. The eyes, eyebrows, nose, and mouth are then painted on and the silk hair implanted. All the pieces are then organized and glued to another piece of paper before being attached to the paddle with brass tacks.

The Battledore Market (Hagoita Ichi) is still a popular event in Tokyo's calendar, and those who have become proud owners of one of these brightly decorated *hagoita* are forced to carry them aloft for fear that they might get damaged among the crowds that throng the limited temple grounds and surrounding streets. This craft, so prized in the past, still holds a special place in the hearts of the people.

MIHARU DOLLS • *Miharu Hariko*

Miharu-machi and Kōriyama, Fukushima Prefecture

Winter is a very slack season for farmers in most parts of Japan. It is not uncommon, even today, for a farmer to seek other kinds of employment in the winter months to help pay his bills.

It was in this spirit of fostering work besides agriculture that the leader of the Miharu clan, Akita Kiyosue, invited doll makers from Edo (now Tokyo) to this northern province in the early part of the eighteenth century. Kiyosue's aim was to make better use of the available labor during the seasonal lull, and the result was the development of the Miharu *hariko* papier-mâché dolls. Before this, the minor fiefdom of Takashiba, a part of present-day Kōriyama, had been famous for its Miharu *ningyō*, and this has created some confusion with the dolls later produced at Miharu itself. What are now called Miharu *hariko* started out by being known as Takashiba *ningyō* or Miharu *ningyō*. Eventually a name combining the method of fabrication and the name of the locality stuck, establishing the reputation of the Miharu *hariko*. With the name set and the support of the clan, techniques were further refined, and by the beginning of the nineteenth century, Miharu *hariko*

were known nationwide. During this golden age for the craft, upward of five hundred different types of dolls were being made. Today there are less of the highly ornate types of figures and animals than there used to be, but a good number are still available. Among these, the *tama usagi* (a rabbit with a cute expression), the portrayal of the god Tenjin riding on a bullock, and representations of Kabuki and other popular characters all manifest the traditions of this uncomplicated folkcraft.

As with most other types of papier-mâché craft, several layers of small pieces of paper, in this case *washi*, are fastened with rice paste to the outside of a wooden form or to the inside of a wooden mold. A further coat of the paste is applied to bind all the pieces of paper together, and sometimes a top-quality paper is used as a final covering. The form is removed by slitting the paper, then more paper is pasted on to cover the slit. Next, a white undercoat made from powdered shells is applied, and finally the dolls are painted. The finished products retain an element of primitive expression to rank them among the world's best folk art.

MIYAGI KOKESHI DOLLS
Miyagi Dentō Kokeshi
Naruko-chō, Zaō-machi, and Shiroishi, Miyagi Prefecture

The cylindrical *kokeshi* doll is well known outside Japan, principally because it is small and light, reasonably priced, and so distinctively Japanese that it makes a popular present or souvenir.

The doll's distinctive cylindrical body, which has neither hands nor feet, has changed very little since it was first created as a toy, probably from leftover scraps of wood, by craftsmen making other wooden articles to sell in one of the many spa towns of Miyagi Prefecture. The making of the *kokeshi* spread to other places, first simply as a toy, and then as a souvenir made in the other northeastern spa towns opened to the general public in the early part of the nineteenth century. In the middle of the twentieth century, new and imaginative types began to appear, and the dolls are now made all over the country to be collected or simply used as ornaments rather than played with.

At the outset, the pieces of this very simple doll were made on a two-person lathe, but in 1885, as demand from souvenir buyers increased, a one-person lathe was introduced. This gave rise to the modern form of *kokeshi*, and as a result of the interest shown in them by collectors and researchers alike, their status as a craft object solidified and their position as a decorative accessory was established.

There are five basic types of traditional Miyagi *kokeshi*, four of which originate from the spa towns of Miyagi. The Naruko Spa gives its name to the *naruko* type, which squeaks when the head is rotated. The *tōgatta* type takes its name from the Tōgatta Spa, while the *sakunami* type is also named after a spa town. Similarly, the *hijiori* type comes from the Hijiori Spa in Yamagata Prefecture. The odd doll out, as far as naming is concerned, is the *yajirō* type from the Kamasaki Spa. Although the shapes of all five types vary slightly, what they share is a beautifully simplified form and elegant outline. The shapes of the heads are usually either flattened spheres, or spheres narrowing toward the neck. The shoulders are sometimes rounded, sometimes stepped, but usually expressed in some way. There are also several styles in which the hair is painted. On the bodies, flowers such as the chrysanthemum, peony, and iris are incorporated in various designs, often together with rings that are painted on when the body is still on the lathe. In their traditional forms, however, almost all of the shapes and designs follow an accepted pattern.

The dolls are fashioned from dogwood, maple, zelkova, cherry, or Japanese pagoda, among others. Some dolls are fabricated in one piece, the heads being turned together with the bodies. Other designs call for the head to be turned separately, then attached to the main body. In this case, two methods may be used. One calls for a part of the head to be turned as a plug on a horizontal lathe, then forced into a hole only just big enough to accept it. This tight fit produces the squeak when the head is twisted. The other method utilizes a peg either projecting from the body or inserted into a hole in the body, onto which the head is fitted. Once the form is finished, the faces, hair, and designs are painted on with either *sumi*—black ink—or stain. After decoration, the doll receives a wax polish.

The story of the *kokeshi* is far from finished. Contemporary versions and innovations go on being crafted, building on the tradition of what might originally have been made by someone to keep a child amused when the snow lay deep outside.

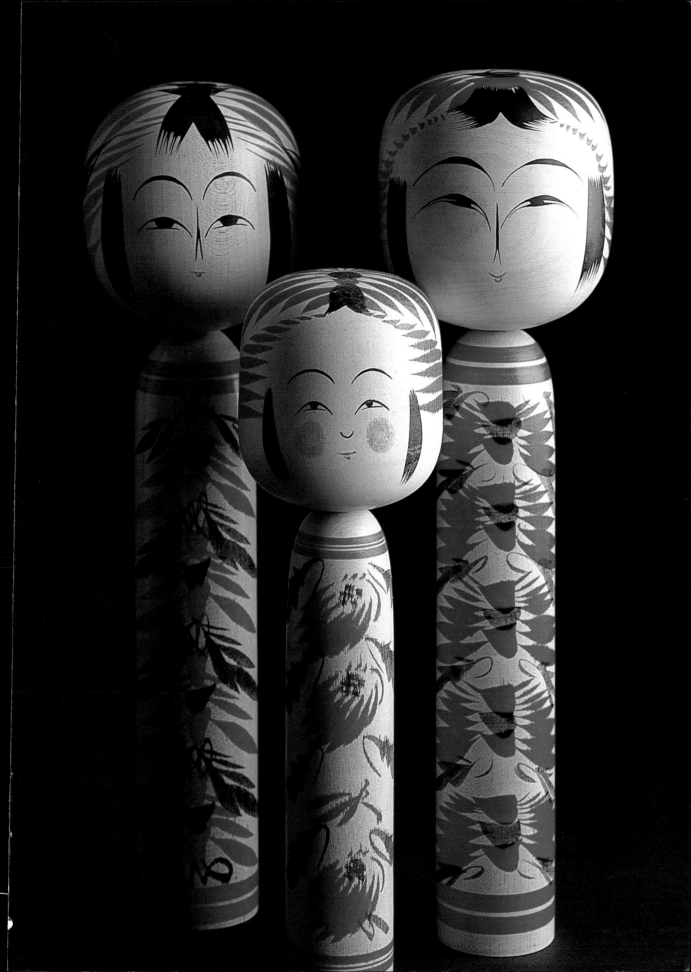

LIST OF REGIONAL CRAFT MUSEUMS, SHOWROOMS, AND CRAFT CENTERS

Many of the places below exhibit and sell items of local manufacture. However, the availability of salable goods and the content of exhibitions vary from place to place, and both museums and showrooms are sometimes closed for short periods of time or accessible only with an appointment. It is recommended that you call ahead in Japanese before making a special trip. Any correspondence should also be in Japanese.

Some crafts, particularly those centered in larger cities, do not have museums or showrooms devoted to the craft. For Kyoto crafts, the Kyoto Museum of Traditional Industry listed under Kyoto Ware displays a number of traditional Kyoto items. In some instances, commercial enterprises have been listed as alternatives. Additional information may be obtained by contacting the appropriate agency noted in the List of Craft Associations that follows.

Official English names are marked with an asterisk. All other names are equivalents provided for the reader's reference only.

CERAMICS 陶磁器 *Tōjiki*

KUTANI WARE • *Kutani Yaki*

MUSEUM FOR TRADITIONAL PRODUCTS AND CRAFTS*
石川県立伝統産業工芸館
〒920　1-1 Kenroku-machi, Kanazawa, Ishikawa Prefecture
〒920　石川県金沢市兼六町1-1
☎ 0762-62-2020

TERAI-MACHI KUTANI POTTERY CENTER
寺井町九谷焼陶芸館
〒923-11　9 Aza Izumidai-minami, Terai-machi, Nomi-gun, Ishikawa Prefecture
〒923-11　石川県能美郡寺井町字泉台南9
☎ 0761-58-6300

MASHIKO WARE • *Mashiko Yaki*

POTTERY MESSE MASHIKO
陶芸メッセ益子
〒321-42　3021 Ōaza Mashiko, Mashiko-machi, Haga-gun, Tochigi Prefecture
〒321-42　栃木県芳賀郡益子町大字益子3021
☎ 0285-72-7555

THE MASHIKO REFERENCE COLLECTION MUSEUM*
益子参考館
〒321-42　3388 Ōaza Mashiko, Mashiko-machi, Haga-gun, Tochigi Prefecture
〒321-42　栃木県芳賀郡益子町大字益子3388
☎ 0285-72-5300

MINO WARE • *Mino Yaki*

TOKI MINO WARE TRADITIONAL INDUSTRY HALL*
土岐市美濃焼伝統産業会館
〒509-51　1429-8 Aza Kitayama, Izumi-chō Kujiri, Toki, Gifu Prefecture
〒509-51　岐阜県土岐市泉町久尻字北山1429-8
☎ 0572-55-5527

TOKI MUNICIPAL INSTITUTE OF CERAMICS*
セラテクノ土岐
〒509-51　287-3-1 Hida-chō Hida, Toki, Gifu Prefecture
〒509-51　岐阜県土岐市肥田町肥田287-3-1
☎ 0572-59-8312

HAGI WARE • *Hagi Yaki*

YAMAGUCHI REGIONAL CENTER
山口ふるさと伝承総合センター
〒753　12 Ōaza Shimotate-kōji, Yamaguchi, Yamaguchi Prefecture
〒753　山口県山口市大字下堅小路12
☎ 0839-28-3333

HAGI WARE GALLERY
萩焼資料館
〒758　Horiuchi Jōshi, Hagi, Yamaguchi Prefecture
〒758　山口県萩市堀内城跡
☎ 0838-25-8981

KYOTO WARE, KIYOMIZU WARE • *Kyō Yaki, Kiyomizu Yaki*

KYOTO CITY INDUSTRIAL EXHIBITION HALL*
京都伝統産業ふれあい館　京都市勧業館「みやこめっせ」内
〒606　9-1 Seishōji-chō, Okazaki, Sakyō-ku, Kyoto
〒606　京都府京都市左京区岡崎成勝寺町9-1
☎ 075-222-3337（temporary; 京都市伝統産業課）

THE MUSEUM OF KYOTO*
京都文化博物館

〒604　Sanjō-takakura, Nakagyō-ku, Kyoto
〒604　京都府京都市中京区三条高倉
☎ 075–222–0888

KYOTO PORCELAIN CENTER
京都陶磁器会館
〒605　Higashi-Ōji Higashi-iru, Gojō-zaka, Higashiyama-ku, Kyoto
〒605　京都府京都市東山区五条坂東大路東入
☎ 075–541–1102

SHIGARAKI WARE • *Shigaraki Yaki*

THE TRADITIONAL CRAFT CENTER*
信楽伝統産業会館
〒529–18　1142 Ōaza Nagano, Shigaraki-chō, Kōka-gun, Shiga Prefecture
〒529–18　滋賀県甲賀郡信楽町大字長野1142
☎ 0748–82–2345

THE SHIGARAKI CERAMIC CULTURAL PARK*
滋賀陶芸の森
〒529–18　2188–7 Chokushi, Shigaraki-chō, Kōka-gun, Shiga Prefecture
〒529–18　滋賀県甲賀郡信楽町勅旨2188–7
☎ 0748–83–0909

BIZEN WARE • *Bizen Yaki*

BIZEN WARE TRADITIONAL CRAFT CENTER
備前焼伝統産業会館
〒705　1657–2 Inbe, Bizen, Okayama Prefecture
〒705　岡山県備前市伊部1657–2
☎ 0869–64–1001

BIZEN WARE POTTERY MUSEUM
備前陶芸美術館
〒705　1659–6 Inbe, Bizen, Okayama Prefecture
〒705　岡山県備前市伊部1659–6
☎ 0869–64–1400

ARITA WARE • *Arita Yaki*

IMARI ARITA TRADITIONAL CRAFT CENTER*
伊万里・有田焼伝統産業会館
〒848　222 Ōkawachi-yama Hei, Ōkawachi-chō, Imari, Saga Prefecture
〒848　佐賀県伊万里市大川内町大川内山丙222
☎ 0955–22–6333

ARITA PORCELAIN PARK*
有田ポーセリンパーク
〒844　370–2 Chūbu-Otsu, Arita-machi, Nishi-Matsuura-gun, Saga Prefecture
〒844　佐賀県西松浦郡有田町中部乙370–2
☎ 0955–42–6100

KYŪSHŪ CERAMIC MUSEUM*
九州陶磁文化会館
〒844　3100–1 Chūbu-Hei, Arita-machi, Nishimatsuura-gun, Saga Prefecture
〒844　佐賀県西松浦郡有田町中部丙3100–1
☎ 0955–43–3681

SAKAIDA KAKIEMON GALLERY
酒井田柿右衛門ギャラリー
〒844　352 Seibu-Tei, Arita-machi, Nishimatsuura-gun, Saga Prefecture

〒844　佐賀県西松浦郡有田町西部丁352
☎ 0955–43–2267

IMAIZUMI IMAEMON GALLERY
今泉今右衛門ギャラリー
〒844　1590 Akae-machi, Arita-machi, Nishimatsuura-gun, Saga Prefecture
〒844　佐賀県西松浦郡有田町赤絵町1590
☎ 0955–42–3101

TOKONAME WARE • *Tokoname Yaki*

TOKONAME POTTERY CENTER
常滑市陶磁器会館
〒479　3–8 Sakae-machi, Tokoname, Aichi Prefecture
〒479　愛知県常滑市栄町3–8
☎ 0569–35–2033

TOKONAME MUNICIPAL POTTERY INSTITUTE
常滑市立陶芸研究所展示室
〒479　7–22 Okujō, Tokoname, Aichi Prefecture
〒479　愛知県常滑市奥条7–22
☎ 0569–35–3970

TOBE WARE • *Tobe Yaki*

TOBE POTTERY TRADITIONAL INDUSTRY HALL*
砥部焼伝統産業会館
〒791–21　335 Ōminami, Tobe-chō, Iyo-gun, Ehime Prefecture
〒791–21　愛媛県伊予郡砥部町大南335
☎ 0899–62–6600

TOBE WARE POTTERY CENTER
砥部焼陶芸館
〒791–21　83 Miyauchi, Tobe-chō, Iyo-gun, Ehime Prefecture
〒791–21　愛媛県伊予郡砥部町宮内83
☎ 0899–62–3900

TSUBOYA WARE • *Tsuboya Yaki*

NAHA TRADITIONAL CRAFT CENTER
那覇市伝統工芸館
〒901–01　1–1 Aza Tōma, Naha, Okinawa Prefecture
〒901–01　沖縄県那覇市字当間1–1
☎ 098–858–6655

TSUBOYA POTTERY CENTER
壺屋陶器会館
〒902　1–21–14 Tsuboya, Naha, Okinawa Prefecture
〒902　沖縄県那覇市壺屋1–21–14
☎ 0988–66–3284

KIKUMA TILES • *Kikuma Gawara*

KIKUMA TILE CENTER
菊間瓦会館
〒799–23　3037 Hama, Kikuma-machi, Ochi-gun, Ehime Prefecture
〒799–23　愛媛県越智郡菊間町浜3037
☎ 0898–54–3450

TEXTILES　染織　*Senshoku*

KIRYŪ FABRICS • *Kiryū Ori*

KIRYŪ LOCAL INDUSTRY PROMOTION CENTER*
桐生地域地場産業振興センター
〒376　2–5 Orihime-chō, Kiryū, Gunma Prefecture

〒376　群馬県桐生市織姫町2–5
☎ 0277–46–1011

MORIHIDE TEXTILE CENTER · YUKARI
森秀織物参考館・紫（ゆかり）
〒376　4-2-24 Higashi, Kiryū, Gunma Prefecture
〒376　群馬県桐生市東4–2–24
☎ 0277–45–3111

OITAMA PONGEE • *Oitama Tsumugi*

YONEZAWA TEXTILE ARCHIVES
米沢織物歴史資料館
〒992　1–1-5 Montō-machi, Yonezawa, Yamagata Prefecture
〒992　山形県米沢市門東町1–1–5
☎ 0238–23–3006

YAMAGISHI TEXTILE
山岸織物
〒992　20457–12 Akakuzure, Yonezawa, Yamagata Prefecture
〒992　山形県米沢市赤崩20457–12
☎ 0238–38–2878

YŪKI PONGEE • *Yūki Tsumugi*

YŪKI PONGEE CENTER
結城紬染織資料館
〒307　12 Ōaza Yūki, Yūki, Ibaragi Prefecture
〒307　茨城県結城市大字結城12
☎ 0296–33–3111

OJIYA RAMIE CREPE • *Ojiya Chijimi*

OJIYA TRADITIONAL CRAFT CENTER
小千谷市伝統産業会館
〒947　1-8-25 Jōnai, Ojiya, Niigata Prefecture
〒947　新潟県小千谷市城内1–8–25
☎ 0258–83–2329

SHINSHŪ PONGEE • *Shinshū Tsumugi*

AIZUYA
会津屋
〒390　7–6 Habaue, Matsumoto, Nagano Prefecture
〒390　長野県松本市巾上7–6
☎ 0263–32–3728

NAMIYA TEXTILE
那美屋織物
〒395　2 Kodenma-chō, Iida, Nagano Prefecture
〒395　長野県飯田市小伝馬町2
☎ 0265–24–7380

NISHIJIN FABRICS • *Nishijin Ori*

NISHIJIN TEXTILE CENTER*
西陣織会館
〒602　Imadegawa Minami-iru, Horikawa-dōri, Kamigyō-ku, Kyoto
〒602　京都府京都市上京区堀川通今出川南入ル
☎ 075–451–9231

YUMIHAMA IKAT • *Yumihama Gasuri*

TOTTORI PREFECTURE TOURIST CENTER
鳥取県物産観光センター
〒680　160 Suehiro-onsen-chō, Tottori, Tottori Prefecture
〒680　鳥取県鳥取市末広温泉町160
☎ 0857–29–0021

ASIAN ARTIFACTS MUSEUM
アジア博物館
〒683–01　57 Ōshinozu-chō, Yonago, Tottori Prefecture
〒683–01　鳥取県米子市大篠津町57
☎ 0859–25–1251

HAKATA WEAVE • *Hakata Ori*

HAKATA TEXTILE CENTER
博多織伝産展示館
〒812　1–14–12 Hakataeki-minami, Hakata-ku, Fukuoka, Fukuoka Prefecture
〒812　福岡県福岡市博多区博多駅南1–14–12
☎ 092–472–0761

TRUE ŌSHIMA PONGEE • *Honba Ōshima Tsumugi*

TRUE ŌSHIMA PONGEE TRADITIONAL CRAFT CENTER
本場大島紬伝統産業会館（奄美群島大島紬総合会館）
〒894　15 Minato-machi, Naze, Kagoshima Prefecture
〒894　鹿児島県名瀬市港町15
☎ 0997–52–3411

ŌSHIMA TSUMUGI NO SATO*
本場大島紬の里
〒891–01　1–8 Nan'ei, Kagoshima, Kagoshima Prefecture
〒891–01　鹿児島県鹿児島市南栄1–8
☎ 0992–68–0331

MIYAKO RAMIE • *Miyako Jōfu*

MIYAKO TRADITIONAL CRAFT CENTER
宮古伝統的工芸品研究センター
〒906　3 Aza Nishizato, Hirara, Okinawa Prefecture
〒906　沖縄県平良市字西里3
☎ 09807–2–8022

SHURI FABRICS • *Shuri Ori*

SHURI FABRIC CENTER
首里織工芸館
〒903　2–64 Shuritōbaru-chō, Naha, Okinawa Prefecture
〒903　沖縄県那覇市首里桃原町2–64
☎ 098–887–2746

KIJOKA ABACA • *Kijoka no Bashōfu*

ŌGIMI-SON ABACA CENTER
大宜味村立芭蕉布会館
〒905–13　454 Aza Kijoka, Ōgimi-son, Kunigami-gun, Okinawa Prefecture
〒905–13　沖縄県国頭郡大宜味村字喜如嘉454
☎ 0980–44–3033

YONTANZA MINSAA • *Yomitanzan Minsaa*

YOMITAN HISTORICAL AND FOLK CRAFT MUSEUM
読谷村立歴史民族資料館
〒904–03　708-6 Aza Zakimi, Yomitan-son, Nakagami-gun, Okinawa Prefecture
〒904–03　沖縄県中頭郡読谷村字座喜味708–6
☎ 098–958–3141

YOMITAN-SON TRADITIONAL CRAFT CENTER
読谷村伝統工芸総合センター
〒904–03　2974-2 Aza Zakimi, Yomitan-son, Nakagami-gun, Okinawa Prefecture
〒904–03　沖縄県中頭郡読谷村字座喜味2974–2
☎ 098–958–4674

ISESAKI IKAT • *Isesaki Gasuri*

ISESAKI TEXTILE CENTER
伊勢崎織物総合展示場
〒372　31-9 Kuruwa-chō, Isesaki, Gunma Prefecture
〒372　群馬県伊勢崎市曲輪町31-9
☎ 0270-25-2700

TSUGARU KOGIN STITCHING • *Tsugaru Kogin*

HIROSAKI KOGIN STITCHING STUDIO
弘前こぎん研究所
〒036　61 Zaifu-chō, Hirosaki, Aomori Prefecture
〒036　青森県弘前市在府町61
☎ 0172-32-0595

TOKYO STENCIL DYEING • *Tokyo Somekomon*

FUTABAEN
二葉苑
〒161　2-3-2 Kami Ochiai, Shinjuku-ku, Tokyo
〒161　東京都新宿区上落合2-3-2
☎ 03-3368-8133

KAGA YŪZEN DYEING • *Kaga Yūzen*

KAGA YŪZEN TRADITIONAL CRAFT CENTER
加賀友禅伝統産業会館
〒920　8-8 Koshō-machi, Kanazawa, Ishikawa Prefecture
〒920　石川県金沢市小将町8-8
☎ 0762-24-5511

KYOTO YŪZEN DYEING • *Kyō Yūzen*
KYOTO STENCIL DYEING • *Kyō Komon*

KYOTO YŪZEN CULTURAL HALL*
京都友禅文化会館
〒615　6 Mameda-chō, Nishi-Kyōgoku, Ukyō-ku, Kyoto
〒615　京都府京都市右京区西京極豆田町6
☎ 075-311-0025

TOKYO YUKATA STENCIL DYEING • *Tokyo Honzome Yukata*

OKAMURA DYEING FACTORY
株式会社　岡村染工場
〒120　29-6 Senjunakai-chō, Adachi-ku, Tokyo
〒120　東京都足立区千住中居町29-6
☎ 03-3881-0111

KYOTO EMBROIDERY • *Kyō Nui*

NISHI EMBROIDERY
有限会社　西刺繍
〒600　Kōtake-chō, Matsubara-agaru, Kawaramachi-dōri, Shimogyō-ku, Kyoto
〒600　京都府京都市下京区河原町通松原上ル幸竹町
☎ 075-361-5494

NAGAKUSA EMBROIDERY
有限会社　長艸刺繍
〒600　562-1 Suhama-chō, Uramon-sagaru, Kamichōja-machi-dōri, Kamigyō-ku, Kyoto
〒600　京都府京都市上京区上長者町通裏門下ル須浜町562-1
☎ 075-451-3391

IGA BRAIDED CORDS • *Iga Kumihimo*

IGA KUMIHIMO CENTER
伊賀くみひもセンター
〒518　1929-10 Shijūku-chō, Ueno, Mie Prefecture
〒518　三重県上野市四十九町1929-10
☎ 0595-23-8038

LACQUER WARE　漆器　*Shikki*

WAJIMA LACQUER • *Wajima Nuri*

WAJIMA LACQUER WARE CENTER
輪島漆器会館
〒928　55, 24 bu Kawai-machi, Wajima, Ishikawa Prefecture
〒928　石川県輪島市河井町24部55
☎ 0768-22-2155

ISHIKAWA WAJIMA URUSHI ART MUSEUM*
石川県輪島漆芸美術館
〒928　11 Shijūgari, Mitomori-chō, Wajima, Ishikawa Prefecture
〒928　石川県輪島市水守町四十苅11
TEL: 0768-22-9788

ŌMUKAI KŌSHŪDŌ GALLERY
株式会社　大向高洲堂
〒928　6-45 Futatsuya-machi, Wajima, Ishikawa Prefecture
〒928　石川県輪島市二つ屋町6-45
TEL: 0768-22-1313

AIZU LACQUER • *Aizu Nuri*

FUKUSHIMA PREFECTURE TRADITIONAL CRAFT CENTER
福島県伝統産業会館
〒965　1-7-3 Ōmachi, Aizuwakamatsu, Fukushima Prefecture
〒965　福島県会津若松市大町1-7-3
☎ 0242-24-5757

SHIROKIYA LACQUER WARE GALLERY
株式会社　白木屋漆器店
〒965　1-2-10 Ōmachi, Aizuwakamatsu, Fukushima Prefecture
〒965　福島県会津若松市大町1-2-10
☎ 0242-22-0203

KISO LACQUER • *Kiso Shikki*

KISO CRAFT CENTER
木曽くらしの工芸館
〒399-63　2272-7 Aza Nagase, Hirasawa, Narakawa-mura, Kiso-gun, Nagano Prefecture
〒399-63　長野県木曽郡楢川村平沢字長瀬2272-7
☎ 0264-34-3888

GALLERY CHIKIRIYA
有限会社　ちきりや手塚万右衛門商店
〒399-63　1736-1 Hirasawa, Narakawa-mura, Kiso-gun, Nagano Prefecture
〒399-63　長野県木曾郡楢川村平沢1736-1
☎ 0264-34-2002

HIDA SHUNKEI LACQUER • *Hida Shunkei*

HIDA TAKAYAMA SHUNKEI CENTER
飛驒高山春慶会館
〒506　1 Kanda-machi, Takayama, Gifu Prefecture
〒506　岐阜県高山市神田町1丁目
☎ 0577-32-3373

HIDA LOCAL INDUSTRY PROMOTION CENTER
飛驒地域地場産業振興センター

〒506　5-1 Tenma-chō, Takayama, Gifu Prefecture
〒506　岐阜県高山市天満町5-1
☎ 0577-35-0370

KISHŪ LACQUER • *Kishū Shikki*

KISHŪ LACQUER WARE TRADITIONAL CRAFT CENTER
紀州漆器伝統産業会館
〒642　222 Funao, Kainan, Wakayama Prefecture
〒642　和歌山県海南市船尾222
☎ 0734-82-0322

MURAKAMI CARVED LACQUER • *Murakami Kibori Tsuishu*

MURAKAMI TSUISHU CRAFT CENTER
村上堆朱工芸館
〒958　1-8-24 Midori-machi, Murakami, Niigata Prefecture
〒958　新潟県村上市緑町1-8-24
☎ 0254-53-2478

KAMAKURA LACQUER • *Kamakura Bori*

KAMAKURA BORI CENTER
鎌倉彫会館
〒248　2-15-13 Komachi, Kamakura, Kanagawa Prefecture
〒248　神奈川県鎌倉市小町2-15-13
☎ 0467-25-1500

KAMAKURA BORI MUSEUM
鎌倉彫資料館
〒248　2-21-20 Komachi, Kamakura, Kanagawa Prefecture
〒248　神奈川県鎌倉市小町2-21-20
☎ 0467-25-1502

YAMANAKA LACQUER • *Yamanaka Shikki*

YAMANAKA LACQUER WARE TRADITIONAL CRAFT CENTER
山中漆器伝統産業会館
〒922-01　268-2, Tsukatani-machi-I, Yamanaka-machi,
　　Enuma-gun, Ishikawa Prefecture
〒922-01　石川県江沼郡山中町塚谷町イ268-2
☎ 07617-8-0305

MUSEUM FOR TRADITIONAL PRODUCTS AND CRAFTS*
石川県立伝統産業工芸館
〒920　1-1 Kenroku-machi, Kanazawa, Ishikawa Prefecture
〒920　石川県金沢市兼六町1-1
☎ 0762-62-2020

KAGAWA LACQUER • *Kagawa Shikki*

KAGAWA PREFECTURE PROMOTION CENTER
香川県商工奨励館
〒760　1-20-16 Ritsurin-chō, Takamatsu, Kagawa Prefecture
〒760　香川県高松市栗林町1-20-16　栗林公園内
☎ 0878-33-7411

KAGAWA PREFECTURE INDUSTRY CENTER
香川県産業会館
〒760　2-2-2 Fukuoka-chō, Takamatsu, Kagawa Prefecture
〒760　香川県高松市福岡町2-2-2
☎ 0878-51-5669

INTERIOR MORISHIGE MARUGAME GALLERY
インテリア・モリシゲ丸亀町店
〒760　2-4 Marugame-chō, Takamatsu, Kagawa Prefecture
〒760　香川県高松市丸亀町2-4
☎ 0878-51-3617

TSUGARU LACQUER • *Tsugaru Nuri*

TSUGARU LACQUER WARE STUDIOS COOP*
津軽塗団地協同組合会館
〒036　2-3-10 Kanda, Hirosaki, Aomori Prefecture
〒036　青森県弘前市神田2-3-10
☎ 0172-33-1188

TANAKAYA
田中屋
〒036　Ichibanchi-kado, Hirosaki, Aomori Prefecture
〒036　青森県弘前市一番地角
☎ 0172-33-6666

BAMBOO CRAFT　竹工品　*Chikkōhin*

SURUGA BASKETRY • *Suruga Take Sensuji Zaiku*

SHIZUOKA INDUSTRY CENTER
静岡市産業展示館
〒422　2992 Nakajima, Shizuoka, Shizuoka Prefecture
〒422　静岡県静岡市中島2992
☎ 054-287-5550

CHIKUDAI STUDIO
ちくだい工房
〒422　139 Takyo, Shizuoka, Shizuoka Prefecture
〒422　静岡県静岡市建穂139
☎ 054-278-3270

NENRINBŌ
燃林房
〒420　130-26 Yanagi-chō, Shizuoka, Shizuoka Prefecture
〒420　静岡県静岡市柳町130-26
☎ 0542-71-0631

BEPPU BASKETRY • *Beppu Take zaiku*

BEPPU TRADITIONAL BAMBOO CRAFT CENTER
別府市竹細工伝統産業会館
〒874　8-3 Higashi Sōen-chō, Beppu, Ōita Prefecture
〒874　大分県別府市東荘園町8-3
☎ 0977-23-1072

IWAO CHIKURAN
岩尾竹籃
〒874　1-5 Hikari-chō, Beppu, Ōita Prefecture
〒874　大分県別府市光町1-5
☎ 0977-22-4074

ŌITA INDUSTRIAL RESEARCH INSTITUTE, BEPPU
　INDUSTRIAL ARTS RESEARCH DIVISION*
大分県産業科学技術センター　別府産業工芸試験所
〒874　3-3 Higashi Sōen-chō, Beppu, Ōita Prefecture
〒874　大分県別府市東荘園町3-3
☎ 0977-22-0208

TAKAYAMA TEA WHISKS • *Takayama Chasen*

SUICHIKUEN
翠竹園
〒630-01　5621 Takayama-chō, Ikoma, Nara Prefecture
〒630-01　奈良県生駒市高山町5621
☎ 07437-8-0067

KUBO RYŌSAI
久保良斎
〒630-01　6659-3 Takayama-chō, Ikoma, Nara Prefecture
〒630-01　奈良県生駒市高山町6659-3
☎ 07437-8-0059

MIYAKONOJŌ BOWS • *Miyakonojō Daikyū*

MIYAKONOJŌ LOCAL CRAFT PROMOTION CENTER
都城圏域地場産業振興センター
〒885　5225-1 Tohoku-chō, Miyokonojō, Miyazaki Prefecture
〒885　宮崎県都城市北町5225-1
☎ 0986-38-4561

JAPANESE PAPER　和紙　*Washi*

ECHIZEN PAPER • *Echizen Washi*

PAPYRUS CENTER
パピルス館
〒915-02　8-44 Shinzaike, Imadate-chō, Imadate-gun, Fukui Prefecture
〒915-02　福井県今立郡今立町新在家8-44
☎ 0778-42-1363

WASHI PAPER CENTER
和紙の里会館
〒915-02　11-12 Shinzaike, Imadate-chō, Imadate-gun, Fukui Prefecture
〒915-02　福井県今立郡今立町新在家11-12
☎ 0778-42-0016

AWA PAPER • *Awa Washi*

AWAGAMI FACTORY*
阿波和紙伝統産業会館
〒779-34　141 Aza Kawahigashi, Yamakawa-chō, Oe-gun, Tokushima Prefecture
〒779-34　徳島県麻植郡山川町字川東141
☎ 0883-42-6120

TOKUSHIMA CRAFT CENTER
徳島工芸村
〒770　1-1 Higashi-Hamabōji, Yamashiro-chō, Tokushima, Tokushima Prefecture
〒770　徳島県徳島市山城町東浜傍示1-1
☎ 0886-24-5000

TOSA PAPER • *Tosa Washi*

TOSA WASHI VILLAGE COUR AUX DONS*
土佐和紙伝統産業会館（紙の博物館）
〒781-21　110-1 Saiwai-chō, Ino-chō, Agawa-gun, Kōchi Prefecture
〒781-21　高知県吾川郡伊野町幸町110-1
☎ 0888-93-0886

TOSA PAPER CRAFT CENTER
土佐和紙工芸村
〒781-21　1226 Kashiki, Ino-chō, Agawa-gun, Kōchi Prefecture
〒781-21　高知県吾川郡伊野町鹿敷1226
☎ 0888-92-1001

UCHIYAMA PAPER • *Uchiyama Gami*

IIYAMA FOLK ART MUSEUM
飯山市民芸館
〒389-22　Sekizawa, Ōaza Mizuho, Iiyama, Nagano Prefecture
〒389-22　長野県飯山市大字瑞穂関沢
☎ 0269-65-2501

IIYAMA TRADITIONAL CRAFT CENTER
飯山市伝統産業会館
〒389-22　1436-1 Ōaza Iiyama, Iiyama, Nagano Prefecture

〒389-22　長野県飯山市大字飯山1436-1
☎ 0269-62-4019

INSHŪ PAPER • *Inshū Washi*

YAMANE PAPER GALLERY
山根和紙資料館
〒689-05　128-5 Yamane, Aoya-chō, Ketaka-gun, Tottori Prefecture
〒689-05　鳥取県気高郡青谷町山根128-5
☎ 0857-86-0011

SAJI PAPER GALLERY (KAMING SAJI*)
佐治和紙民芸館
〒689-13　Kamo, Saji-son, Yazu-gun, Tottori Prefecture
〒689-13　鳥取県八頭郡佐治村加茂
☎ 0858-89-1816

WOODCRAFT　木工品　*Mokkōhin*

IWAYADŌ CHESTS • *Iwayadō Tansu*

IWAYADŌ TANSU CHEST GALLERY
岩谷堂箪笥展示館
〒023-11　68-1 Aza Ebishima, Odaki, Esashi, Iwate Prefecture
〒023-11　岩手県江刺市愛宕字海老島68-1
☎ 0197-35-0275

FUJISATO WOODCRAFT GALLERY
匠の森
〒023-17　185 Kanizawa, Tawara, Esashi, Iwate Prefecture
〒023-17　岩手県江刺市田原字蟹沢185
☎ 0197-35-7711

KAMO PAULOWNIA CHESTS • *Kamo Kiri Tansu*

KAMO KIRITANSU, INCORPORATED
加茂桐たんす株式会社
〒959-13　398-1 Ōaza Urasuda, Kamo, Niigata Prefecture
〒959-13　新潟県加茂市大字後須田398-1
☎ 0256-52-6740

KYOTO WOODWORK • *Kyō Sashimono*

ENAMI, INCORPORATED
有限会社　江南
〒600　89 Ebisuno-chō, Aino-machi Nishi-iru, Rokujō-dōri, Shimogyō-ku, Kyoto
〒600　京都府京都市下京区六條通間之町西入夷之町89
☎ 075-361-2816

ŌDATE BENTWOOD WORK • *Ōdate Magewappa*

DENSHŌ, INCORPORATED
株式会社　伝承
〒010　88-3 Aza Nomura, Soto-Asahikawa, Akita, Akita Prefecture
〒010　秋田県秋田市外旭川字野村88-3
☎ 0188-80-1101

AKITA CEDAR BOWLS AND BARRELS • *Akita Sugi Oke Taru*

AKITA PREFECTURE INDUSTRY CENTER
秋田県産業会館
〒010　Atorion B1F, 2-3-8 Naka-dōri, Akita, Akita Prefecture
〒010　秋田県秋田市中通2-3-8　アトリオン地下1階
☎ 0188-36-7830

TARUTOMI KAMATA
樽富かまた
〒016 4-3 Suehiro-chō, Noshiro, Akita Prefecture
〒016 秋田県能代市末広町4-3
☎ 0185-52-2539

HAKONE MARQUETRY • *Hakone Yosegi Zaiku*

HATAJUKU YOSEGI CRAFT CENTER
畑宿寄木会館
〒250-03 103 Hatajuku, Hakone-machi, Ashigarashimo-gun, Kanagawa Prefecture
〒250-03 神奈川県足柄下郡箱根町畑宿103
☎ 0460-5-8170

HONMA WOODCRAFT GALLERY
本間美術館
〒250-03 84 Yumoto, Hakone-machi, Ashigarashimo-gun, Kanagawa Prefecture
〒250-03 神奈川県足柄下郡箱根町湯本84
☎ 0460-5-5646

NAGISO TURNERY • *Nagiso Rokuro Zaiku*

NAGISO TURNERY ASSOCIATION
南木曾ろくろ工芸協同組合
〒399-53 4689 Azuma, Nagiso-chō, Kiso-gun, Nagano Prefecture
〒399-53 長野県木曽郡南木曾町吾妻4689
☎ 0264-58-2434

TAKAYAMA WOODCARVING • *Takayama Ichii-Ittōbori*

WANI HISAYUKI
和丹久幸
〒506 1-296-6 Morishita-chō, Takayama, Gifu Prefecture
〒506 岐阜県高山市森下町1-296-6
☎ 0577-33-0744

SUZUKI WOODCARVING
鈴木彫刻
〒506 1-chōme Hatta-chō, Takayama, Gifu Prefecture
〒506 岐阜県高山市初田町1丁目
☎ 0577-32-1367

INAMI WOODCARVING • *Inami Chōkoku*

INAMI WOODCARVING TRADITIONAL CRAFT CENTER
井波彫刻伝統産業会館
〒932-02 700-111 Inami, Inami-machi, Higashi-Tonami-gun, Toyama Prefecture
〒932-02 富山県東礪波郡井波町井波700-111
☎ 0763-82-5158

INAMI WOODCARVING CENTER
井波彫刻総合会館
〒932-02 733 Kitakawa, Inami-machi, Higashi-Tonami-gun, Toyama Prefecture
〒932-02 富山県東礪波郡井波町北川733
☎ 0763-82-5158

KISO OROKU COMBS • *Kiso Oroku Gushi*

OROKU COMBS CENTER ŌTSUTAYA
お六櫛センター大つたや
〒399-62 1224 Yabuhara, Kiso-mura, Kiso-gun, Nagano Prefecture
〒399-62 長野県木曽郡木祖村藪原1224
☎ 0264-36-2205

AKITA CHERRY-BARK WORK • *Akita Kabazaiku*

KAKUNODATE CHERRY-BARK CRAFT CENTER
角館町樺細工伝承館（ふるさとセンター）
〒014-03 10-1 Shimo-chō Omote-machi, Kakunodate-machi, Senboku-gun, Akita Prefecture
〒014-03 秋田県仙北郡角館町表町下町10-1
☎ 0187-54-1700

FUJIKI DENSHIRŌ, INCORPORATED
株式会社　藤木伝四郎商店
〒014-03 45 Shimoshin-chō, Kakunodate-machi, Senboku-gun, Akita Prefecture
〒014-03 秋田県仙北郡角館町下新町45
☎ 0187-54-1151

METALWORK 金工品 *Kinkōhin*

NANBU CAST IRONWORK • *Nanbu Tekki*

MORIOKA REGIONAL INDUSTRY PROMOTION CENTER
盛岡地域地場産業振興センター（盛岡手づくり工芸村）
〒020 64-102 Aza Oirino, Tsunagi, Morioka, Iwate Prefecture
〒020 岩手県盛岡市繋字尾入野64-102
☎ 0196-89-2336

MIZUSAWA CAST IRON FOUNDRY COOPERATIVE ASSOCIATION*
水沢鋳物工業協同組合
〒023 18 Aza Namiyanagi, Hada-chō, Mizusawa, Iwate Prefecture
〒023 岩手県水沢市羽田町字並柳18
☎ 0197-24-1551

IWACHŪ CASTING WORKS*
岩鋳鉄器館
〒020 2-23-9 Minami Senboku, Morioka, Iwate Prefecture
〒020 岩手県盛岡市南仙北2-23-9
☎ 0196-35-2501

TSUBAME BEATEN COPPERWARE • *Tsubame Tsuiki Dōki*

TSUBAME INDUSTRY ARCHIVES
燕市産業史料館
〒959-12 4330-1 Ōaza Ōmagari, Tsubame, Niigata Prefecture
〒959-12 新潟県燕市大字大曲4330-1
☎ 0256-63-7666

GYOKUSENDŌ GALLERY
株式会社　玉川堂
〒959-12 2 Chūō-dōri, Tsubame, Niigata Prefecture
〒959-12 新潟県燕市中央通2
☎ 0256-62-2015

TAKAOKA CASTING • *Takaoka Dōki*

TAKAOKA'S REGIONAL INDUSTRIAL CENTER*
高岡地域地場産業センター
〒933 1-1 Kaihatsu-honmachi, Takaoka, Toyama Prefecture
〒933 富山県高岡市開発本町1-1
☎ 0766-25-8283

TAKAOKA CASTING GALLERY
高岡銅器展示館
〒933 53-1 Toide Sakae-machi, Takaoka, Toyama Prefecture
〒933 富山県高岡市百出栄町53-1
☎ 0766-63-5556

OSAKA NANIWA PEWTER WARE • *Osaka Naniwa Suzuki*

SUZUHAN PEWTER GALLERY
錫半ショールーム
〒541　3-6-9 Minami Kyūhōji-machi, Chūō-ku, Osaka
〒541　大阪市中央区南久宝寺町3-6-9
☎ 06-251-8031

TOKYO SILVERSMITHERY • *Tokyo Ginki*

ŌBUCHI SILVERWARE GALLERY
株式会社　大淵銀器ショールーム
〒110　3-1-13 Higashi Ueno, Taitō-ku, Tokyo
〒110　東京都台東区東上野3-1-13
☎ 03-3847-7711

SAKAI FORGED BLADES • *Sakai Uchi Hamono*

SAKAI METAL WORK CENTER
堺金物会館
〒590　1-1-24 Shukuya-chō Nishi, Sakai, Osaka
〒590　大阪府堺市宿屋町西1-1-24
☎ 0722-27-1001

SAKAI FORGED BLADES GALLERY
堺刀司資料館
〒590　1-11 Nishi 2-chō, Sakurano-chō, Sakai, Osaka
〒590　大阪府堺市桜之町西2丁1-11
☎ 0722-38-0888

MIZUNO FORGED BLADES STUDIO
水野鍛錬所
〒590　1-27 Nishi 1-chō, Sakurano-chō, Sakai, Osaka
〒590　大阪府堺市桜之町西1丁1-27
☎ 0722-29-3253

SASUKE STUDIO
佐助
〒590　3-4-20 Kita Shimizu-chō, Sakai, Osaka
〒590　大阪府堺市北清水町3-4-20
☎ 0722-33-6812

KYOTO METAL INLAY • *Kyō Zōgan*

KAWAHITO HANDS
川人象嵌・象嵌の館川人ハンズ
〒603　76 Minami-machi, Tōjiin, Kita-ku, Kyoto
〒603　京都府京都市北区等持院南町76
☎ 075-461-2773

OTHER CRAFTS　諸工芸品　*Shokōgeihin*

BANSHŪ ABACUS • *Banshū Soroban*

ONO TRADITIONAL CRAFT CENTER
小野市伝統産業会館
〒675-13　806-1 Ōji-chō, Ono, Hyōgo Prefecture
〒675-13　兵庫県小野市王子町806-1
☎ 07946-2-3121

MIYAMOTO KAZUHIRO
宮本一広
〒675-13　1113 Tenjin-chō, Ōno, Hyōgo Prefecture
〒675-13　兵庫県小野市天神町1113
☎ 0794-62-6419

FUKUYAMA PLANE HARP • *Fukuyama Koto*

OGAWA MUSICAL INSTRUMENT, INCORPORATED
小川楽器製造株式会社

〒720　3-2-8 Miyoshi-machi, Fukuyama, Hiroshima Prefecture
〒720　広島県福山市三吉町3-2-8
☎ 0849-24-1150

KŌSHŪ LACQUERED DEERHIDE • *Kōshū Inden*

UEHARA YŪSHICHI INDEN GALLERY
株式会社　印傳屋上原勇七ショールーム
〒400　201 Aria, Kawada-chō, Kōfu, Yamanashi Prefecture
〒400　山梨県甲府市川田町アリア201
☎ 0552-20-1661

YAMANASHI TRADITIONAL CRAFT CENTER
山梨伝統産業会館
〒406　1569 Yokkaichiba, Isawa-chō, Higashi-Yatsushiro-gun, Yamanashi Prefecture
〒406　山梨県東八代郡石和町四日市場1569
☎ 0552-63-6741

NARA SUMI INK • *Nara Zumi*

KOBAIEN
古梅園
〒630　7 Tsubai-chō, Nara, Nara Prefecture
〒630　奈良県奈良市椿井町7
☎ 0742-23-2965

BOKU-UN-DŌ GALLERY
株式会社　墨運堂内　墨の資料館
〒630　1-5-35 Rokujō, Nara, Nara Prefecture
〒630　奈良県奈良市六条1-5-35
☎ 0742-41-7155

NARA BRUSHES • *Nara Fude*

AKASHIYA INCORPORATED
株式会社　あかしや
〒630　4-1 Shijō Ōji, Nara, Nara Prefecture
〒630　奈良県奈良市四条大路4-1
☎ 0742-33-6181

OGATSU INKSTONES • *Ogatsu Suzuri*

OGATSU INKSTONE TRADITIONAL CRAFT CENTER (STONE PLAZA*)
雄勝硯伝統産業会館
〒986-13　53-1 Aza Tera, Ōaza Ogatsu, Ogatsu-chō, Monou-gun, Miyagi Prefecture
〒986-13　宮城県桃生郡雄勝町大字雄勝字寺53-1
☎ 0225-57-3211

GYŌTOKU ŌKARAHAFŪ PORTABLE SHRINE • *Gyōtoku Ōkarahafū Mikoshi*

NAKADAI PORTABLE SHRINE
中台神輿製作所
〒272-01　21-3 Honjio, Ichikawa, Chiba Prefecture
〒272-01　千葉県市川市本塩21-3
☎ 0473-57-2061

KYOTO HOUSEHOLD BUDDHIST ALTARS, FITTINGS • *Kyō Butsudan, Kyō Butsugu*

MATSUMOTO-YA
松本屋
〒600　Takatsuji-kado, Teramachi-dōri, Shimogyō-ku, Kyoto
〒600　京都府京都市下京区寺町通高辻角
☎ 075-343-1200

KYOTO CANDLES • *Kyō Rōsoku*

TANJI RENSHŌDŌ
丹治蓮生堂
〒600　114 Nakai-chō, Karasuma Nishi-iru, Shichijō-dōri, Shimogyō-ku, Kyoto
〒600　京都府京都市下京区七条通烏丸西入中居町114
☎ 075-361-0937

GIFU LANTERNS • *Gifu Chōchin*
GIFU UMBRELLAS • *Gifu Wagasa*

GIFU INDUSTRY CENTER
岐阜県物産展木室
〒500　2-11-1 Rokujō-minami, Gifu, Gifu Prefecture
〒500　岐阜県岐阜市六条南2-11-1
☎ 0582-72-3399

IZUMO STONE LANTERNS • *Izumo Ishidōrō*

SHIMANE PREFECTURE TOURIST CENTER
島根県物産観光館
〒690　191 Tono-machi, Matsue, Shimane Prefecture
〒690　島根県松江市殿町191　島根ふるさと館内
☎ 0852-22-5758

MARUGAME ROUND FANS • *Marugame Uchiwa*

KAGAWA INDUSTRY CENTER
香川県産業会館
〒760　2-2-2 Fukuoka-chō, Takamatsu, Kagawa Prefecture
〒760　香川県高松市福岡町2-2-2
☎ 0878-51-5669

UCHIWA NO MINATO MUSEUM
うちわの港ミュージアム
〒763　307-15 Minato-machi, Marugame, Kagawa Prefecture
〒763　香川県丸亀市港町307-15
☎ 0877-24-7055

KYOTO FOLDING FANS • *Kyō Sensu*

MIYAWAKI BAISEN-AN
宮脇賣扇庵
〒604　Tominokōji Nishi-iru, Rokkaku-dōri, Nakagyō-ku, Kyoto
〒604　京都府京都市中京区六角通富小路西入ル
☎ 075-221-0181

EDO "ART" DOLLS • *Edo Kimekomi Ningyō*

MATARO DOLLS CENTER
真多呂人形会館
〒110　5-15-13 Ueno, Taitō-ku, Tokyo
〒110　東京都台東区上野5-15-13
☎ 03-3833-9661

KAKINUMA DOLL, INCORPORATED
株式会社　柿沼人形
〒343　2-174-4 Hichiza-chō, Koshigaya, Saitama Prefecture
〒343　埼玉県越谷市七左町2-174-4
☎ 0489-64-7877

EDO BATTLEDORES • *Edo Oshie Hagoita*

HAGOITA BATTLEDORE GALLERY
羽子板資料館
〒131　5-43-25 Mukōjima, Sumida-ku, Tokyo
〒131　東京都墨田区向島5-43-25
☎ 03-3623-1305

MIHARU DOLLS • *Miharu Hariko*

FUKUSHIMA PREFECTURE REGIONAL PRODUCTS CENTER
福島県物産館
〒960　4-15 Ōmachi, Fukushima, Fukushima Prefecture
〒960　福島県福島市大町4-15
☎ 0245-22-3948

TAKASHIBA DEKO YASHIKI
高柴デコ屋敷
〒977-01　163 Aza Tateno, Takashiba, Nishida-machi, Kōriyama, Fukushima Prefecture
〒977-01　福島県郡山市西田町高柴字館野163
☎ 0249-71-3176

MIHARU DOLL MUSEUM
三春郷土人形館
〒960　30 Aza Ōmachi, Miharu-machi, Fukushima Prefecture
〒960　福島県福島市三春町字大町30
☎ 0247-62-7053

MIYAGI KOKESHI DOLLS • *Miyagi Dentō Kokeshi*

ZAŌ-MACHI TRADITIONAL CRAFT CENTER
蔵王町伝統産業会館（みやぎ蔵王こけし館）
〒989-09　36-135 Nishi-Urayama, Aza Shinchi, Tōgatta-onsen, Zaō-machi, Katta-gun, Miyagi Prefecture
〒989-09　宮城県刈田郡蔵王町遠刈田温泉字新地西裏山36-135
☎ 0224-34-2385

JAPAN KOKESHI MUSEUM
日本こけし館
〒989-68　74-2 Aza Sutomae, Naruko-chō, Tamazukuri-gun, Miyagi Prefecture
〒989-68　宮城県玉造郡鳴子町字尿前74-2
☎ 0229-83-3600

LIST OF LOCAL CRAFT ASSOCIATIONS

Most of the organizations listed below are locally run and possess limited resources. While they are eager to lend assistance, they rarely have English-speaking staff, so your initial contact, whether by telephone or facsimile, should be in Japanese. An asterisk indicates an official English name. In cases where an English name was not available, an approximation of the Japanese name has been supplied. When appropriate or when a representative association could not be located, a company name has been suggested.

CERAMICS 陶磁器 *Tōjiki*

KUTANI WARE • *Kutani Yaki*

KUTANI PORCELAIN ASSOCIATION, ISHIKAWA PREFECTURE
石川県九谷陶磁器商工業協同組合連合会
〒923-11　25 Aza Terai-Yo, Terai-machi, Nomi-gun, Ishikawa Prefecture
〒923-11　石川県能美郡寺井町字寺井よ25
☎ 0761-57-0125
FAX: 0761-57-0320

MASHIKO WARE • *Mashiko Yaki*

MASHIKO POTTERS' ASSOCIATION
益子焼協同組合
〒321-42　4352-2 Ōaza Mashiko, Mashiko-machi, Haga-gun, Tochigi Prefecture
〒321-42　栃木県芳賀郡益子町大字益子4352-2
☎ 0285-72-3107
FAX: 0285-72-3058

MINO WARE • *Mino Yaki*

MINO WARE ASSOCIATION
美濃焼伝統工芸品協同組合
〒509-51　1429-8 Izumi-chō Kujiri, Toki, Gifu Prefecture
〒509-51　岐阜県土岐市泉町久尻1429-8
☎ 0572-55-5527
FAX: 0572-55-7352

HAGI WARE • *Hagi Yaki*

HAGI MUNICIPAL OFFICE
萩市経済部商工課
〒758　510 Emukai, Hagi, Yamaguchi Prefecture
〒758　山口県萩市江向510
☎ 0838-25-3131
FAX: 0838-26-0716

KYOTO WARE, KIYOMIZU WARE • *Kyō Yaki, Kiyomizu Yaki*

KYOTO FEDERATION OF CERAMICS ASSOCIATION*
京都陶磁器協同組合連合会
〒605　570-3 Shiraito-chō, Higashi-Ōji, Higashi-iru, Gojō-dōri, Higashiyama-ku, Kyoto
〒605　京都府京都市東山区五条通東大路東入ル白糸町570-3　京都陶磁器会館内
☎ 075-541-1102
FAX: 075-541-1195

SHIGARAKI WARE • *Shigaraki Yaki*

ASSOCIATION OF SHIGARAKI CERAMIC INDUSTRY*
信楽陶器工業協同組合
〒529-18　1142 Ōaza Nagano, Shigaraki-chō, Kōka-gun, Shiga Prefecture
〒529-18　滋賀県甲賀郡信楽町大字長野1142
☎ 0748-82-0831
FAX: 0748-82-3473

BIZEN WARE • *Bizen Yaki*

BIZEN POTTERY ASSOCIATION, OKAYAMA PREFECTURE
協同組合岡山県備前焼陶友会
〒705　1657-2 Inbe, Bizen, Okayama Prefecture
〒705　岡山県備前市伊部1657-2
☎ 0869-64-1001
FAX: 0869-64-1002

ARITA WARE • *Arita Yaki*

SAGA PREFECTURAL CERAMIC WARE INDUSTRY COOPERATIVE*
佐賀県陶磁器工業協同組合
〒844　1217 Chūbu-Hei, Arita-machi, Nishi-Matsuura-gun, Saga Prefecture
〒844　佐賀県西松浦郡有田町中部丙1217
☎ 0955-42-3164
FAX: 0955-43-2917

TOKONAME WARE • *Tokoname Yaki*

TOKONAME POTTERY ASSOCIATION
とこなめ焼協同組合
〒479　3-8 Sakae-machi, Tokoname, Aichi Prefecture
〒479　愛知県常滑市栄町3-8
☎ 0569-35-4309
FAX: 0569-34-4952

TOBE WARE • *Tobe Yaki*

IYO CERAMICS ASSOCIATION

伊予陶磁器協同組合
〒791-21　604 Ōminami, Tobe-chō, Iyo-gun, Ehime Prefecture
〒791-21　愛媛県伊予郡砥部町大南604
☎ 0899-62-2018
FAX: 0899-62-6246

TSUBOYA WARE • *Tsuboya Yaki*

TSUBOYA POTTERY COOPERATIVE SOCIETY*
壷屋陶器事業協同組合
〒902　1-21-14 Tsuboya, Naha, Okinawa Prefecture
〒902　沖縄県那覇市壺屋1-21-14
☎ 098-866-3284
FAX: 098-864-1472

KIKUMA TILES • *Kikuma Gawara*

KIKUMA TILES ASSOCIATION
菊間町窯業協同組合
〒799-23　316-2 Hama, Kikuma-chō, Ochi-gun, Ehime Prefecture
〒799-23　愛媛県越智郡菊間町浜316-2
☎ 0898-54-5511
FAX: 0898-54-5511

TEXTILES　染織　*Senshoku*

KIRYŪ FABRICS • *Kiryū Ori*

KIRYŪ TEXTILES WEAVERS' COOPERATIVE ASSOCIATION*
桐生織物協同組合
〒376　5-1 Eiraku-chō, Kiryū, Gunma Prefecture
〒376　群馬県桐生市永楽町5-1
☎ 0277-43-7171
FAX: 0277-47-5517

OITAMA PONGEE • *Oitama Tsumugi*

OITAMA PONGEE TRADITIONAL TEXTILE ASSOCIATION
置賜紬伝統織物協同組合連合会
〒992　1-1-5 Montō-machi, Yonezawa, Yamagata Prefecture
〒992　山形県米沢市門東町1-1-5
☎ 0238-23-3525
FAX: 0238-23-7229

YŪKI PONGEE • *Yūki Tsumugi*

YŪKI PONGEE TEXTILE ASSOCIATION, IBARAGI PREFECTURE
茨城県本場結城紬織物協同組合
〒307　607 Ōaza Yūki, Yūki, Ibaragi Prefecture
〒307　茨城県結城市大字結城607
☎ 02963-2-1108
FAX: 02963-2-1108

TRUE KIHACHIJŌ • *Honba Kihachijō*

KIHACHIJŌ TEXTILE ASSOCIATION
黄八丈織物協同組合
〒100-14　2025 Kashitate, Hachijō-machi, Hachijōjima, Tokyo
〒100-14　東京都八丈島八丈町樫立2025
☎ 04996-7-0516

OJIYA RAMIE CREPE • *Ojiya Chijimi*

OJIYA TEXTILE ASSOCIATION
小千谷織物同業協同組合

〒947　1-8-25 Jōnai, Ojiya, Niigata Prefecture
〒947　新潟県小千谷市城内1-8-25
☎ 0258-83-2329
FAX: 0258-83-2328

SHINSHŪ PONGEE • *Shinshū Tsumugi*

NAGANO PREFECTURAL TEXTILE ASSOCIATION
長野県織物工業組合
〒399　1-7-7 Nomizo-Nishi, Matsumoto, Nagano Prefecture
〒399　長野県松本市野溝西1-7-7
☎ 0263-26-0721
FAX: 0263-26-5350（試験場）

NISHIJIN FABRICS • *Nishijin Ori*

NISHIJIN TEXTILE INDUSTRIAL COOPERATIVE*
西陣織工業組合
〒602　414 Tatemonzen-chō, Imadegawa Minami-iru, Horikawa-dōri, Kamigyō-ku, Kyoto
〒602　京都府京都市上京区堀川通今出川南入ル堅門前町414
☎ 075-432-6131
FAX: 075-414-1521

YUMIHAMA IKAT • *Yumihama Gasuri*

YUMIHAMA IKAT ASSOCIATION, TOTTORI PREFECTURE
鳥取県弓浜絣協同組合
〒683　3001-3 Yomi-chō, Yonago, Tottori Prefecture
〒683　鳥取県米子市夜見町3001-3　鳥取県工業試験場生産技術科
☎ 0859-29-0851
FAX: 0859-29-5482

HAKATA WEAVE • *Hakata Ori*

HAKATA TEXTILE INDUSTRIAL ASSOCIATION*
博多織工業組合
〒812　1-14-12 Hakataeki-Minami, Hakata-ku, Fukuoka, Fukuoka Prefecture
〒812　福岡県福岡市博多区博多駅南1-14-12
☎ 092-472-0761
FAX: 092-472-1254

TRUE ŌSHIMA PONGEE • *Honba Ōshima Tsumugi*

FEDERATION OF KAGOSHIMA PREFECTURE ŌSHIMA TSUMUGI COOPERATIVE ASSOCIATIONS*
鹿児島県本場大島紬協同組合連合会
〒894　15-1 Minato-machi, Naze, Kagoshima Prefecture
〒894　鹿児島県名瀬市港町15-1
☎ 0997-53-4968
FAX: 0997-53-8255

MIYAKO RAMIE • *Miyako Jōfu*

MIYAKO TEXTILE ASSOCIATION
宮古織物事業協同組合
〒906　3 Aza Nishizato, Hirara, Okinawa Prefecture
〒906　沖縄県平良市字西里3
☎ 09807-2-8022
FAX: 09807-2-8022

SHURI FABRICS • *Shuri Ori*

NAHA TRADITIONAL TEXTILE ASSOCIATION
那覇伝統織物事業協同組合
〒903　2-64 Shuritōbaru-chō, Naha, Okinawa Prefecture
〒903　沖縄県那覇市首里桃原町2-64
☎ 098-887-2746
FAX: 098-885-5674

KIJOKA ABACA • *Kijoka no Bashōfu*

KIJOKA ABACA ASSOCIATION
喜如嘉芭蕉布事業協同組合
〒905-13　1103 Aza Kijoka, Ōgimi-son, Kunigami-gun, Okinawa Prefecture
〒905-13　沖縄県国頭郡大宜味村字喜如嘉1103
☎ 0980-44-3202
FAX: 0980-44-3202

YONTANZA MINSAA • *Yomitanzan Minsaa*

YOMITANZAN MINSAA ASSOCIATION
読谷山花織事業協同組合
〒904-03　2974-2 Aza Zakimi, Yomitan-son, Nakagami-gun, Okinawa Prefecture
〒904-03　沖縄県中頭郡読谷村字座喜味2974-2
☎ 098-958-4674
FAX: 098-958-4674

ISESAKI IKAT • *Isesaki Gasuri*

ISESAKI TEXTILE ASSOCIATION
伊勢崎織物工業組合
〒372　31-9 Kuruwa-chō, Isesaki, Gunma Prefecture
〒372　群馬県伊勢崎市曲輪町31-9
☎ 0270-25-2700
FAX: 0270-24-6347

TSUGARU KOGIN STITCHING • *Tsugaru Kogin*

HIROSAKI KOGIN NEEDLEPOINT CENTER
（有）弘前こぎん研究所
〒036　61 Zaifu-chō, Hirosaki, Aomori Prefecture
〒036　青森県弘前市在府町61
☎ 0172-32-0595
FAX: 0172-32-0595

TOKYO STENCIL DYEING • *Tokyo Somekomon*

TOKYO ORDER-MADE DYEING ASSOCIATION*
東京都染色工業協同組合
〒169　3-20-12 Nishi-Waseda, Shinjuku-ku, Tokyo
〒169　東京都新宿区西早稲田3-20-12
☎ 03-3208-1521
FAX: 03-3208-1523

KAGA YŪZEN DYEING • *Kaga Yūzen*

KAGAZOME COOPERATIVE ASSOCIATION*
協同組合加賀染振興協会
〒920　8-8 Koshō-machi, Kanazawa, Ishikawa Prefecture
〒920　石川県金沢市小将町8-8
☎ 0762-24-5511
FAX: 0762-24-5533

KYOTO YŪZEN DYEING • *Kyō Yūzen*
KYOTO STENCIL DYEING • *Kyō Komon*
KYOTO TIE-DYEING • *Kyō Kanoko Shibori*

KYOTO CORPORATE FEDERATION OF DYERS & COLORISTS*
京都染色協同組合連合会
〒604　481 Tōrōyama-chō, Shijō-agaru, Nishinotōin-dōri, Nakagyō-ku, Kyoto
〒604　京都府京都市中京区西洞院通四条上ル蟷螂山町481　京染会館3F
☎ 075-255-4496
FAX: 075-255-4496

TOKYO YUKATA STENCIL DYEING • *Tokyo Honzome Yukata*

TOKYO YUKATA ASSOCIATION
東京ゆかた工業協同組合
〒103　9-16 Nihonbashi-kobuna-chō, Chūō-ku, Tokyo
〒103　東京都中央区日本橋小舟町9-16
☎ 03-3661-3862
FAX: 03-3669-0888

KYOTO EMBROIDERY • *Kyō Nui*

KYOTO EMBROIDERY ASSOCIATION*
京都刺繍協同組合
〒600　378-1 Kōtake-chō, Matsubara-agaru, Kawaramachi-dōri, Shimogyō-ku, Kyoto
〒600　京都府京都市下京区河原町通松原上ル幸竹町378-1　西刺繍内
☎ 075-361-5494
FAX: 075-365-0791

IGA BRAIDED CORDS • *Iga Kumihimo*

MIE PREFECTURAL KUMIHIMO COOPERATIVE SOCIETY*
三重県組紐協同組合
〒518　1929-10 Shijuku-chō, Ueno, Mie Prefecture
〒518　三重県上野市四十九町1929-10　伊賀くみひもセンター内
☎ 0595-23-8038
FAX: 0595-24-1015

LACQUER WARE　漆器　*Shikki*

WAJIMA LACQUER • *Wajima Nuri*

WAJIMA URUSHI WARE COOPERATIVE SOCIETY*
輪島漆器商工業協同組合
〒928　55, 24-bu, Kawai-machi, Wajima, Ishikawa Prefecture
〒928　石川県輪島市河井町24部55
☎ 0768-22-2155
FAX: 0768-22-2894

AIZU LACQUER • *Aizu Nuri*

AIZU LACQUER WARE COOPERATION UNION*
会津漆器協同組合連合会
〒965　1-7-3 Ōmachi, Aizuwakamatsu, Fukushima Prefecture
〒965　福島県会津若松市大町1-7-3
☎ 0242-24-5757
FAX: 0242-24-5726

KISO LACQUER • *Kiso Shikki*

KISO SHIKKI INDUSTRIAL COOPERATIVE ASSOCIATION*
木曽漆器工業協同組合
〒399-63　1729 Ōaza Hirasawa, Narakawa-mura, Kiso-gun, Nagano Prefecture
〒399-63　長野県木曽郡楢川村大字平沢1729
☎ 0264-34-2113
FAX: 0264-34-2312

HIDA SHUNKEI LACQUER • *Hida Shunkei*

HIDA SHUNKEI LACQUER WARE ASSOCIATION
飛騨春慶連合協同組合
〒506　Kamisanno-machi, Takayama, Gifu Prefecture
〒506　岐阜県高山市上三之町　福田屋内
☎ 0577-32-0065
FAX: 0577-35-1727

KISHŪ LACQUER • *Kishū Shikki*

WAKAYAMA-KEN LACQUER WARE COMMERCIAL AND INDUSTIAL COOPERATIVE ASSOCIATION*
和歌山県漆器商工業協同組合
〒642　222 Funao, Kainan, Wakayama Prefecture
〒642　和歌山県海南市船尾222
☎ 0734-82-0322
FAX: 0734-83-2341

MURAKAMI CARVED LACQUER • *Murakami Kibori Tsuishu*

MURAKAMI TSUISHU LACQUER WARE ASSOCIATION
村上堆朱事業協同組合
〒958　3-1-17 Matsubara-chō, Murakami, Niigata Prefecture
〒958　新潟県村上市松原町3-1-17
☎ 0254-53-1745
FAX: 0254-53-3053

KAMAKURA LACQUER • *Kamakura Bori*

TRADITIONAL KAMAKURA BORI ASSOCIATION
伝統鎌倉彫事業協同組合
〒248　3-4-7 Yuigahama, Kamakura, Kanagawa Prefecture
〒248　神奈川県鎌倉市由比ヶ浜3-4-7　神奈川県工芸指導所鎌倉支所内
☎ 0467-23-0154
FAX: 0467-23-0154

YAMANAKA LACQUER • *Yamanaka Shikki*

YAMANAKA LACQUER WARE COOPERATIVE ASSOCIATION*
山中漆器連合協同組合
〒922-01　268-2 Tsukatani-machi-I, Yamanaka-machi, Enuma-gun, Ishikawa Prefecture
〒922-01　石川県江沼郡山中町塚谷町イ268-2
☎ 07617-8-0305
FAX: 07617-8-5205

KAGAWA • *Kagawa Shikki*

KAGAWA LACQUER WARE ASSOCIATION
香川県漆器工業協同組合
〒761-01　1595 Kasuga-chō, Takamatsu, Kagawa Prefecture
〒761-01　香川県高松市春日町1595
☎ 0878-41-9820
FAX: 0878-41-9854

TSUGARU LACQUER • *Tsugaru Nuri*

AOMORI PREFECTURAL LACQUER WARE ASSOCIATION
青森県漆器協同組合連合会
〒036　2-4-9 Ōaza Kanda, Hirosaki, Aomori Prefecture
〒036　青森県弘前市大字神田2-4-9　津軽塗福祉センター内
☎ 0172-35-3629
FAX: 0172-33-1189

BAMBOO CRAFT　竹工品　*Chikkōhin*

SURUGA BASKETRY • *Suruga Take Sensuji Zaiku*

SHIZUOKA BAMBOO CRAFT COOPERATIVE ASSOCIATION*
静岡竹工芸協同組合
〒420　22 Hachiban-chō, Shizuoka, Shizuoka Prefecture
〒420　静岡県静岡市八番町22
☎ 054-252-4924
FAX: 054-273-2679

BEPPU BASKETRY • *Beppu Take Zaiku*

BEPPU BAMBOO CRAFT ASSOCIATION
別府竹製品協同組合
〒874　5-Kumi, Ōhata-machi, Beppu, Ōita Prefecture
〒874　大分県別府市大畑町5組　早野久雄クラフト研究室内
☎ 0977-23-6043
FAX: 0977-23-6093

TAKAYAMA TEA WHISKS • *Takayama Chasen*

TAKAYAMA TEA WHISK ASSOCIATION, NARA PREFECTURE
奈良県高山茶筌生産協同組合
〒630-01　6439-3 Takayama-chō, Ikoma, Nara Prefecture
〒630-01　奈良県生駒市高山町6439-3
☎ 07437-8-0034
FAX: 07437-9-1851

MIYAKONOJŌ BOWS • *Miyakonojō Daikyū*

SOUTH KYŪSHŪ ARCHERY BOW ASSOCIATION
全日本弓道具南九州地区協会
〒885　8-14 Tsumagaoka-chō, Miyakonojō, Miyazaki Prefecture
〒885　宮崎県都城市妻ケ丘町8-14
☎ 0986-22-4604
FAX: 0986-22-4009

JAPANESE PAPER　和紙　*Washi*

ECHIZEN PAPER • *Echizen Washi*

FUKUI-KEN JAPANESE PAPER INDUSTRIAL COOPERATIVE*
福井県和紙工業協同組合
〒915-02　11-11 Ōtaki, Imadate-chō, Imadate-gun, Fukui Prefecture
〒915-02　福井県今立郡今立町大滝11-11
☎ 0778-43-0875
FAX: 0778-43-1142

AWA PAPER • *Awa Washi*
AWAGAMI FACTORY*
阿波手漉和紙商工業協同組合
〒779-34　141 Aza Kawahigashi, Yamakawa-chō, Oe-gun, Tokushima Prefecture
〒779-34　徳島県麻植郡山川町字川東141　阿波和紙伝統産業会館内
☎ 08834-2-6120
FAX: 08834-2-6120

TOSA PAPER • *Tosa Washi*

KŌCHI PREFECTURAL HANDMADE PAPER COOP UNION*
高知県手すき和紙協同組合
〒781-21　287-4 Hakawa, Ino-chō, Agawa-gun, Kōchi Prefecture
〒781-21　高知県吾川郡伊野町波川287-4
☎ 0888-92-4170
FAX: 0888-92-4168

UCHIYAMA PAPER • *Uchiyama Gami*

UCHIYAMA HANDMADE PAPER INDUSTRY ASSOCIATION, NORTH NAGANO
北信内山紙工業協同組合
〒389-23　6385 Ōaza Mizuho, Iiyama, Nagano Prefecture
〒389-23　長野県飯山市大字瑞穂6385
☎ 0269-65-2511
FAX: 0269-65-2601

INSHŪ PAPER • *Inshū Washi*

SAJI INSHŪ HANDMADE PAPER ASSOCIATION
佐治因州和紙協同組合
〒689–13　37–3 Fukuzono, Saji-son, Yazu-gun, Tottori Prefecture
〒689–13　鳥取県八頭郡佐治村福園37–3　佐治村商工会内
☎ 0858–88–0540
FAX: 0858–88–0540

WOODCRAFT 木工品 *Mokkōhin*

IWAYADŌ CHESTS • *Iwayadō Tansu*

IWAYADO TANSU CHESTS ASSOCIATION
岩谷堂箪笥生産協同組合
〒023–11　68–1 Aza Ebishima, Odaki, Esashi, Iwate Prefecture
〒023–11　岩手県江刺市愛宕字海老島68–1
☎ 0197–35–0275
FAX: 0197–35–0972

KAMO PAULOWNIA CHESTS • *Kamo Kiri Tansu*

KAMO PAULOWNIA CHESTS ASSOCIATION
加茂箪笥協同組合
〒959–13　2–2–4 Saiwai-chō, Kamo, Niigata Prefecture
〒959–13　新潟県加茂市幸町2–2–4　加茂市産業センター2F
☎ 0256–52–0445
FAX: 0256–52–0428

KYOTO WOODWORK • *Kyō Sashimono*

KYOTO JOINERY CRAFT ASSOCIATION
京都木工芸協同組合
〒600　89 Ebisuno-chō, Aino-machi Nishi-iru, Rokujō-dōri, Shimogyō-ku, Kyoto
〒600　京都府京都市下京区六条通間之町西入ル夷之町89　（有）江南ビル
☎ 075–361–2816
FAX: 075–351–8657

ŌDATE BENTWOOD WORK • *Ōdate Magewappa*

ŌDATE BENTWOOD WARE ASSOCIATION
大館曲ワッパ協同組合
〒017　1–3–1 Onari-chō, Ōdate, Akita Prefecture
〒017　秋田県大館市御成町1–3–1
☎ 0186–49–5221
FAX: 0186–49–5221

AKITA CEDAR BOWLS AND BARRELS • *Akita Sugi Oke Taru*

AKITA CEDAR BOWLS AND BARRELS ASSOCIATION
秋田杉桶樽協同組合
〒010　1–5 Kyokuhokusakae-machi, Akita, Akita Prefecture
〒010　秋田県秋田市旭北栄町1–5　（社）秋田木材会館
☎ 0188–64–2761
FAX: 0188–64–2756

HAKONE MARQUETRY • *Hakone Yosegi Zaiku*

ODAWARA & HAKONE TRADITIONAL MARQUETRY ASSOCIATION
小田原箱根伝統寄木協同組合
〒250　1–21 Jōnai, Odawara, Kanagawa Prefecture
〒250　神奈川県小田原市城内1–21　商工会館5F　（社）箱根物産連合会内
☎ 0465–22–4896
FAX: 0465–23–4531

NAGISO TURNERY • *Nagiso Rokuro Zaiku*

NAGISO TURNED GOODS ASSOCIATION
南木曾ろくろ工芸協同組合
〒399–53　4689 Azuma, Nagiso-machi, Kiso-gun, Nagano Prefecture
〒399–53　長野県木曽郡南木曽町吾妻4689
☎ 0264–58–2434
FAX: 0264–58–2434

TAKAYAMA WOODCARVING • *Takayama Ichii-Ittōbori*

HIDA WOODCARVING ASSOCIATION
飛騨一位一刀彫協同組合
〒506　1–296–6 Morishita-machi, Takayama, Gifu Prefecture
〒506　岐阜県高山市森下町1–296–6
☎ 0577–33–0744
FAX: 0577–33–0744

INAMI WOODCARVING • *Inami Chōkoku*

INAMI WOODCARVING ASSOCIATION
井波彫刻協同組合
〒932–02　700–111 Inami, Inami-machi, Higashi-Tonami-gun, Toyama Prefecture
〒932–02　富山県東砺波郡井波町井波700–111　井波彫刻伝統産業会館内
☎ 0763–82–5158
FAX: 0763–82–5163

KISO OROKU COMBS • *Kiso Oroku Gushi*

YABUHARA OROKU COMBS ASSOCIATION
籔原お六櫛組合
〒399–62　Ōaza Yabuhara, Kiso-mura, Kiso-gun, Nagano Prefecture
〒399–62　長野県木曽郡木祖村大字籔原
☎ 0264–36–2205
FAX: 0264–36–2727

AKITA CHERRY-BARK WORK • *Kabazaiku*

KAKUNODATE CRAFT ASSOCIATION
角館工芸協同組合
〒014–03　18 Aza Tonoyama, Iwase, Kakunodate-machi, Senboku-gun, Akita Prefecture
〒014–03　秋田県仙北郡角館町岩瀬字外ノ山18
☎ 0187–53–2228
FAX: 0187–53–2228

METALWORK 金工品 *Kinkōhin*

NANBU CAST IRONWORK • *Nanbu Tekki*

NAMBU IRON WARE ASSOCIATION, IWATE PREFECTURE
岩手県南部鉄器協同組合連合会
〒020　64–102 Aza Oirino, Tsunagi, Morioka, Iwate Prefecture
〒020　岩手県盛岡市繋字尾入野64–102
☎ 0196–89–2336
FAX: 0196–89–2337

TSUBAME BEATEN COPPER WARE • *Tsubame Tsuiki Dōki*

TSUBAME BUNSUI COPPER WARE ASSOCIATION
燕・分水銅器協同組合
〒959–12　2 Chūō-dōri, Tsubame, Niigata Prefecture
〒959–12　新潟県燕市中央通2

☎ 0256-62-2015
FAX: 0256-64-5945

TAKAOKA CASTING • *Takaoka Dōki*

TAKAOKA COPPER WARE ASSOCIATION
伝統工芸高岡銅器振興協同組合
〒933　1-1 Kaihatsu-honmachi, Takaoka, Toyama Prefecture
〒933　富山県高岡市開発本町1-1　高岡地域地場産業センター内
☎ 0766-24-8565
FAX: 0766-26-0875

OSAKA NANIWA PEWTER WARE • *Osaka Naniwa Suzuki*

PEWTER WARE ASSOCIATION
錫器事業協同組合
〒540　Matsuya Building No. 6, 628, 2-1-31, Nōninbashi, Chūō-ku, Osaka
〒540　大阪市中央区農人橋2-1-31　第6松屋ビル628号
☎ 06-947-2773
FAX: 06-947-2773

TOKYO SILVERSMITHERY • *Tokyo Ginki*

TOKYO ART SILVER WARE ASSOCIATION
東京金銀器工業協同組合
〒110　2-24-4 Higashi-Ueno, Taitō-ku, Tokyo
〒110　東京都台東区東上野2-24-4　東京銀器会館
☎ 03-3831-3317
FAX: 03-3831-3326

SAKAI FORGED BLADES • *Sakai Uchi Hamono*

SAKAI CUTLERY FEDERATION COOPERATIVE*
堺刃物商工業協同組合連合会
〒590　1-1-24 Shukuya-chō Nishi, Sakai, Osaka
〒590　大阪府堺市宿屋町西1-1-24
☎ 0722-27-1001
FAX: 0722-38-8906

KYOTO METAL INLAY • *Kyō Zōgan*

KYOTO METAL INLAY ASSOCIATION
京都府象嵌振興会
〒616　10-3 Setogawa-chō, Saga Tenryūji, Ukyō-ku, Kyoto
〒616　京都府京都市右京区嵯峨天竜寺瀬戸川町10-3
☎ 075-871-2610
FAX: 075-882-0525

OTHER CRAFTS　諸工芸品　*Shokōgeihin*

BANSHŪ ABACUS • *Banshū Soroban*

BANSHŪ ABACUS ASSOCIATION
播州算盤工芸品協同組合
〒675-13　600 Hon-machi, Ono, Hyōgo Prefecture
〒675-13　兵庫県小野市本町600
☎ 07946-2-2108
FAX: 07946-2-2109

FUKUYAMA PLANE HARPS • *Fukuyama Koto*

FUKUYAMA MUSICAL INSTRUMENT ASSOCIATION
福山邦楽器製造業協同組合
〒720　3-2-8 Miyoshi-chō, Fukuyama, Hiroshima Prefecture
〒720　広島県福山市三吉町3-2-8　小川楽器製造（株）内
☎ 0849-24-1150
FAX: 0849-22-0119

KŌSHŪ LACQUERED DEERHIDE • *Kōshū Inden*

KŌSHŪ INDEN ASSOCIATION
甲府印伝商工業協同組合
〒400　3-11-15 Chūō, Kōfu, Yamanashi Prefecture
〒400　山梨県甲府市中央3-11-15
☎ 0552-33-1100
FAX: 0552-32-8428

NARA SUMI INK • *Nara Zumi*

NARA INKSTICK ASSOCIATION
奈良製墨協同組合
〒630　43 Nashihara-chō, Nara, Nara Prefecture
〒630　奈良県奈良市内侍原町43
☎ 0742-23-6589
FAX: 0742-23-6589

NARA BRUSHES • *Nara Fude*

NARA BRUSH ASSOCIATION
奈良毛筆協同組合
〒630　80-1 Nakatsuji-chō, Nara, Nara Prefecture
〒630　奈良県奈良市中辻町80-1
☎ 0742-22-3024
FAX: 0742-24-0356

OGATSU INKSTONES • *Ogatsu Suzuri*

OGATSU INKSTONE ASSOCIATION
雄勝硯生産販売協同組合
〒986-13　53-1 Aza Tera, Ōaza Ogatsu, Ogatsu-chō, Monou-gun, Miyagi Prefecture
〒986-13　宮城県桃生郡雄勝町大字雄勝字寺53-1　雄勝硯伝統産業会館内
☎ 0225-57-2632
FAX: 0255-57-3211

GYŌTOKU ŌKARAHAFU PORTABLE SHRINE • *Gyōtoku Ōkarahafū Mikoshi*

NAKADAI RELIGIOUS ORNAMENTS INCORPORATED
中台神仏具製作所
〒272-01　21-3 Hon-Gyōtoku, Ichikawa, Chiba Prefecture
〒272-01　千葉県市川市本行徳21-3
☎ 0473-57-2061
FAX: 0473-57-0809

KYOTO HOUSEHOLD BUDDHIST ALTARS, FITTINGS • *Kyō Butsudan, Kyō Butsugu*

KYOTO RELIGIOUS ORNAMENTS ASSOCIATION
京都府仏具協同組合
〒600　Marudai Building 4F, Minamigawa, Nishinotōin-Nishi-iru, Shichijō-dōri, Shimogyō-ku, Kyoto
〒600　京都府京都市下京区七条通西洞院西入ル南側　マルダイビル4F
☎ 075-341-2426
FAX: 075-343-2850

KYOTO CANDLES • *Kyō Rōsoku*

NAKAMURA CANDLE INCORPORATED
中村ろうそく（株）
〒604　211 Hashiura-chō, Sanjō-agaru, Higashi-Horikawa-dōri, Nakagyō-ku, Kyoto
〒604　京都府京都市中京区東堀川通三条上ル橋浦町211
☎ 075-221-1621
FAX: 075-251-1705

GIFU LANTERNS • *Gifu Chōchin*

GIFU LANTERN ASSOCIATION
岐阜提灯振興会
〒500　1-chōme, Oguma-chō, Gifu, Gifu Prefecture
〒500　岐阜県岐阜市小熊町1丁目
☎ 0582-63-0111
FAX: 0582-62-0058

IZUMO STONE LANTERNS • *Izumo Ishidōrō*

MATSUE STONE LANTERN ASSOCIATION
松江石灯ろう協同組合
〒690　86 Kuroda-chō, Matsue, Shimane Prefecture
〒690　島根県松江市黒田町86
☎ 0852-24-1815
FAX: 0852-24-1815

GIFU UMBRELLAS • *Gifu Wagasa*

GIFU UMBRELLA ASSOCIATION
岐阜和傘振興会
〒500　7 Yashima-chō, Gifu, Gifu Prefecture
〒500　岐阜県岐阜市八島町7
☎ 0582-71-3958
FAX: 0582-72-0095

MARUGAME ROUND FANS • *Marugame Uchiwa*

KAGAWA FAN ASSOCIATION
香川県うちわ協同組合連合会
〒763　2-3-1 Ōte-chō, Marugame, Kagawa Prefecture
〒763　香川県丸亀市大手町2-3-1　丸亀市役所商工観光課内
☎ 0877-23-2111
FAX: 0877-24-8863

KYOTO FOLDING FANS • *Kyō Sensu*

KYOTO FAN ASSOCIATION
京都扇子・団扇商工協同組合
〒600　Hama Bldg. 5F, 583-4, Moto-Siogama-chō, Gojō-sagaru, Kawaramachi-dōri, Shimogyō-ku, Kyoto
〒600　京都府京都市下京区河原町通五条下ル木塩竈町583-4　ハマビル5F
☎ 075-352-3254
FAX: 075-352-3253

EDO "ART" DOLLS • *Edo Kimekomi Ningyō*
EDO BATTLEDORE • *Edo Oshie Hagoita*

TOKYO HINA DOLL ASSOCIATION
東京都雛人形工業協同組合
〒111　2-1-9 Yanagibashi, Taitō-ku, Tokyo
〒111　東京都台東区柳橋2-1-9　東京卸商センター内
☎ 03-3861-3950
FAX: 03-3851-8248

MIHARU DOLLS • *Miharu Hariko*

TAKASHIBA DEKO YASHIKI
高柴デコ屋敷
〒977-01　163 Aza Tateno, Takashiba, Nishida-machi, Kōriyama, Fukushima Prefecture
〒977-01　福島県郡山市西田町高柴字館野163
☎ 0249-71-3176
FAX: 0249-71-3176

MIYAGI KOKESHI DOLLS • *Miyagi Dentō Kokeshi*

NARUKO WOODEN TOY ASSOCIATION
鳴子木地玩具協同組合
〒989-68　122-12 Aza Shin-yashiki, Naruko-chō, Tamazukuri-gun, Miyagi Prefecture
〒989-68　宮城県玉造郡鳴子町字新屋敷122-12
☎ 0229-83-3515
FAX: 0229-83-3512

AN ANNOTATED READING LIST

The following list was assembled with the idea of acknowledging some of the better publications on Japanese craft and providing avenues for further exploration. Some of the books and catalogs below are no longer in print, but may be found in select museums and public libraries in Japan, the United States, Europe, and elsewhere.

GENERAL

Birdsall, Derek, ed. *The Living Treasures of Japan.* London: Wildwood House, 1973.

Features fourteen selected craftsmen, including a papermaker, weavers, dyers, potters, stencil cutters, a woodworker, a lacquer artist, a swordsmith, and a bamboo craftsmen. Text in both English and Japanese based on actual interviews.

Fontein, Jan, ed. *Living National Treasures of Japan.* Tokyo, 1982.

Exhibition catalogue, with color photographs of more than 200 works by "Living National Treasures." Included are ceramics, textiles, dolls, lacquer ware, wood and bamboo crafts, metalwork, swords, and handmade paper. There are summaries of the history of each craft tradition and brief biographies of the artists.

Hauge, Victor and Takako. *Folk Traditions in Japanese Art.* Tokyo: Kodansha International, 1978.

Exhibition catalogue with 231 examples of painting, printmaking, sculpture, ceramics, textiles, lacquer ware, woodwork, metalwork, bamboo ware and basketry, dolls, and toys. Introductory essay contains overviews of the various craft traditions and individual entries for each of the objects.

Hickman, B., ed. *Japanese Crafts: Materials and their Applications.* London: Fine Books Oriental, 1977.

Text emphasizing materials, techniques, and uses of different objects, covering wood, bamboo, and metalwork. More than half of the book is devoted to bows and arrows, swords, and other military accoutrements. Illustrated by a combination of small black-and-white photographs and drawings.

Japan Folk Crafts Museum. *Mingei: Masterpieces of Japanese Folkcraft.* Tokyo: Kodansha International, 1991.

Beautifully illustrated book (158 color plates) featuring traditional textiles, ceramics (includes Hamada, Kawai, and Leach), woodcraft, lacquer ware, metalwork, and some pictorial art. There are essays on the *mingei* movement, the Japan Folk Crafts Museum, and Yanagi Sōetsu as well as descriptive notes to the plates adapted from Yanagi's writings.

Lowe, John. *Japanese Crafts.* London: John Murray, 1983.

Short descriptions, emphasizing general history and technique, of various craft objects such as folding fans, paper umbrellas and lanterns, writing and painting brushes, seals, wooden combs, brooms, kitchen knives, and tatami mats.

Massy, Patricia. *Sketches of Japanese Crafts and the People Who Make Them.* Tokyo: The Japan Times, 1980.

Brief introductions to a host of folkcrafts, including furniture, lacquer ware, pottery, textiles, toys, umbrellas, folding fans, bamboo baskets, and inkstones.

Moes, Robert. *Mingei: Japanese Folk Art.* New York: The Brooklyn Museum, 1985.

Exhibition catalogue covering 115 works including stone and wood sculpture, ceramics, furniture, kitchen utensils, metalwork, basketry, toys, and textiles, with separate sections on Okinawan and Ainu folk art. Good general essays on the history and characteristics of folk art in Japan.

Munsterberg, Hugo. *The Folk Arts of Japan.* Tokyo: Charles E. Tuttle, 1958.

Rudimentary introduction to selected craft traditions including pottery, basketry, lacquer ware, woodcraft, metalwork, toys, textiles, painting and sculpture, and peasant houses. Also discussion of folk art aesthetics and the contemporary folk art movement.

——. *Mingei: Folk Arts of Old Japan.* New York: The Asia Society, 1965.

Exhibition catalogue, with ceramics, lacquer ware, paintings, book illustrations, rubbings, sculpture, toys, textiles, and wood and metal objects (ninety-eight in total). Brief introductory essay on *mingei* traditions and their appreciation in the twentieth century.

Muraoka, Kageo and Okamura Kichiemon. *Folk Arts and Crafts of Japan.* The Heibonsha Survey of Japanese Art, Vol. 26. New York and Tokyo: Weatherhill/Heibonsha, 1973.

Well-illustrated survey (covers ceramics, textiles, wood-

work, metalwork, and folk pictures), with essays on the *mingei* movement, the history and appreciation of folk crafts in Japan, and the special characteristics and "beauty" of folk art.

Ogawa, Masataka, et. al. *The Enduring Crafts of Japan: 33 Living National Treasures*. New York and Tokyo: Walker/ Weatherhill, 1968.

Selection of thirty-three potters, weavers, dyers, paper stencil cutters, lacquer craftsmen, metal craftsmen, bamboo craftsmen, and doll makers, accompanied by short biographies and photographs (mostly black-and-white) by Sugimura Tsune of each artist at work.

Rathbun, William, and Michael Knight. *Yo no Bi: The Beauty of Japanese Folk Art*. Seattle: University of Washington Press, 1983.

Catalogue of exhibition of Japanese folk art from the Seattle Art Museum and other Pacific Northwest collections (179 objects). Includes sculpture, woodwork, furniture, metalwork, lacquer ware, bamboo ware and basketry, textiles, paintings, shop signs, and ceramics. Short introductory essay on *mingei* and individual essays on all of the above categories, illustrated by works in the exhibition.

Suzuki, Hisao. *Living Crafts of Okinawa*. New York and Tokyo: Weatherhill, 1973.

Basic introduction to Okinawan craft traditions including carpentry, stonemasonry, textiles, pottery and ceramic roof tiles, lacquer ware, and musical instruments. The strength of this book is the photography (mostly black-and-white) by Sugimura Tsune showing craftspeople at work and their creations.

Yanagi, Sōetsu, adapted by Bernard Leach. *The Unknown Craftsman: A Japanese Insight into Beauty*. New York and Tokyo: Kodansha International, 1972.

Collection of essays by a leader of the Japanese craft movement, focusing on the aesthetics and appreciation of traditional Japanese crafts. Includes seventy-six photographs of craft objects originally in his collection.

CERAMICS

Cort, Louise Allison. *Seto and Mino Ceramics*. Freer Gallery of Art, 1992.

Catalogue of 126 examples of Seto and Mino ceramics in the Freer Gallery collection, divided chronologically and according to kilns and types of ware. Text provides overviews of various traditions, followed by detailed entries on individual pieces. Technology of selected ceramics discussed in detail in an appendix by Pamela B. Vandiver of the Smithsonian's Conservation Analytical Laboratory.

Cort, Louise Allison. *Shigaraki, Potters' Valley*. Tokyo: Kodansha International, 1979.

Major scholarly work covering the evolution of ceramics in Shigaraki from early times up to the present day. Appendices include accounts of Shigaraki made in 1678 and 1872 by potters from other districts, the biography of a Shigaraki woman, a list of kiln sites, and technical information on Shigaraki clays.

Fujioka, Ryōichi. *Shino and Oribe Ceramics*. Japan Arts Library, Vol. 1. Tokyo: Kodansha International, 1977.

Comprehensive survey of Shino and Oribe traditions, abundantly illustrated and accompanied by a short introduction to ceramics and the tea ceremony by the translator, Samuel Morse.

Inumaru, Tadashi and Yoshida Mitsukuni, eds. *Ceramics*. The Traditional Crafts of Japan, Vol. 3. Tokyo: Diamond, 1992

Informative essays on twenty-eight regional ceramic traditions and three production centers of tiles, accompanied by beautiful color photographs, including many close-ups.

Jenyns, Soame. *Japanese Pottery*. London: Faber and Faber, 1971.

Chronological survey of traditional Japanese ceramic wares, with detailed descriptions and small black-and-white photographs. A useful introduction even though knowledge of certain wares has been expanded through recent research and excavations.

Mikami, Tsugio. *The Art of Japanese Ceramics*. Heibonsha Survey of Japanese Art, Vol. 29. Tokyo and New York: Weatherhill and Heibonsha, 1973.

Broad overview of ceramics in Japan, with general discussions of many of the best-known wares and 200 photographs in both black-and-white and color.

Mizuo, Hiroshi. *Folk Kilns I*. Famous Ceramics of Japan, Vol. 3. Tokyo: Kodansha International, 1981.

Introduction to selected folk wares in Honshu, divided by district. Accompanied by ninety-four color photographs with notes.

Moes, Robert. *Japanese Ceramics*. New York: The Brooklyn Museum, 1972.

Illustrated catalogue of exhibition (seventy-five objects) featuring primarily the Brooklyn Museum collection. Short essay on the general characteristics of Japanese ceramics and summaries of the development of different wares in each historical period.

Nakagawa, Sensaku. *Kutani Ware*. Tokyo: Kodansha International, 1979.

Well-illustrated survey of the origins and development of Old Kutani and later (Edo-period) Kutani wares.

Okamura, Kichiemon. *Folk Kilns II*. Famous Ceramics of Japan, Vol. 4. Tokyo: Kodansha International, 1981.

Introduction to some of the folk ceramic traditions in Kyushu, Shikoku, and Okinawa. There are seventy-four color plates with notes.

Rhodes, Daniel. *Tamba Pottery: The Timeless Art of a Japanese Village*. Tokyo: Kodansha International, 1970.

Overview of the development of pottery in Tamba from the Middle Ages up to the present day. Many black-and-white photographs of potters at work as well as of wares.

Sanders, Herbert H., with Tomimoto Kenkichi. *The World of Japanese Ceramics*. Tokyo: Kodansha International, 1967.

Detailed descriptions of the tools and materials used

for making pottery, forming and decorating techniques, and glazing and overglaze enamel decoration, gleaned from personal interviews and kiln visits. Includes appendices with other technical information for potters.

Satō Masahiko. *Kyoto Ceramics.* New York: Weatherhill, 1973.

General overview of the origins and development of ceramics in Kyoto, with special chapters on Ninsei and Kenzan.

Seattle Art Museum. *Ceramic Art of Japan: One Hundred Masterpieces from Japanese Collections.* Seattle: Seattle Art Museum, 1972.

Catalogue of the first major exhibition in America of Japanese ceramics from collections in Japan. Introductory essay with general background on many of the major wares and descriptive notes to the plates.

Simpson, Penny and Sodeoka Kanji. *The Japanese Pottery Handbook.* Tokyo: Kodansha International, 1979.

Contains short but thorough descriptions (and many drawings) of tools and equipment, forming processes, decoration, kilns and firing, etc. English terminology is accompanied by Japanese characters and romanization, making this a handy reference book for those wishing to communicate with Japanese potters.

Yoshiharu, Sawada. *Tokoname.* Famous Ceramics of Japan, Vol. 7. Tokyo: Kodansha International, 1982.

General essay outlining the origins, types, and techniques of Tokoname ware. There are fifty-eight color plates accompanied by brief descriptions.

TEXTILES

Bethe, Monica. "Color: Dyes and Pigments." In *Kosode: 16th-19th Century Textiles from the Nomura Collection,* eds. Naomi Noble, Richard and Margot Paul. New York: Japan Society and Kodansha International, 1984.

Volume provides detailed information on traditional dyes and techniques, and the aesthetics and significance of different colors in Japan.

Brandon, Reiko Mochinaga. *Country Textiles of Japan: The Art of Tsutsugaki.* New York and Tokyo: Weatherhill, 1986.

Published in conjunction with an exhibition at the Honolulu Academy of Arts. In addition to commentaries on each of the forty-eight works, there are essays giving background on the historical development, functions, motifs, and techniques associated with *tsutsugaki,* as well as on cotton and indigo.

Dusenbury, Mary. "Kasuri: A Japanese Textile." *The Textile Museum Journal,* Vol. 17 (1978).

Scholarly treatise on the origins and development of *kasuri* weaving in Japan, including discussion of materials, dyes, and techniques.

Inumaru, Tadashi and Yoshida Mitsukuni, eds. *Textiles I, Textiles II.* The Traditional Crafts of Japan, Vols. 1 and 2. Tokyo: Diamond, 1992.

Lavish color plates accompanied by lengthy entries introducing forty-six textile traditions of Okinawa and other parts of Japan. Introductory essays survey the development of weaving and dyeing.

Nakano, Eisha and Barbara B. Stephan. *Japanese Stencil Dyeing: Paste-Resist Techniques.* New York and Tokyo: Weatherhill, 1982.

Introduction to the *katazome* tradition, with technical instructions on making stencils, preparing the paste and fabric, laying the paste, sizing and dyeing the fabric, etc.

Rathbun, William Jay, ed. *Beyond the Tanabata Bridge: Traditional Japanese Textiles.* Seattle: Seattle Art Museum, 1993.

Exhibition catalogue, with discussions of sixty-one works (illustrated in color) and informative essays on the tradition of folk textiles in Japan, color, bast fibers, *sashiko,* resist-dyeing, *kasuri,* and Okinawan and Ainu textiles.

Tomito, Jun and Noriko. *Japanese Ikat Weaving: The Techniques of Kasuri.* London: Routledge & Kegan Paul, 1982.

Basic introduction to *kasuri,* with technical instructions on weaving and dyeing. Explanations accompanied by drawings and a few black-and-white photographs.
Wada, Yoshiko, et al., *Shibori: The Inventive Art of Japanese Shaped Resist Dyeing.* New York and Tokyo: Kodansha International, 1983.

Historical overview of the *shibori* tradition, followed by detailed descriptions of various techniques (generously illustrated with drawings and photographs). There is also a discussion of the *shibori* craft in contemporary Japan and the West, with examples by twenty-four artists. Appendix with technical information on preparing cloth and dyes, and glossary.

LACQUER WARE

Brommelle, N. S. and Perry Smith, eds. *Urushi: Proceedings of the Urushi Study Group, June 10–27, 1985, Tokyo.* Marina del Rey, California: The Getty Conservation Institute, 1988

Includes scholarly papers dealing with the historical development of lacquer in Japan, conservation, and techniques. Comprehensive glossary of terminology.

Inumaru, Tadashi and Yoshida Mitsukuni, eds. *Lacquerware.* The Traditional Crafts of Japan, Vol. 4. Tokyo: Diamond, 1992

Beautiful color photographs document the lacquer craft traditions of Tsugaru, Hidehira, Jōhōji, Kawatsura, Aizu, Kamakura, Odawara, Murakami, Takaoka, Wajima, Yamanaka, Kanazawa, Echizen, Wakasa, Kiso, Hida Shunkei, Kyoto, Kishū, Ōuchi, Kagawa, and Ryūkyū. In addition to a general essay covering the development of lacquer production in Japan, each regional tradition is discussed individually.

Von Rague, Beatrix. *A History of Japanese Lacquerwork.* Toronto and Buffalo: University of Toronto Press, 1976.

Chronological survey of lacquer focusing on stylistic development and dating, with photographs of 199 representative works. Includes glossary and list of characters for Japanese names and technical terms. Translation from German.

Watt, James and Barbara Brennan Ford. *East Asian Lacquer: The Florence and Herbert Irving Collection.* New York: The Metropolitan Museum of Art, 1991.

Exhibition catalogue including approximately eighty

examples of Japanese lacquer and twenty examples of lacquer from the Ryūkyū islands. Essays discussing *makie* and *negoro*, Kōdaiji and *namban* lacquer, as well as informative entries on the individual works. Glossary of lacquer terms.

Yonemura, Ann. *Japanese Lacquer*. Washington, D.C.: Freer Gallery of Art, Smithsonian Institution, 1979.

Exhibition catalogue featuring fifty-seven objects from the Freer Gallery of Art collection. Introductory essay outlines the historical development of Japanese lacquer, and individual entries discuss the lacquer techniques and design of each object. Useful glossary of Japanese lacquer terms.

BAMBOO CRAFT

Inumaru, Tadashi and Yoshida Mitsukuni. *Wood and Bamboo*. The Traditional Crafts of Japan, Vol. 5. Tokyo: Diamond, 1992. (*See* Woodcraft)

Kudō, Kazuyoshi. *Japanese Bamboo Baskets*. Form and Function Series. Tokyo: Kodansha International, 1980.

Fine black-and-white photographs of a wide range of baskets, with explanatory captions in English providing information on functions, special features, and provenances.

PAPER

Barrett, Timothy. *Japanese Papermaking: Traditions, Tools and Techniques*. New York: Weatherhill, 1983.

Part 1 describes in detail the traditional papermaking process in Japan, while Part 2 gives step-by-step directions on how to make Japanese-style paper. A valuable source of information on raw materials, tools, equipment, etc.

Hughes, Sukey. *Washi: The World of Japanese Paper*. Tokyo: Kodansha, International, 1982.

Covers the history of papermaking and uses of paper in Japan, with detailed descriptions of materials and processes accompanied by many drawings and photographs. Also included are interviews with contemporary papermakers, a discussion of the aesthetics of *washi*, a catalog of different kinds of papers with short descriptions, and a glossary of terms.

Inumaru, Tadashi and Yoshida Mitsukuni. *Paper and Dolls*. The Traditional Crafts of Japan, Vol. 7. Tokyo: Diamond, 1992

Beautifully illustrated (all-color) book with a general essay outlining the historical development of paper in Japan, and separate essays on ten regional papers, as well as umbrellas, lanterns, fans, stencils, dolls, drums, shamisen, and fishing flies.

WOODCRAFT

Clarke, Rosy. *Japanese Antique Furniture: A Guide to Evaluating and Restoring*. New York and Tokyo: Weatherhill, 1983.

Introduction to traditional Japanese furniture, especially *tansu*, with photographs and discussions of different types and styles. Includes useful information on materials and techniques, and glossary of Japanese terms.

Heineken, Ty and Kiyoko. *Tansu: Traditional Japanese Cabinetry*. New York and Tokyo: Weatherhill, 1981.

Covers the historical development of *tansu* from the Edo to the Taisho periods, regional styles, materials, and

construction techniques. Amply illustrated with black-and-white and color photographs as well as drawings.

Inumaru, Tadashi and Yoshida Mitsukuni. *Wood and Bamboo*. The Traditional Crafts of Japan, Vol. 5. Tokyo: Diamond, 1992.

Handsomely illustrated (all-color) book covering twenty-nine regional wood and bamboo craft traditions. Includes *tansu* and other furniture items, household containers and vessels, *go* and *shōgi* boards, abacuses, carved wood transoms, sculpture, masks, bamboo wares and basketry, and tea whisks. Each craft is discussed in detail in individual essays.

Koizumi, Kazuko. *Traditional Japanese Furniture: A Definitive Guide*. Tokyo: Kodansha International, 1986.

A thorough survey of most types of furniture, including *tansu*, screens, shelving, and lanterns. Introductory text on each type of piece, followed by a historical overview tracing the evolution and use of these different types. Extensive color and black-and-white illustrations, a short section on techniques, and an impressive section entitled Illustrated History of Japanese Furniture.

METALWORK

Arts, P.L.W. *Tetsubin: A Japanese Waterkettle*. Groningen: Geldermalsen Publications, 1988.

Scholarly treatise on cast-iron waterkettles, with chapters on the development of *tetsubin* as a tea and household utensil, regional centers of manufacture, guilds, patronage patterns, casting techniques, and metallographic data.

Inumaru, Tadashi and Yoshida Mitsukuni. *Metal and Stone*. The Traditional Crafts of Japan, Vol. 6. Tokyo: Diamond, 1992.

Covers twenty-two regional metal and stone craft traditions, including iron teakettles; silver, bronze, copper, and pewter vessels; forged blades; gold leaf; cloisonne; metal inlay; agate, crystal, and coral carving; and stone lanterns and basins. Each craft is documented by beautiful color photographs and a descriptive, informative text.

OTHER CRAFTS

Inumaru, Tadashi and Yoshida Mitsukuni. *Writing Utensils and Household Buddhist Altars*. The Traditional Crafts of Japan, Vol. 8. Tokyo; Diamond, 1992.

Opening essay with historical overview followed by lavish color plates of inkstones, brushes, ink sticks, household Buddhist altars, and other Buddhist as well as Shinto paraphernalia, produced in various regions. Each of the twenty-six craft traditions is discussed in detail in essays appended at the end.

Usui, Masao. *Japanese Brushes*. Form and Function Series. Tokyo: Kodansha International, 1979.

Black-and-white photographs of a diversity of brushes made by skilled craftsmen in Tokyo, Kyoto, and Nara. Notes to the plates provide information on the type of hair used and the functions of the brushes. The process of making a brush is documented with sequential photographs.

ENGLISH-JAPANESE CRAFTS INDEX

JAPANESE-ENGLISH CRAFTS INDEX

にほん でんとうこうげいひん
日本の伝統工芸品
JAPANESE CRAFTS

2001 年 4 月16日　第 1 刷発行

著　者　伝統工芸国際フォーラム
　　　　でんとうこうげいこくさい
発行者　野間佐和子
発行所　講談社インターナショナル株式会社
　　　　〒112-8652　東京都文京区音羽 1-17-14
　　　　電話：03-3944-6493
印刷所　凸版印刷株式会社
製本所　凸版印刷株式会社